GREAT WESTERN SALT WORKS

essays on

the meaning of Post-Formalist art

ALSO BY JACK BURNHAM
Beyond Modern Sculpture
The Structure of Art

GREAT WESTERN SALT WORKS

essays on the meaning
of Post-Formalist art

JACK BURNHAM

GEORGE BRAZILLER / NEW YORK

ACKNOWLEDGMENTS

Some of these essays have previously appeared in *Artforum* and *Arts,* to whose editors grateful acknowledgment is made:

ARTFORUM

"Systems Esthetics," (1968),
"Real Time Systems" (1969),
"Les Levine — Business as Usual," (1970),
"Alice's Head" (1970);

ARTS

"Willoughby Sharp Interviews Jack Burnham" (1971),
"Duchamp's Bride Stripped Bare, I, II, III" (1972),
"Voices from the Gate" (1972),
"The Semiotics of 'End-Game' Art" (1972),
"The Artist as Shaman" (1973),
"Objects and Ritual" (1973),
"Contemporary Ritual" (1973).

Art in art is art.

The end of art is art as art.

The end of art is not the end.

Ad Reinhardt

CONTENTS

PREFACE

Writing on contemporary art implies a double life for the author. It demands complete involvement in that protean sea of ideas and emotion, namely the "art system," and there must be some semblance of quiet and seclusion where one can think and hopefully write. During two crucial summers Armand and Celeste Bartos and the Aspen Center for Contemporary Art have offered me that opportunity. For this, and for many hours of happy conversation, these two very generous people have my deepest gratitude. Also I wish to thank Northwestern University for its continued support. Some of the editing and final work on the present volume was completed during my fellowship year. This was made possible by the John Simon Guggenheim Memorial Foundation and its invaluable program for scholars, writers, and artists.

Judith Burnham is responsible for much of the criticism, editing, and retyping of these essays; for this she has my loving appreciation. Again, I am most grateful to George Braziller for his moral support and continued belief in my ideas, and to my editor, Victoria Newhouse, for her perceptive work on my behalf.

J. B.
December, 1973

INTRODUCTION

After the last few years of awaiting "the next revolution" the art world's controlling interests are beginning to suspect that formal innovation is at an end. Five years ago few would have entertained that possibility. With the demise of Formalism in painting and sculpture, "Ecological Art," "Anti-Form," "Arte Povera," "Body Art," and "Conceptual Art" — to name a few manifestations — have gradually come under stronger attack. Not because they replace Formalism financially, but because it is so obvious to many that they constitute all that is left of the avant-garde. Sadder still is the tendency to cram these newer "isms" into similar stylistic categories. As aesthetic activities free of illusionism and formal manipulation they are preeminently concerned with the everyday world, thus moving toward political involvement, alternate living experiments, ritual, and craft as symbolic endeavor.

Through the last decade it was easy enough to label any critical support for these tendencies as anti-art or literary dadaism, and this was done often enough. Yet there was and still remains a sincere desire among a few critics, and more artists, to steer art away from its various self-appointed guardians. Looking back over this period, one must not underestimate the ingenuity of curators and galleries for reifying (transforming into catalogued works of art) what are essentially social and personal gestures by artists. Still, and this remains the primary message of these essays, if art is the barometer of a culture's spiritual health, authentic art, like authentic existence, must maintain its substance in pure being. As of now art is tremendously weighted down with an obsession for the past and future. Ideally, however, art would achieve its full significance from the daily recurrence of structured acts. These constitute the psychic and living "glue" that binds a culture together. Thrust into history these same acts are represented by a series of material objects that define art's "fall from grace."

The present volume traces my own psychological metamorphosis. Given the quasi-scientific rationalism implicit in the first few systems essays, the gradual transition toward high magic in cabalism and alchemy appears to be a complete inversion. Yet fundamentally the systems view of reality, with its theory of hierarchies and fusion of living and nonliving structures, is not inconsistent with hermetic philosophy. In terms of practical application, its utilitarianism and obsession with efficiency leave much about organic relationships misunderstood. Ultimately systems theory may be another attempt by science to resist the emotional pain and ambiguity that remain an unavoidable aspect of life.

For some readers these essays, at least the later ones, may sound rather apocalyptic. We commonly think of apocalypse as pertaining to a frightening and catastrophic end. Present Western culture certainly supports this view. However, the true meaning of this Biblical term comes closer to revelation, rediscovery, and ultimate disclosure. It may be that in time we will come to understand the dialectics of art change as a process running parallel to the gradual demythification of our collective psyche.

The interview taped by Willoughby Sharp in September of 1970 is included because it sums up in rather simple terms a number of critical ideas that were running through my mind at the time. One of the archetypal desires of "hard science" is to create a man-made intelligence, something in all ways superior to nature. My experiences with real-time computer usage in making art and the software exhibition convinced me that these were Faustian myths of the highest order. I began to sense that nature contains (and through it art) a series of hidden prohibitions

against such artificial domination. Moreover the main vehicle blocking the logical exegesis of art and other mythic conventions seems to be, as the Structuralists have indicated, the fabric of natural language itself.

In *The Structure of Art* (Braziller, 1971), I partitioned some examples of modernist art according to the taxonomic principles of Roland Barthe's semiology, borrowing ideas from Saussure and Hjelmslev. Organizing *The Structure of Art* gave me a sense of the limits of structural analysis as it existed then in various anthropological and linguistic essays. Beyond Structuralism the evasive notion of linguistic universals holds more appeal, if only because the idea of art springing from a set of generative axioms seems to lie at the heart of Duchamp's cabalistic technique. Clearly the enormously varied set of offerings termed "Western Art" are far richer in their logical relations than those mythic conventions discussed within the traditionalist cultures studied by Jakobson and Lévi-Strauss.

A substantial portion of this collection represents homage to the most elusive artist of the twentieth century, Marcel Duchamp. "The Purposes of the Ready-mades" was reconstructed from two essays that regard Duchamp as an accomplished cabalist and alchemist ("Unveiling the Consort" in *Artforum,* March and April, 1971; and "The True Ready–Made?" in *Art and Artists,* February, 1972). These presume more knowledge than I had, or presently have, on the subject. Nevertheless, many of my conclusions will be helpful for developing a hermetic theory of art. Several scholars have already noted Duchamp's propensity for using alchemical symbolism. My essays move beyond this and propose that Duchamp mastered the creative powers of the Hebrew letters as they are determined in the *Sepher Yetzirah,* the ancient key to cabalistic knowledge. It is said that these powers are unique to the human brain. They not only control all the human sign systems by which culture is fashioned, but they express all the laws of universal growth and decay. As a result, in cabalistic lore man is considered to be a perfect microcosm of the universe.

These essays also indicate that Duchamp's *The Large Glass* and his *Notes from the Green Box* contain a series of obscure clues — mathematical, neurological, physiological, and historical — to the powers of the letters as they apply to the historical formulation of art. Thus all of Duchamp's mature activities are hermetic preparation for an incipient crisis in Western culture, one that is presently extending into the arts and also challenging most of the epistemological assumptions shaping Western thought and tradition.

In one early note Duchamp writes of "a Regulation of regrets from one removed part to another." And in explaining this "removal" of the limbs and organs from the corpus (of the fine arts), commenting on their inability to communicate, Duchamp alludes to the strange and alienated condition in which the art world finds itself today. If I were to explain the physics of this condition I might describe a body of water containing a small island of some viscous substance floating on its surface. A single bit of soap dropped into the center of this substance suddenly creates a dispersion in a thousand directions. Similarly the syntactical consistency of illusionism in high art has been eroded to the point where such a chemical reaction can and has taken place. Now the syntax of art consists simply of a few logical relationships. What remains is a series of fragments and actions collectively representing the condition of art in its original state of unity.

My task has been to see these fragments as a part of a cycle leading us back to a fresh conception of our own bodies and habitation. Some of the artists mentioned appear to sense this condition and their work is accordingly didactic. Such art has to a smaller or larger degree the function of the philosopher's SALT. Both in structure and intention Duchamp's works embody this final and essential element in the Great Work. Salt dissolves and purifies the false chemistry of current artistic ambition. It balances between chemical extremes and seeks to unite the polarities. Salt is the negation of all past "Anti-Art."

SYSTEMS ESTHETICS

A polarity is presently developing between the finite, unique work of high art, i.e., painting or sculpture, and conceptions which can loosely be termed "unobjects," these being either environments or artifacts which resist prevailing critical analysis. This includes works by some primary sculptors (though some may reject the charge of creating environments), some gallery kinetic and luminous art, some outdoor works, happenings, and mixed media presentations. Looming below the surface of this dichotomy is a sense of radical evolution which seems to run counter to the waning revolution of abstract and non-objective art. The evolution embraces a series of absolutely logical and incremental changes, wholly devoid of the fevered iconoclasm which accompanied the heroic period from 1907 to 1925. As yet the evolving esthetic has no critical vocabulary so necessary for its defense, nor for that matter a name or explicit cause.

In a way this situation might be likened to the "morphological development" of a prime scientific concept—as described by Thomas Kuhn in The Structure of Scientific Revolutions (1962). Kuhn sees science at any given period dominated by a single "major paradigm"; that is, a scientific conception of the natural order so pervasive and intellectually powerful that it dominates all ensuing scientific discovery. Inconsistent facts arising through experimentation are invariably labeled as bogus or trivial — until the emergence of a new and more encompassing general theory.

Transition between major paradigms may best express the state of present art. Reasons for it lie in the nature of current technological shifts.

The economist, J. K. Galbraith, has rightly insisted that until recently the needs of the modern industrial state were never served by complete expression of the esthetic impulse. Power and expansion were its primary aims.

Special attention should be paid to Galbraith's observation. As an arbiter of impending socio-technical changes his position is pivotal. For the Left he represents America's most articulate apologist for Monopoly Capitalism; for the Right he is the socialist éminence grise of the Democratic Party. In The New Industrial State (1967) he challenges both Marxist orthodoxies and American mythologies premised upon laissez-faire Capitalism. For them he substitutes an incipient technocracy shaped by the evolving technostructure. Such a drift away from ideology has been anticipated for at least fifty years. Already in California think-tanks and in the central planning committees of each soviet, futurologists are concentrating on the role of the technocracy, i.e., its decision-making autonomy, how it handles the central storage of information, and the techniques used for smoothly implementing social change. In the automated state power resides less in the control of the traditional symbols of wealth than in information.

In the emergent "superscientific culture" long-range decision making and its implementation become more difficult and more necessary. Judgment demands precise socio-technical models. Earlier the industrial state evolved by filling consumer needs on a piecemeal basis. The kind of product design that once produced "better living" precipitates vast crises in human ecology in the 1960s. A striking parallel exists between the "new" car of the automobile stylist and the syndrome of formalist invention in art, where "discoveries" are made through visual manipulation. Increasingly "products" — either in art or life — become irrelevant and a different set of needs arise: these revolve around such concerns as maintaining the biological livability of the Earth, pro-

ducing more accurate models of social interaction, understanding the growing symbiosis in man-machine relationships, establishing priorities for the usage and conservation of natural resources, and defining alternate patterns of education, productivity, and leisure. In the past our technologically-conceived artifacts structured living patterns. We are now in transition from an *object-oriented* to a *systems-oriented culture.* Here change emanates, not from *things,* but from *the way things are done.*

The priorities of the present age revolve around the problems of organization. A systems viewpoint is focused on the creation of stable, on-going relationships between organic and non-organic systems, be these neighborhoods, industrial complexes, farms, transportation systems, information centers, recreation centers, or any of the other matrixes of human activity. All living situations must be treated in the context of a systems hierarchy of values. Intuitively many artists have already grasped these relatively recent distinctions, and if their "environments" are on the unsophisticated side, this will change with time and experience.

The major tool for professionally defining these concerns is systems analysis. This is best known through its usage by the Pentagon and has more to do with the expense and complexity of modern warfare, than with any innate relation between the two. Systems analysts are not cold-blooded logicians; the best have an ever-expanding grasp of human needs and limitations. One of the pioneers of systems applications, E. S. Quade, has stated that "Systems analysis, particularly the type required for military decisions, is still largely a form of art. Art can be taught in part, but not by the means of fixed rules . . ."[1] Thus "The Further Dimensions"[2] elaborated upon by Galbraith in his book are esthetic criteria. Where for some these become the means for tidying up a derelict technology, for Galbraith esthetic decision-making becomes an integral part of any future technocracy. As yet few governments fully appreciate that the alternative is biological self-destruction.

Situated between aggressive electronic media and two hundred years of industrial vandalism, the long held idea that a tiny output of art objects could somehow "beautify" or even significantly modify the environment was naive. A parallel illusion existed in that artistic influence prevails by a psychic osmosis given off by such objects. Accordingly lip service to public beauty remains the province of well-guarded museums. Through the early stages of industrialism it remained possible for decorative media, including painting and sculpture, to embody the esthetic impulse; but as technology progresses this impulse must identify itself with the means of research and production. Obviously nothing could be less true for the present situation. In a society thus estranged only the didactic function of art continues to have meaning. The artist operates as a quasipolitical *provocateur,* though in no concrete sense is he an ideologist or a moralist. *"L'art pour l'art"* and a century's resistance to the vulgarities of moral uplift have insured that.

The specific function of modern didactic art has been to show that art does not reside in material entities, but in relations between people and between people and the components of their environment. This accounts for the radicality of Duchamp and his enduring influence. It throws light on Picasso's lesser position as a seminal force. As with all succeeding formalist art, Cubism followed the tradition of circumscribing art value wholly within finite objects.

In an advanced technological culture the most important artist best succeeds by liquidating his position as artist vis-à-vis society. Artistic nihilism established itself through this condition. At the outset the artist refused to participate in idealism through craft. "Craft-fetishism,"[3] as termed by the critic Christopher Caudwell, remains the basis of modern formalism. Instead the significant artist strives to reduce the technical and psychical distance between his artistic output and the productive means of society. Duchamp, Warhol, and Robert Morris are similarly directed in this respect. Gradually this strategy transforms artistic and

technological decision-making into a single activity — at least it presents that alternative in inescapable terms. Scientists and technicians are not converted into "artists," rather the artist becomes a symptom of the schism between art and technics. Progressively the need to make ultrasensitive judgments as to the uses of technology and scientific information becomes "art" in the most literal sense.

As yet the implication that art contains survival value is nearly as suspect as attaching any moral significance to it. Though with the demise of literary content, the theory that art is a form of psychic preparedness has gained articulate supporters.

> Art, as an adaptive mechanism, is reinforcement of the ability to be aware of the disparity between behavioral pattern and the demands consequent upon the interaction with the environment. Art is rehearsal for those real situations in which it is vital for our survival to endure cognitive tension, to refuse the comforts of validation by affective congruence when such validation is inappropriate because too vital interests are at stake . . . [4]

* * *

The post-formalist sensibility naturally responds to stimuli both within and outside the proposed art format. To this extent some of it does begin to resemble "theater," as imputed by Michael Fried. More likely though, the label of "theatricality" is a red herring disguising the real nature of the shift in priorities. In respect to Mr. Fried's argument,[5] the theater was never a purist medium, but a conglomerate of arts. In itself this never prevented the theater from achieving "high art." For clearer reading, rather than maintaining Mr. Fried's adjectives, "theatrical" or "literalist" art, or the phrase used until now in this essay, "post-formalist esthetic," the term systems esthetic seems to encompass the present situation more fully.

The systems approach goes beyond a concern with staged environments and happenings; it deals in a revolutionary fashion with the larger problem of boundary concepts. In systems perspective there are no contrived confines such as the theater proscenium or picture frame. Conceptual focus rather than material limits define the system. Thus any situation, either in or outside the context of art, may be designed and judged as a system. Inasmuch as a system may contain people, ideas, messages, atmospheric conditions, power sources, etc., a system is, to quote the systems biologist, Ludwig von Bertalanffy, a "complex of components in interaction," [6] comprised of material, energy, and information in various degrees of organization. In evaluating systems the artist is a perspectivist considering goals, boundaries, structure, input, output, and related activity inside and outside the system. Where the object almost always has a fixed shape and boundaries, the consistency of a system may be altered in time and space, its behavior determined both by external conditions and its mechanisms of control.

In his book, The New Vision, Moholy-Nagy described fabricating a set of enamel on metal paintings. These were executed by telephoning precise instructions to a manufacturer. An elaboration of this was projected recently by the director of the Museum of Contemporary Art in Chicago, Jan van der Marck, in a tentative exhibition, "Art by Telephone." In this instance the recorded conversation between artist and manufacturer was to become part of the displayed work of art. For systems, information, in whatever form conveyed, becomes a viable esthetic consideration.

Fifteen years ago Victor Vasarely suggested mass art as a legitimate function of industrial society. For angry critics there existed the fear of undermining art's fetish aura, of shattering the mystique of craft and private creation. If some forays have been made into serially produced art, these remain on the periphery of the industrial system. Yet the entire phenomenon of reproducing an art object ad infinitum is absurd; rather than making quality available to a large number of people, it signals the end of concrete objects embodying visual metaphor. Such demythification is the Kantian Imperative applied esthetically. On the other hand, a systems esthetic is literal in that all phases of the life cycle of a system are relevant. There

is no end product which is primarily visual, nor does such an esthetic rely on a "visual" syntax. It resists functioning as an applied esthetic, but is revealed in the principles underlying the progressive reorganization of the natural environment.

Various postures implicit in formalist art were consistently attacked in the later writings of Ad Reinhardt. His black paintings were hardly rhetorical devices (nor were his writings) masking Zen obscurities; rather they were the means of discarding formalist mannerism and all the latent illusionism connected with post-realistic art. His own contribution he described as:

> The one work for the fine artist, the one painting, is the painting of the one-sized canvas . . . The single theme, one formal device, one color-monochrome, one linear division in each direction, one symmetry, one texture, one free-hand brushing, one rhythm, one working everything into dissolution and one indivisibility, each painting into one overall uniformity and nonirregularity.[7]

Even before the emergence of the anti-formalist "specific object" there appeared an oblique type of criticism, resisting emotive and literary associations. Pioneered between 1962 and 1965 in the writings of Donald Judd, it resembles what a computer programmer would call an entity's "list structure," or all the enumerated properties needed to *physically* rebuild an object. Earlier the phenomenologist, Maurice Merleau-Ponty, asserted the impossibility of *conceptually* reconstructing an object from such a procedure. Modified to include a number of perceptual insights not included in a "list structure," such a technique has been used to real advantage by the anti-novelist, Alain Robbe-Grillet. A web of sensorial descriptions is spun around the central images of a plot. The point is not to internalize scrutiny in the Freudian sense, but to infer the essence of a situation through detailed examination of surface effects. Similar attitudes were adopted by Judd for the purpose of critical examination. More than simply an art object's list structure, Judd included phenomenal qualities which would have never shown up in a fabricator's plans,

but which proved necessary for the "seeing" of the object. This cleared the air of much criticism centered around meaning and private intention.

It would be misleading to interpret Judd's concept of "specific objects" as the embodiment of a systems esthetic. Rather object art has become a stage towards further rationalization of the esthetic process in general — both by reducing the iconic content of art objects and by Judd's candidness about their conceptual origins. However, even in 1965 he gave indications of looking beyond these finite limits.

> A few of the more general aspects may persist, such as the work's being like an object or even being specific, but other characteristics are bound to develop. Since its range is wide, three-dimensional work will probably divide into a number of forms. At any rate, it will be larger than painting and much larger than sculpture, which, compared to painting, is fairly particular. . . . Because the nature of three dimension isn't set, given beforehand, something credible can be made, almost anything.[8]

In the 1966 "68th American Show" at the Chicago Art Institute, the sculptor, Robert Morris, was represented by two large, L-shaped forms which were shown the previous year in New York. Morris sent plans of the pieces to the carpenters at the Chicago museum where they were assembled for less than the cost of shipping the originals from New York. In the context of a systems esthetic possession of a privately fabricated work is no longer important. Accurate information takes priority over history and geographical location.

Morris was the first essayist to precisely describe the relation between sculpture style and the progressively more sophisticated use of industry by artists. He has lately focused upon material-forming techniques and the arrangement of these results so that they no longer form specific objects but remain uncomposed. In such handling of materials the idea of *process* takes precedence over end results: "Disengagement with preconceived

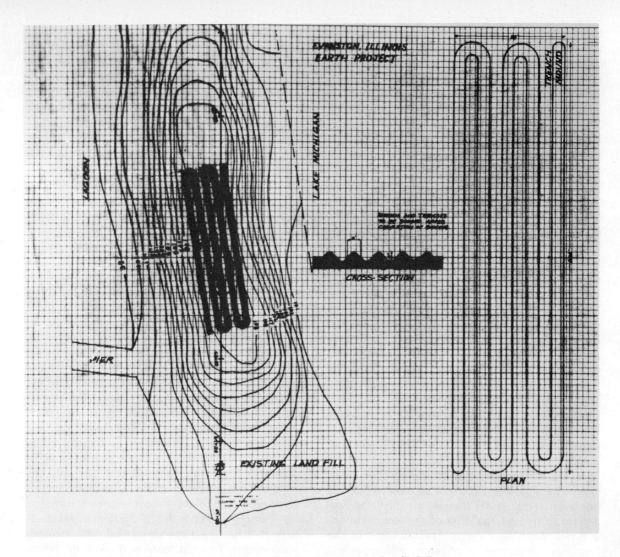

1. Robert Morris, drawing for *Earth Project*, Evanston, Illinois. Courtesy Leo Castelli Gallery.

enduring forms and orders of things is a positive assertion."[9] Such loose assemblies of materials encompass concerns that resemble the cycles of industrial processing. Here the traditional priority of end results over technique breaks down; in a systems context both may share equal importance, remaining essential parts of the esthetic.

Already Morris has proposed systems which move beyond the confines of the minimal object. One work proposed to the City of New York last fall was later included in Willoughby Sharp's "Air Art" show in a Y.M.H.A. gallery in Philadelphia. In its first state Morris's piece involved capturing steam from the pipes in the city streets, projecting this from nozzles on a platform. In Philadelphia such a system took its energy from the steam

bath room. Since 1966 Morris's interests have included designs for low relief earth sculptures consisting of abutments, hedges, and sodded mounds, visible from the air and not unlike Indian burial mounds. "Transporting" one of these would be a matter of cutting and filling earth and resodding. Morris is presently at work on one such project and unlike past sculptural concerns, it involves precise information from surveyors, landscape gardeners, civil engineering contractors, and geologists. In the older context, such as Isamu Noguchi's sunken garden at Yale University's Rare Book Library, sculpture defined the environment, with Morris's approach the environment defines what is sculptural.

More radical for the gallery are the constructions of Carl Andre. His assemblies of modular, unattached forms stand out from the works of artists who have comprised unit assembly with the totality of fixed objects. The mundane origins of Andre's units are not "hidden" within the art work as in the technique of collage. Andre's floor reliefs are architectural modifications — though they are not subliminal since they visually disengage from their surroundings. One of Andre's subtler shows took place in New York last year. The viewer was encouraged to walk stocking-footed across three areas, each 12 by 12 feet and composed of 144 one-foot-square metal plates. One was not only invited to see each of these "rugs" as a grid arrangement in various metals, but each metal grid's thermal conductivity was registered through the soles of the feet. Sight analysis diminishes in importance for some of the best new work; the other senses and especially kinesthesis makes "viewing" a more integrated experience.

The scope of a systems esthetic presumes that problems cannot be solved by a single technical solution, but must be attacked on a multileveled, interdisciplinary basis. Consequently some of the more aware sculptors no longer think like sculptors, but they assume a span of problems more natural to architects, urban planners, civil engineers, electronic technicians, and cultural anthropologists. This is not as pretentious as some critics have insisted. It is a legitimate extension of McLuhan's remark about Pop art when he said that it was an announcement that the entire environment was ready to become a work of art.

As a direct descendant of the "found object," Robert Smithson's identifying mammoth engineering projects as works of art ("Site-Selections")[10] makes eminent sense. Refocusing the esthetic away from the preciousness of the work of art is in the present age no less than a survival mechanism. If Smithson's "Site-Selections" are didactic exercises, they show a desperate need for environmental sensibility on a larger than room scale. Sigfried Giedion pointed to specific engineering feats as *objets d'art* thirty years ago. Smithson has transcended this by putting engineering works into their natural settings and treating the whole as a time-bound web of man-nature interactions.

Methodologically Les Levine is possibly the most consistent exponent of a systems esthetic. His environments of vacuum-formed, modular plastic units are never static; by means of an experience's ambulation through them, they consistently alter their own degree of space-surface penetrability. Levine's *Clean Machine* has no ideal vantage points, no "pieces" to recognize, as are implicit in formalist art. One is *processed* as in driving through the Holland Tunnel. Certainly this echoes Michael Fried's reference to Tony Smith's night-time drive along the uncompleted New Jersey Turnpike.[11] Yet if this is theater, as Fried insists, it is not the stage concerned with focused-upon events. That has more to do with the boundary definitions which have traditionally circumscribed classical and post-classical art. In a recent environment by Levine rows of live electric wires emitted small shocks to passersby. Here behavior is controlled in an esthetic situation with no primary reference to visual circumstances. As Levine insists, "What I am after here is physical reaction, not visual concern." [12]

This brings to mind some of the original intentions of the "Group de Recherches d'Art Visuel"

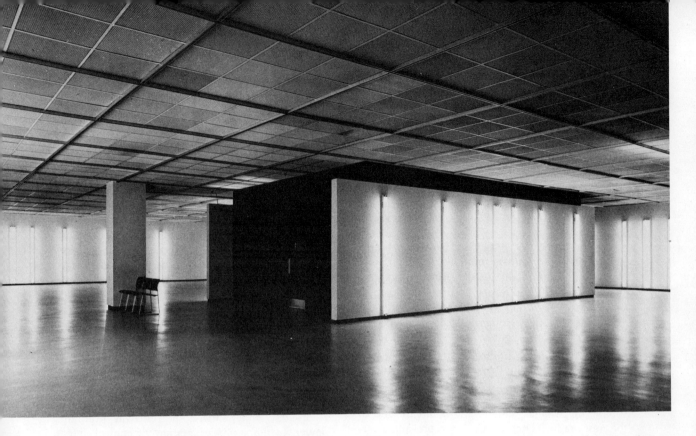

2. Dan Flavin, view of installation, *Pink and Gold*, 8' florescent lamps, 1967.
Museum of Contemporary Art, Chicago.

in the early 1960s. The Paris-based group had sought to engage viewers kinesthetically, triggering involuntary responses through ambient-propelled "surprises." Levine's emphasis on visual disengagement is much more assured and iconoclastic; unlike the labyrinths of the G.R.A.V., his possesses no individual work of art deflecting attention from the environment as a concerted experience.

Questions have been raised concerning the implicit anti-art position connected with Levine's *disposable* and *infinite* series. These hardly qualify as anti-art as John Perrault has pointed out. Besides emphasizing that the context of art is fluid, they are a *reductio ad absurdum* of the entire market mechanism which controls art through the fiction of "high art." They do not deny art,

they deny scarcity as a legitimate correlative of art.

The components of systems — whether these are artistic or functional — have no higher meaning or value. Systems components derive their value solely through their assigned context. Therefore it would be impossible to regard a fragment of an art system as a work of art in itself — as say, one might treasure a fragment of one of the Parthenon friezes. This became evident in December 1967 when Dan Flavin designed six walls with the same alternate pattern of "rose" and "gold" 8-foot fluorescent lamps. This "Broad Bright Gaudy Vulgar System," as Flavin called it, was installed in the new Museum of Contemporary Art in Chicago. The catalog accompanying the exhibition scrupulously resolves some of the

important esthetic implications for modular systems.

> The components of a particular exhibition upon its termination are replaced in another situation. Perhaps put into non-art as part of a different whole in a different future. Individual units possess no intrinsic significance beyond their concrete utility. It is difficult either to project into them extraneous qualities, a spurious insight, or for them to be appropriated for fulfillment or personal inner needs. The lights are untransformed. There are no symbolic transcendental redeeming or monitary added values present.[13]

Flavin's work has progressed in the past six years from light sources mounted on flat reliefs, to compositions in fluorescent fixtures mounted directly on walls and floors, and recently to totalities such as his Chicago "walk-in" environment. While the majority of other light artists have continued to fabricate "light sculpture" — as if *sculpture* were the primary concern — Flavin has pioneered articulated illumination systems for given spaces.

By the fact that most systems move or are in some way dynamic, kinetic art should be one of the more radical alternatives to the prevailing formalist esthetic. Yet this has hardly been the case. The best publicized kinetic sculpture is mainly a modification of static formalist sculpture composition. In most instances these have only the added bonus of motion, as in the case of Tinguely, Calder, Bury, and Rickey. Only Duchamp's kinetic output managed to reach beyond formalism. Rather than visual appearance there is an entirely different concern which makes kinetic art unique. This is the peripheral perception of sound and movement in a space filled with activity. All too often gallery kinetic art has trivialized the more graspable aspect of motion: this is motion internalized and experienced kinesthetically.

There are a few important exceptions to the above. These include Otto Piene's early "Light Ballets" (1958-1962), the early (1956) water hammocks and informal on-going environments of Japan's *Gutai* group, some works by Len Lye, Bob Breer's first show of "Floats" (1965), Robert Whitman's laser show "Dark" (1967), and most recently, Boyd Mefferd's "Strobe-Light Floor" (1968).

Formalist art embodies the idea of deterministic relations between a composition's visible elements. But since the early 1960s Hans Haacke has depended upon the invisible components of systems. In a systems context, invisibility, or invisible parts, share equal importance with things seen. Thus air, water, steam and ice have become major elements in his work. On both coasts this has precipitated interest in "invisible art" among a number of young artists. Some of the best of Haacke's efforts are shown outside the gallery. These include his *Rain Tree,* a tree dripping patterns of water; *Sky Line,* a nylon line kept aloft by hundreds of helium filled white balloons; a weather balloon balanced over a jet of air; and a large-scale nylon tent with air pockets designed to remain in balance one foot off the ground.

Haacke's systems have a limited life as an art experience, though some are quite durable. He insists that the need for empathy does not make his work function as with older art. Systems exist as on-going independent entities away from the viewer. In the systems hierarchy of control, *interaction* and *autonomy* become desirable values. In this respect Haacke's *Photo-Electric Viewer Programmed Coordinate System* is probably one of the most elegant responsive environments made to date *by an artist* (certainly more sophisticated ones have been conceived for scientific and technical purposes). Boundary situations are central to his thinking.

> A "sculpture" that physically reacts to its environment is no longer to be regarded as an object. The range of outside factors affecting it, as well as its own radius of action, reach beyond the space it materially occupies. It thus merges with the environment in a relationship that is better understood as a "system" of interdependent processes. These processes evolve without the viewer's empathy. He becomes a witness. A system is not imagined, it is real.[14]

Tangential to this systems approach is Allan

3. Hans Haacke, *Photo-Electric Viewer-Programmed Coordinate System*. (Spectator interrupts infrared light beams positioned as a regular, right-angled grid in the room. Lighted bulbs determine the movements of spectators in the room.) Courtesy Hans Haacke.

Kaprow's very unique concept of the Happening. In the past ten years Kaprow has moved the Happening from a rather self-conscious and stagy event to a strict and elegant procedure. The Happening now has a sense of internal logic which was lacking before. It seems to arise naturally from those same considerations which have crystalized the systems approach to environmental situations. As described by their chief inventor, the Happenings establish an indivisibility between themselves and everyday affairs; they consciously avoid materials and procedures identified with art; they allow for geographical expansiveness and mobility; they include experience and duration as part of their esthetic format; and they emphasize practical activities as the most meaningful mode of procedure.[15] As structured events the Happenings are usually reversible. Alterations in the environment may be "erased" after the Happening, or as a part of the Happening's conclusion. While they may involve large areas of space, the format of the Happening is kept relatively simple, with the emphasis on establishing a participatory esthetic.

The emergence of a "post-formalist esthetic" may seem to some to embody a kind of absolute philosophy, something which, through the nature of its concerns cannot be transcended. Yet it is more likely that a "systems esthetic" will become the dominant approach to a maze of socio-technical conditions rooted only in the present. New circumstances will with time generate other major paradigms for the arts.

For some readers these pages will echo feelings of the past. It may be remembered that in the fall of 1920 an ideological schism ruptured two factions of the Moscow Constructivists. The radical Marxists, led by Vladimir Tatlin, proclaimed their rejection of art's false idealisms. Establishing themselves as "Productivists," one of their slogans became: "Down with guarding the traditions of art. Long live the constructivist technician." [16] As a group dedicated to historical materialism and the scientific ethos, most of its members were quickly subsumed by the technological needs of Soviet Russia. As artists they ceased to exist. While the Productivist program might have had some basis as a utilitarian esthetic, it was crushed amid the Stalinist anti-intellectualism that followed.

The reasons are almost self-apparent. Industrially underdeveloped, food and heavy industry remained the prime needs of the Soviet Union for the next forty years. Conditions and structural interdependencies which naturally develop in an advanced industrial state were then only latent. In retrospect it is doubtful if any group of artists had either the knowledge or political strength to meaningfully affect Soviet industrial policies. What emerged was another vein of formalist innovation based on scientific idealism; this manifested itself in the West under the leadership of the Constructivist emigres, Gabo and Pevsner.

But for our time the emerging major paradigm in art is neither an *ism* nor a collection of styles. Rather than a novel way of rearranging surfaces and spaces, it is fundamentally concerned with the implementation of the art impulse in an advanced technological society. As a culture producer, man has traditionally claimed the title, *Homo Faber: man the maker* (of tools and images). With continued advances in the industrial revolution, he assumes a new and more critical function. As *Homo Arbiter Formae* his prime role becomes that of *man the maker of esthetic decisions*. These decisions — whether they are made concertedly or not — control the quality of all future life on the Earth. Moreover these are value judgments dictating the direction of technological endeavor. Quite plainly such a vision extends beyond political realities of the present. This cannot remain the case for long.

1. Quade, E. S. (November 1964) "Methods and Procedures" in *Analysis for Military Decisions* (Santa Monica: The Rand Corp.) p. 153.
2. Galbraith, John Kenneth (1967) *The New Industrial State* (Boston: Houghton Mifflin Co.) pp. 343-353.
3. Caudwell, Christopher (pseud.) (1937) *Illusion and Reality: A Study of the Sources of Poetry* (London: MacMillan and Co.) p. 111.
4. Peckham, Morse (1965) *Man's Rage for Chaos: Biology, Behavior & the Arts* (New York: Schocken Books, 1967) p. 314.
5. Fried, Michael (Summer, 1967) "Art and Objecthood" *Artforum*, p. 15.

6. Bertalanffy, Ludwig von (1967) *Robots, Men and Minds* (New York: George Braziller Inc.) p. 69.
7. Anonymous (September 1, 1967) "Ad Reinhardt, Painter, Is Dead, Reduced Color to Bare Minimum" in *The New York Times* p. 33.
8. Judd, Donald (1965) "Specific Objects" in *Contemporary Sculpture* (New York: The Arts Digest, Inc.) p. 78.
9. Morris, Robert (April 1968) "Anti Form," *Artforum*, p. 35.
10. Smithson, Robert (Summer 1967) "Towards the Development of an Air Terminal Site" *Artforum*, pp. 36-40.
11. Fried, *op cit.*, p. 19.
12. Jacobs, Jay (March 1968) "More Les" *the ART gallery* (Ivoryton, Connecticut: Hollycraft Press) p. 27.
13. Flavin, Dan (with introduction by) (December 1967) *Dan Flavin: Pink and Gold,* exhibition catalog, (Chicago: The Museum of Contemporary Art).
14. Haacke, Hans (with statement by) (January 1968) *Hans Haacke,* exhibition catalog (New York: Howard Wise Gallery).
15. Kaprow, Allen (March 1966) "The Happenings are Dead—Long Live Happenings" *Artforum*, pp. 36-39.
16. Gabo, Naum (1957) *Gabo: Constructions, Sculptures, Paintings, Drawings, Engravings* (Cambridge: Harvard University Press) p. 153.

REAL TIME SYSTEMS

I read the news today oh boy
Four thousand holes in Blackburn
Lancashire
And though the holes were rather small
They had to count them all
Now they know how many holes it takes
To fill the Albert Hall
I'd love to turn you on

Presently it will be accepted that art is an archaic information processing system, characteristically Byzantine rather than inefficient. To emphasize this cybernetic analogy, programming the art system involves some of the same features found in human brains and in large computer systems. Its command structure is typically hierarchical.[1] At the basic level artists are similar to programs and subroutines. They prepare new codes and analyze data in making works of art. These activities are supervised by metaprograms which consist of instructions, descriptions, and the organizational structures of programs. Metaprograms include art movements, significant stylistic trends, and the business, promotional, and archival structures of the art world. At the highest level art contains a self-metaprogram which, on a long-term basis, reorganizes the goals of the art impulse. The self-metaprogram operates as an undetected overseer, establishing strategies on all lower levels in terms of societal needs. Because we have no comprehensive picture of human life, these needs remain rather obscure (*Zeitgeist* is not sufficiently teleologic to express the anticipatory monitoring function of the self-metaprogram).

Esthetic values emanate from the self-metapro-gram. These are now changing, as evidenced by a number of symptomatic conditions: loss of interest in the gallery scene by the informed public, strong support for "street art" by several important critics, the "newsreels" of the underground cinema, anxiety marked by rising prices in blue-chip art, the fact that museums of modern art are closing the circuit on modernism, and the response to so politically inept a group as the Art Workers Coalition.

Values, though, are simply the result of long-term information processing structures. This is the business of museums and art historians. The more aggressive commercial galleries have long considered controlling and creating art information vital to selling, while not forgetting that sales are art information. The survival strategy of all social organizations, including the art system, is that of transforming preferred information into values.

In business this is taken for granted. At the management level, information "is data that has been culled, analyzed, interpreted, and presented on a selective basis in a manner useful for understanding and decision making. Its function is to decrease uncertainty."[2] As indicated, every artist produces data by making art. Critics, magazines, galleries, museums, collectors, and historians exist to create information out of unprocessed art data. History is uncertainty about art minimized.

A major illusion of the art system is that art resides in specific objects. Such artifacts are the material basis for the concept of the "work of art." But in essence, all institutions which process art data, thus making information, are components of the work of art. Without the support system, the object ceases to have definition; but without the object, the support system can still sustains the notion of art. So we can see why the art experience attaches itself less and less to canonical or given forms but embraces every conceivable experiential mode, including living in everyday environments. Thus art, according to John McHale, becomes "temporal immersion in a continuous contextual flow of communicated experiences."[3]

Examine the function of information in art:

communication theory states that information is obtained when a signal reduces uncertainty within a system. Information is need requited; hence information for a system has high entropy-reducing potential (negentropy). Negentropy is the ability of information to increase the structure and potential energy within a system. Such information is only obtained by expending the energy of systems outside the one receiving information. Thus the art system has maintained its vitality by constantly reaching outside of itself for data. In the past this has taken the form of new subject matter, materials, and techniques. But art now challenges the entire art information processing structure, not merely its content.

Encoding information always involves some physical process. In high-speed processing this takes the form of digital computer "hardware." The procedures or programs for processing data are called "software." For all previous art, distinctions between software and hardware were not recognized, so that encoding took the form of other art media and materials, where some information was lost, and perhaps some gained. Graphic reproductions of original works of art were a form of advertising. We now look upon them as works of art in their own right. Electronics have taught us that we often confuse software with its physical transducer. In other words, if we extend the meaning of software to cover the entire art information processing cycle, then art books, catalogs, interviews, reviews, advertisements, sales, and contracts are all software extensions of art, and as such legitimately embody the work of art. The art object is, in effect, an information "trigger" for mobilizing the information cycle. Making, promoting, and buying art are *real time* activities. That is to say, they happen within the day-to-day flow of normal experience. Only Art Appreciation happens in ideal, nonexistential time.

Ideal time and "experimental idealism"[4] are both outgrowths of the classical frame of reference. They stem from the intuition that location and proportion transcend the illusion of time.

Classical scientific methodology, as Spengler pointed out, is so premised. In both classical artistic and scientific experimentation the strictest control is exacted over isolated formal relationships. Only under such conditions may variables be compared. Reduction, isolation, and manipulation are the foundations of the Classic inventive structure—in art or technology. The problem of form and anti-form represents polarities of this structure, not an alternative. Paralleling experiments in Classic science, works of art are simplified models of complex, unmanageable situations. To insist upon the "reality" or "anti-illusionism" of such art, no matter how informal or diffuse its limits, is to deal in tautologies. All models also exist in real time. To sum it up, "style" is the artist's choice of invariants—used to excess.

Experimental idealism rests upon the intellectual and physical isolation of the esthetic experience. Its tools are picture frames, bases, spotlights, guards, galleries, hypostatic objects, and the concept of "high art" itself. It suggests that sensually the world is impossible as experience and must be broken down into palatable sanctuaries. Herbert Marcuse indicates that esthetics originally pertained to the study of the senses. By the end of the 18th century, esthetics had a different meaning: it referred to the study of beauty and specifically beauty related to art.[5] All of which is reminiscent of the words of one young lady: "I don't mind New York City, I just shut off my senses and visit the Met on weekends."

To interpret pragmatism either as a rejection of illusionism and its attendant idealities, or as an appreciation of contextual differences, or as a kind of tough-minded precisionism rooted in literal description, is to underestimate the intentions of one of its founders. As a psychologist, William James realized the scientific value of ordinary, unprepared events; he also understood that such events represent infinite amounts of raw data which defy scientific scrutiny. His alternative was to return to freer and more existential investigation, fully recognizing the limitations of scientific "law." "Concreteness," "adequacy,"

"facts," "action," and "power" are words used by James to describe the methods of pragmatism; however the essence of pragmatic conduct is an ability to remain open and flexible despite conflicting experiences. As a result, correlating experience into a coherent picture of reality is the pragmatist's only objective.

Since the beginning of archeological research into art, theories of art have sought a lateral and vertical synthesis of cultural values, promoting the idea that these theories all represent disparate aspects of the "art impulse." But I agree with Alan Watts that, "What our museums now exhibit as the 'art' of other cultures and ancient times are religious, magical, and household utensils exquisitely and lovingly made."[6] In other words we have imposed upon earlier cultures a conception of high art that justifies *our* value system—not theirs. The problem gets knottier as we see discrepancies between contemporary conceptions of high art. Judging different kinds of art by different criteria is one solution. Multiple value systems, however, were not what James had in mind. As long as there are conflicting experiences, James would insist upon a moratorium. Pragmatism is the recognition that science and technology have fragmented the traditional value structure beyond repair. Thus enclaves of protected values, including art, are fast disappearing.

In societies where existing values adequately deal with the environment, there are no comparative values—only the existing way of life. Values are nonexistent in metabolically stable societies. Hopefully such a metabolic reorganization is under way and will lead to a convergence of global information structures with parallel rather than linear processing. Such is the implication of McLuhan's assertion that the world is on the verge of tribalism, at this stage taking the form of similar patterns of global unrest. In this sense, the image of transcontinental tribalism through electronic technology is far from fanciful hyperbole:

> At the global level, as in man's natural symbiotic relations with plants and animals, his relationship to cybernetic systems has been subtly changing

toward a more closely woven organic interdependency resembling his other ecological ties.

The point reached recently when such systems were combined with the remote sensing, monitoring, and control capacities of the orbiting satellite marks the extension of this symbiosis to include the entire planetary ecology.

The most pervasive aspect on earth has been the automation of production, services, and information flow in the advanced economies. Man's social role and position in society becomes less and less determined by the part he plays in direct production of material wealth goods, the organizing of routine information, or the performance of some standard physical service.[7]

Quite evidently, where advanced technology takes over, our values are chosen for us—if survival remains high on our list of priorities. Moreover, such a reversal demolishes the Classical Ideal. Both in the sciences and in the humanities something is rapidly happening: we are beginning to see scientific "objectivity" as an illusion, as are the notions of independent scientific "disciplines," of isolating subjects of scientific inquiry from their settings, and of the possibility of making unobtrusive measurements.

Such symptoms point to a convergence of knowledge and activities; in a primitive fashion we are beginning to accept the Earth and its "guests" (to borrow from Buckminster Fuller) as a total organism with its own metabolism. Objectively we know very little about the rules of this metabolism. But we know that organic stability is predicated upon extensive communication networks, including memory, feedback and automatic decision-making capacities. The rudiments of such networks already exist, in the form of large-scale digital computer control systems. SAGE, the first computer-based air defense system; Project Mercury, the first real time digital support system for space flight; Telefile, the first online banking system; and SABRE, the first computerized airline reservation system are a few of many operating *real time* systems which gather and process data from environments, in time to effect future events within those environments.

Emotionally most humanists share an instinctive antipathy for these immensely complex computer systems. Their Orwellian overtones far overshadow their conceivable use as artists' tools. But practically, it is imperative that artists do understand them—both technically and philosophically. These computer systems deal with *real time* events, events which are uncontrived and happen under normal circumstances. All of the data processing systems I have referred to are *built into and become a part of* the events they monitor. Already a large part of the metabolic information used to run the military and commercial interests of the United States is real time-oriented. It is not proposed that artists have the choice between traditional media or using the computer. What I am saying is that the realtime information processing mode is rapidly becoming the routine style of handling information.

To date, most artists have been archivists doing the bulk of the art historian's task. The larger implication of this is that since the Renaissance the self-metaprogram of art has been predicated upon nostalgia. Recapturing a real or imagined classical past has been its goal. Modern art is the trauma of moving further and further away from that ideal. The public has been taught to buy and hold on to historical records in the guise of art. What a few artists are beginning to give the public is real time information, information with no hardware value, but with software significance for effecting awareness of events in the present. As long as museums refuse to acknowledge this transformation, they will remain in a peripheral and potentially obsolete role in relation to the most advanced aspects of contemporary art.

Deftness is the mark of the more sensitive artists using real time—the way in which they acknowledge systems. Here I think the work of Hans Haacke has consistently developed since 1963. His first works with water, emulsions, steam, and air had elements of strong geometric containment. These were plainly gallery objects. This cannot be said of the early sail pieces and outdoor balloon lines. Here the decision to allow natural entities to "organize" themselves began. We see this in the artist's plans for the 1966 art festival at Scheveningen, Holland: ". . . a 150' plastic hose, tightly inflated with helium, will fly high above the beach or sea . . . And also, I would like to lure 1000 sea gulls to a certain spot (in the air) by some delicious food so as to construct an air sculpture from their combined mass."[8]

In much the same sense Haacke's *Spray of Ithaca Falls: Freezing and Melting on a Rope* depended upon environmental conditions. A nylon rope was wrapped in screening and suspended across the falls. Flowing water and freezing cycles quickly built a snow and ice configuration over a four day period. A desire to work in neutral, non-art circumstances was evident in Haacke's *Wind Room* (summer, 1968) at the Mexico City University Museum. It consisted of an open, monochrome space bordered on two sides by heavy mesh screens, masking the air distribution system.

Some recent tendencies in Haacke's work intrigue me. One is a willingness to use all forms of organic life—from the most elementary to the most complicated. This seems a logical extension of his philosophy of natural systems. A work of last winter involved the incubation of chicks as an on-going process. Already Haacke is planning more complete animal "ecologies" where information is derived from the normal activities of animals in their environments. For a museum, he is planning a steady output of statistical information about visitors involving a small process-control computer and a display device. Two years ago Haacke would have balked at using this kind of technology; today, working more closely with events, it becomes a necessity. As Haacke explains:

> The artist's business requires his involvement in practically everything . . . It would be bypassing the issue to say that the artist's business is how to work with this and that material or manipulate the findings of perceptual psychology, and that the rest should be left to other professions . . . The total scope of information he receives day after day is of concern. An artist is not an isolated system. In order to survive . . . he has to continuously

1. Hans Haacke, *Chickens Hatching*, Forsgate Farms, New Jersey, April 14, 1969. Courtesy Hans Haacke.

2. Dennis Oppenheim, *September Wheat Project*, Finsterwald, Holland, April 1969. Courtesy Sonnabend Gallery, New York.
Oppenheim's use of tractors, snowplows, airplanes and seacraft are normal uses of available technology. This makes real sense compared to most hardware exotica out of the studio.

interact with the world around him. Theoretically, there are no limits to his involvement. . . .[9]

John Goodyear has departed from Haacke's steam and ice pieces in a series of "heat tubes." Some of these are arrays of tubes with constant temperatures; others temporally fluctuate from hot to cold. As Goodyear has progressed, his constructions look less like sculpture and begin to resemble wall fixtures and unspecific utilities. One of the best is a semi-buried series of plates and pipes entitled *Snowmelter, Measurer* (1968) which acts symbiotically with the weather, possessing no iconographic value.

I found Dennis Oppenheim's exhibition last January the most provocative of the season. The models and documents presented moved beyond his previous "ground systems" to a broad use of interacting ecologies. It included the farm systems of the previous summer, the Connecticut forest floor "removal" and "transplant" pieces of that fall, the New York Stock Exchange transplant, and the "time" and "border" activities of his December visit to Maine and Canada. Oppenheim's use of tractors, snowplows, airplanes, and seacraft are normal uses of available technology. This makes real sense compared to most hardware exotica out of the studio.

In July, 1968, Oppenheim directed the harvest of a 300 by 900 foot oat field in Hamburg, Pennsylvania. Cutting, gathering, baling, and trucking of bales were stages of the art process documented. At that time the artist planned a work for the summer of 1969 in which "isolated episodes will be directed towards a core network involving every permutation (from planting to distributing the product)."[10] This began last April in Finsterwolde, Holland, and is still to be completed. The parameters of this project are more complicated than the one in Pennsylvania, but Oppenheim does specify that "a portion of this crop will be selected by the artist and sold in 25-pound sacks. Also four carloads of wheat will be purchased from the Dutch commodity exchange in Amsterdam, and sold short in the United States."[11]

The significance of this project is that Oppenheim is using the untapped energy and information network of the day-to-day environment. Such situations produce abundant information with a minimum of reorganization. Seen from the artist's point of view, Oppenheim explains that:

In ecological terms what has transpired in recent art is a shift from the "primary" homesite to the alternative or "secondary" homesite. With the fall of the galleries, artists have sensed a similar sensation as do organisms when curtailed by disturbances of environmental conditions. This results in extension or abandonment of the homesite. The loft organism, stifled by the rigidity of his habitat, works on, not recognizing that his output is waning, by contemplating new ways to work within old bounds.[12]

Signal recognition that art is information processing appeared with Conceptual Art. In Sol LeWitt's words, "Since no form is intrinsically superior to another, the artist may use any form, from an expression of words (written or spoken) to physical reality, equally."[13]

One of the early conceptualists, Douglas Huebler has recounted his gradual withdrawal from the making of art objects. As a "second generation" Minimalist, he was forced to consider context. Some works diminished substantially outside the gallery, raising the question of sculpture competing with "real things" in the outdoor environment. He saw art objects as a series of strategies for reducing ambient dominance—while, paradoxically, such rivalry seemed out of place:

An object may defeat or suspend the competition of other things by being made more "interesting": larger and/or with intensification of color, formal complication, etc. However, I see such adjustments as a kind of "mannerism" . . .

I choose not to make objects . . . instead I have set out to create a quality of experience that locates itself "in the world" but is not called on to "judge" nor to infer "meaning" from particular appearances. I now make work that consists of "documents" that form a conceptual "frame" around a . . . location.[14]

Huebler's November, 1968 catalog may become the most important "show" of that year. His documentation is less visual than Oppenheim's.

42° Parallel, involving the sending and receiving of postal receipts to ten towns on the 42° latitude, is simply an annotated map of the United States, photographs of the dated receipts, and a written description.

Rock #2 was "found" while D. Burgy was walking in the fields and woods of Bradford, Massachusetts, on September 4, 1968. It exists as a collection of about thirty documents ". . . from the geologic past to the present moment; and in material size, from the continental to the atomic. The techniques of recording are appropriate to the kind of information presented and include visual, verbal, and mathematical data."[15] The rock is no capitulation to Dada notions about sculpture. Burgy maintains that it is "objective information about his experience in the world." It could be any rock, but it isn't; and it presents in uncompromising terms the nexus of art information, namely focus on experience. Visually this is manifested at a number of resolution levels: the rock appears under an electron microscope at 1250 power, and then from 2 feet, 10 feet and 20 yards, from 500 feet in an airplane, from 500 miles in a space satellite, and from an assortment of official survey maps.

Focus for Robert Barry is reversed: it is what we know about an environment without seeing or experiencing it. Radiation from a vial of Barium-133 buried in Central Park is simply Central Park. Most "air art" is air-supported hardware. But Seth Siegelaub's poster for Barry's "Inert Gas Series" is eminently software, a blank white 22½ by 35 inch sheet with one small line of information at the bottom. On another level Joseph Kosuth and Steven Kaltenbach have used printed media with an eye for all possible spin-offs. Kosuth's present exhibition of duplicate advertisements in ten dif-

3. Photograph of site being occupied by the radiation from "0.5 Microcurie Radiation Installation," January 5, 1969, Barium-133, Central Park, New York, by Robert Barry. ". . . air-supported hardware."

4. Installation photograph, Robert Barry, Douglas Huebler, Joseph Kosuth, and Lawrence Weiner, 44 E. 52 Street, New York, January 1969.
The exhibition is the catalog on the table.

ferent cities, and their museums, is the essence of data dispersion.

For over a year Siegelaub has been "gallery director" for the best of the conceptualists. His publications of calendars and catalogs are already collector's items. That he has already evolved a nonstyle was demonstrated by his exhibition of Barry, Huebler, Kosuth, and Weiner last January. Held in a rented office of the McLendon Building on 52nd Street, the room contained catalogs on a coffee table and a few places to sit. Siegelaub is obviously one of the best artists in his gallery, and in a sense his artists know it. They are subcontracting to his prime contract as a data organizer.

Art as information processing leaves little in the way of protection for the artist. Style used to be the art system's equivalent to patent rights. And even among the conceptualists one senses a certain degree of deference and respect for each other's ideas. But if the output of artists continues to be based upon nonsequential ideas, it may be impossible to support the notion of "ownership." Such ownership amounts to who *amplifies* original data first so that it becomes information. For instance, a particular electronic circuit may be discovered a dozen times before it is invented. "Invention" takes place only when a large firm uses the circuit in a major production, and then

has it entered into an electronic handbook. The design engineers of that particular company then become "inventors." As an information organization principle, this has been expressed by the ecologist, Ramon Margalef. According to Margalef, boundaries between systems in nature are usually asymmetrical. More organized systems always gain information and energy from less organized systems. This pertains to the relations between plants and animals, atmosphere and sea, environment and thermostat, enzyme and RNA molecule, biotope and community, prey and predator, agrarian communities and industrial societies. In each case the last named system feeds on the energy surplus of the first:

> It is a basic property of nature, from the point of view of cybernetics, that any exchange between two systems of different information content does not result in a partition or equalizing of the information, but increases the difference. The system with more accumulated information becomes still richer for the exchange. Broadly speaking, the same principle is valid for persons and human organizations: any exchange increases to a greater extent the information of the party already better informed.[16]

Little imagination is needed to realize how this principle operates within the art system. As the fame of a living artist grows, he ceases simply to make data. His subsequent output is information since it is already art history. Plagiarism of existing information, *i.e.,* the work of well-known artists, has minimal energy — unless original information becomes the object of new data in a very convincing way. On the other hand, famous "avant-garde" artists may capitalize upon the work of their lesser known contemporaries. Being better organized systems, established artists have greater access to museums and media. It is important, however, that they use such material while it is still data, *i.e.*, before it becomes art information.

On a personal level Margalef's cybernetic principle remains a matter of ethics and practicality. But its implications for the total art information system are far-reaching. As information processing becomes more generally understood, institutions and persons — other than artists — will insist upon creating their own art information. Specifically I am thinking about projects which demand money, planning, and technical support far beyond the individual artist's means. Artistic endeavor is thus brought up (or down) to the level of corporate research. We have only to think of that saga of lonely enterprise, the inventor-hero-capitalist. Such a social ideal was only possible in a society with no scientific grasp of the nature of information.

The altruism of artist groups has rarely survived the commercial success of one member. Pulsa, of New Haven, may be different — if it can hold on economically. With members ranging from mathematicians and computer specialists to painters, their focus is on computer-based programs of light and sound output. But it is in the realm of group interaction that Pulsa projects, hopefully, a new breed of artists. The group does not produce conglomerates of separate works by individuals, but rather common projects. As much as possible, all esthetic and technical decisions are shared equally. Ego frictions between technicians and artists seem to have been brought to a minimum.

> Like the human brain, Pulsa operates on principles of parallel processing . . . approaching a point at which specialization becomes irrelevant due to the fact that the operating control system speaks a simplistic environmental language or even operates autonomously. In this sense their objective is an intelligent system which in itself embodies the optimum state of the group's and the system's interactive functioning, which itself constitutes the ultimate work of art.[17]

Having witnessed Pulsa's activities over a year, I am convinced that there is substance behind these words. Ultimately Pulsa see themselves as planners and coordinators, functioning in the industrial, urban and natural environments. However, the full impact of taking art out of its socially acceptable surroundings did not reach me until last winter. I flew in a plane over the Pulsa installation on the outskirts of New Haven, circling into their light configurations for about ten

minutes before heading east for Boston. Five minutes away I overheard a radio conversation between a small plane and air control at New Haven airport. The plane reported a "disturbing" light phenomenon on the ground. Air control told the pilot to file a complaint with the C.A.A.

There are two kinds of artists: those who work within the art system, and those few who *work with* the art system. Les Levine epitomizes the second type. Few people grasp this fact, or its implications, and to dismiss Levine's work as Dada or *kitsch* is missing the point. Where industrialists think of art as a good tax dodge or as a kind of pastoral retreat, Levine considers business and industry to be art in its most essential form.

Every artist of any substance sells his art through shrewd advertising and press agentry. For Levine these are legitimate art forms. Artists are beginning to use signed releases, contracts, and sales conditions as supplementary art information; Levine has done so for years. The fact that he uses them so blatantly, with no deference to the professional gentility of the art system, is the equivalent of style. The worst mistake would be to read taste or style into objects which he has fabricated. Despite the fact that all successful commodity art has to be uncommonly "pretty" and have a convincing pedigree, Levine's plastic shapes are neither. They are direct, raw, neutral results of quantity production. Neither should his objects be considered *multiples* or merely small-sized quality art works. Levine, I feel, has set out to vindicate the art system, namely that anything can be sold with enough public relations energy behind it. His integrity lies in the fact that he has refused to feed collectors' neuroses with illusions of permanence and quality. Levine states:

> All process oriented works rely on the viewer and the art critic for their final definition as works of art. If it is neither photographed nor written about, it disappears back into the environment and ceases to exist. Many serious artists at this time, are for the most part involved in making art producing systems. The works themselves are not to be considered as art, rather systems for the production of art.[18]

On March 27, 1969, Levine bought five hundred common shares of stock in the Cassette Cartridge Corporation; when resold the profit or loss became the work of art. His coin and airline projects have been conducted similarly, using existent societal systems. Inflation-wise, prestigious commodity art is better than money. As I see it, Levine is simply circumventing the roundabout process of producing paintings and sculptures for sale and, instead, making the message — money — become the medium. Some artists involved in "process" announce their projects in archaic art formats; Levine's typically is a press release. In an age when technological processes define lifestyle, "Choice and taste can only be considered neurotic."[19] He goes on to write:

> I've never seen a work of art I didn't like. Good or bad are irrelevant in terms of process. On a process level being totally excited is of no more value than being totally bored. If you run around in your backyard and make a good painting, it's just the same as running around in your backyard and making a bad painting. Running around is running around.[20]

Levine's Restaurant at 19th Street and Park Avenue South *is* a Levine; which is to say, it is refractory, plastic, and the ultimate real time art work devised to date. The restaurant is process in all its vicissitudes. For my taste, his closed-circuit television and color scheme leave much to be desired, but the food is very reasonable. Levine worries and tinkers with the software, and appears to be more concerned with write-ups in *Restaurant News* than in *Art News*. *Levine's* lacks that much-admired Howard Johnson sterility, but he keeps trying. On the art level, it has to be accepted for what it is: a self-organizing, data generating system. What other artist has a gallery showing his work fourteen hours a day seven days a week, always changing, charging no commission, and allowing him to eat free?

At present the art communication and educa-

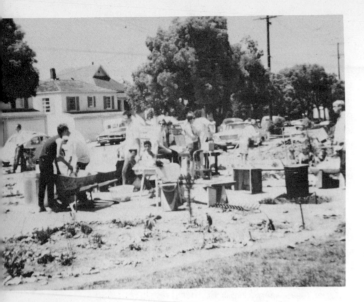

5. People's Park Annex, Berkeley, California, May 1969.

Art is becoming a matter of ecological insight. The Berkeley *People's Park* is a real time work of art. Even as a decimated cyclone-fenced lot, it challenges societal norms in the most fundamental way. As thirty thousand people marched from the *People's Park Annex* for the Memorial Day Protest last May, dozens of grass plots appeared on concrete and asphalt. A loudspeaker played "Why Don't We Do It in the Road?" In a country of 100,000,000 vehicles, what better gallery could you find?

1. Lilly, John Cunningham, M.D. (1967) *Programming and Metaprogramming in the Human Biocomputer: Theory and Experiments* (Baltimore: Communication Research Institute).
2. Heyel, Carl (1969) *Computers, Office Machines, and the New Information Technology* (New York: The Macmillan Company) p. 178.
3. McHale, John (1969) *The Future of the Future* (New York: George Braziller Inc.) p. 300.
4. Sackman, Harold (1967) *Computers, System Science, and Evolving Society* (New York: John Wiley & Sons, Inc.) pp. 516-550.
5. Marcuse, Herbert (1955) *Eros and Civilization: A Philosophical Inquiry into Freud* (Boston: The Beacon Press) paperback edition (New York: Vintage Books, 1967) pp. 157-169.
6. Watts, Alan (with essay by) (January 19-March 23, 1969) *Electric Art*, exhibition catalog (Los Angeles: UCLA Department of Art).
7. McHale, John (1969) *op. cit.*, p. 123.
8. From a letter to the author (February, 1966).
9. From a talk by Hans Haacke at the Annual Meeting of the Intersocietal Color Council, April 1968.
10. From a statement by the artist to the author (September, 1968).
11. From a statement by the artist to the author (March, 1969).
12. *Ibid.*
13. LeWitt, Sol (January, 1969) "Sentences on Conceptual Art" in *0 to 9* (Bernadette Mayer and Vito Hannibal Acconci, eds.) (New York: Vito Hannibal Acconci) p. 4.
14. From a statement by the artist to the author (May, 1969).
15. From a statement by the artist to the author (June, 1969).
16. Margalef, Ramon (1968) *Perspectives in Ecological Theory* (Chicago: The University of Chicago Press) pp. 16-17.
17. From a statement by Pulsa to the author (April, 1969).
18. Levine, Les (May, 1969) "For Immediate Release" in *Arts and the Artist* pp. 46-50.
19. *Ibid.*
20. *Ibid.*

tion structure is hardly prepared to handle such a broad conception of art as *Levine's*. For that matter, it breaks down frequently with current definitions. Any fundamental shift will probably involve the complete absorption of art into the media. But the reality of art continues to reside in its unreality. Any progress in the development of real time art recognizes that conceptual focus must keep the two apart. In this respect, the hoax of treating artists as social beautifiers should be exposed once and for all. As McLuhan insists, the artist is fundamentally antisocial. To use another cybernetic analogy, artists are "deviation-amplifying" systems, or individuals who, because of psychological makeup, are compelled to reveal psychic truths at the expense of the existing societal homeostasis. With increasing aggressiveness, one of the artist's functions, I believe, is to specify how technology uses us.

LES LEVINE
Business as Usual

Superior culture is one of the most artificial of all human creations. . . .

Clement Greenberg [1]

Transparency is the highest, most liberating value in art. . . .

Susan Sontag [2]

Culture, which today has assumed the character of advertising, was never anything for Veblen but advertising, a display of power, loot, and profit.

Theodor Adorno [3]

I don't find it interesting to create antagonism, however, I don't find it very interesting to prevent it either. In a totally programmed society my art is about packaging, but I don't package my work so that it is acceptable to the art world.

Les Levine

Among those knowledgeable about art there are two distinct types: those who detest Les Levine and those who appreciate the negative vibrations which Levine radiates with such effortless ease.

The bomb has gone off and we are all on the beach. Art, that Renaissance product, no longer exists; only the art world and its burn-off are left. So Levine's artifacts, or souvenirs as he calls them, are just the basis for sundry advertising activities. His golden rule is: "No artist ever received any more attention in the media than he deserved, because the media inherently define worth."

By and large, Levine is not a brilliant formalist innovator, heretofore art's criterion of success. Considered to be an "idea" artist, he has had 20 one-man exhibitions in two years. It is patently clear that no artist could be that original. So frequently Levine lifts or "synthesizes" ideas in the air; his uniqueness lies in dealing with these as amplified art information. For instance, Levine's *Clean Machine* is a most elegant summation of Minimalist esthetics, traditionally made palatable for some critics by the inclusion of various surface and spatial articulations relating to, or defying, older traditions. But Levine removed and transformed these allusions into sterile, vacuum-molded, plastic projections, forcing us to deal with the question, "Can you accept this as an esthetic experience, even if it is not prettied-up with art historical allusions?" Few of us could.

The plastic *Disposables* are a structural paradox. Their production and sale as art produce a double bind. They challenge the market mechanisms which restrict the supply of certain art works, making it clear that this restriction is due not to rarity or scarcity, but to economic strategy. Levine thus notes that Noland's stripe paintings could easily be manufactured like awning fabric, with strip frames to match, at virtually no decrease in quality. If this is so, then the perpetuation of high art in the midst of mass-production is nothing short of social hallucination. By signing contracts with department stores for the sale of millions of *Disposables* ($1.25 each), Levine is filling a niche in the ecology of art economics—and in the process may make as much money as Kenneth Noland. Hence Levine, as an artist, sees little use in uniqueness or pseudo-uniqueness, but only in well-considered business methods, a juxtaposition of kitsch and high art which brings to mind the methods of Frank Zappa.

Levine considers business *the* contemporary art form. In an earlier age esthetes and the nobility established cultural norms; but obviously today businessmen define what the public will buy and for what price. Levine admits that "basically I'm a corporate type with interests in all areas of management. By opening a gallery I intend to move into legitimate art; this will be a business based on all the tried and true items of American

1. *Disposables*, Fischbach Gallery, New York, 1966. All
Les Levine photos courtesy Galerie De Gestlo, Hamburg,
Germany.
Levine: "Thousands have sold, and some have thrown them
out. They've probably been sold to only ten or twelve
people who could be considered collectors; this means that
many people who have never owned a work of art have
gotten involved with the activity of collecting. You see it's
like Keynesian economics: it's not what you produce that's
so important, but turnover and circulation. Economically art
movements work the same way."

consumerism: pop, color field, and all the rest."
He maintains that "One of the major functions
of my gallery would be to create artists and art
groups. Obviously you have to start with talent
and ability. Many young artists have this, but for
one reason or another they don't function in a
commercial environment. Intelligent artists can
be reimaged, as some of the best gallery dealers
have proven in this decade. In several cases Rich-
ard Bellamy was much more sensitive than his
artists."

The artist's business dealings, press releases, and
other publicity-getting strategies are regarded by
most of his peers as *déclassé*. As Levine sees it,
all commercially successful artists utilize these ser-
vices through one agency or another; it is only
the professional reticence and anti-bourgeois men-
tality of the working members of the art system

that have obscured this and the fact that all art is advertising for the individual as a profit-making entity.

Levine further points out that "Basically it is business that supports art. Who else buys full page color advertisements? All good art, like any other product, is packaged for a specific market. This is one of the reasons art usually approximates the size of furniture; art works increase in size directly in proportion to a prospective owner's status and apartment size." Furthermore, "If you sell art objects to five collectors for $20,000 each, you as a dealer have enlisted five agents with an interest in supporting the market values of your merchandise. This works in various ways. For example one informal cartel shares many of the same artists. Since these dealers, who are worldwide, buy outright, they collectively support the market prices for their artists. If a painting by one artist goes on the market, they'll bid it up excessively. Actually a small write-off means that their entire inventory of the same artist's works goes up in value. No one is hurt because nobody wants to own cheap art. Most collectors need assurance that they've made the right choices. If you're looking for status, there's not much in buying something for five hundred when it's going to stay at five hundred—so everybody has an interest in seeing that prices move up."

Levine expresses obvious admiration for such an operation—but just as obviously it has nothing to do with his style. On the process level, he insists, there is no such thing as good and bad art, but only business methods which are more or less successful. "Bad art" is just another way of saying that the information about a certain art making process has been downgraded.

All art may appear to bring us more information, but in fact it is only sustaining our notions of "good art" with perhaps minor modifications. In reality the concept of art is built into all art. By learning about the art tradition, Levine feels, we preprogram all further responses to any new art stimuli. More effective artists realize that for a brain programmed to absorb only ritualized art experiences, "new art" is the result of interrupting

only a tiny portion of the art-viewing program. So far only one artist has substituted a totally non-art experience for art. This, of course, was Marcel Duchamp: "With Duchamp, once he signed the first object, all he had to do was let other artists sign other objects—since he defined the system of found objects, subsequently the system defined itself."

Thus artistic choice is a meaningless freedom in any advanced technological society. Rather, Levine sees choice limited to the range of activities defined by the structure of technology itself. The desire to believe otherwise, or tamper with this, is simply a humanist neurosis. Art gives us the safety valve of trivial choice—"so that we don't gum up the works."

Real control has nothing to do with the kind of control that national governments exercised around the world. Control is through the process of information. Man's technologies, viewed as communication, fed back signals telling the brain what to do. While governments exercised their traditional prerogatives, the process continued unnoticed. Who ever voted for the telephone? Who ever voted to allow printing? Who ever voted to let the world X-ray itself with a cathode ray tube? Who ever voted to allow man to step from the ground into a man-made construction and travel 3,000 miles in four hours? Who ever voted for the automobile? "We're talking." Who ever voted for talking? No democratic populace, no legislative body ever indicated by choice, by vote, what kind of information it desired.[4]

The illusion that art provides us with esthetic information is both sustained and destroyed by society's conservative elements. Thus while museums and important collections are largely supported by the business community, these same business interests are responsible for all significant technological innovations. Through "progress," business and technological interests have consistently undermined the very standards of esthetic idealism objectified by the institutions of "high art." Choice, then, is the right to believe in art. For Levine, this represents no paradox; he simply becomes a part of the system as it actually operates: "Is choice ever logical in a system that is totally prechoiced anyway? I tend to think not.

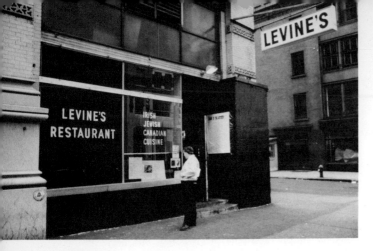

2. *Levine's Restaurant*, 1969.
Levine: "The problem with going into any artists' bar is that there is a very introverted kind of intelligence floating around. Levine's got a fair amount of ordinary people. It was multi-ethnic while most artist bars are ethnic ghettos. Being in a business district where nobody went at night, Levine's was an ecological disaster. Like there is one store on the block that never makes it; you could put a brothel there and it would make it."

3. *Menu for Levine's Restaurant*, 1969.
Levine: Implied in the vulgarity of my opening a restaurant was the fact that Mickey's old customers could afford it. I wanted to make a low pressure place. Originally I had the idea that they should serve TV dinners—but since they come in metal containers, they would melt in a micro-oven. Actually TV dinners are a terrific value; for thirty-nine cents you can't go wrong. The potato latkas were Mickey's idea—a special feature. Personally I thought the menu was very heavy."

| LEVINE'S RESTAURANT IRISH•JEWISH•CANADIAN CUISINE 19th ST. & PARK AVE. SOUTH 674-9809 | NEW YORK'S ONLY CANADIAN RESTAURANT |

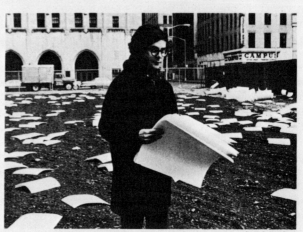

Photo by Fred W. McDarrah

YOU GET MORE WITH LES!

You are now sitting in New York's finest Canadian Restaurant, the autobiographical culinary environment of Les Levine, one of America's foremost artists. Mr. Levine, born and raised in Ireland, emigrated to Canada at the age of 17, bringing with him the memories of the wholesome and delicious dishes prepared by his mother in their simple Irish home. After many years in Canada, he moved to New York City where he now resides. We welcome you to Levine's Restaurant, where Mr. Levine shares with the New York Community a taste of his childhood memories.*

*SPECIAL 20% DISCOUNT IF YOU ARE A LEVINE.

THE FINEST IN IRISH • JEWISH • CANADIAN CUISINE

This kind of choice only relates to a fixing or stopping mechanism in the overall cycle of social activities. But in a society which is no longer much concerned with contemplative devices and selecting mechanisms, choice is a technological anachronism."

Levine's strength as an artist is his ability to reify art as social context, that is, to create art out of whatever concerns art. This was the point of Levine's restaurant, in fact a commentary on the sociology of New York's more frequented artists' bars. Since the middle '60s Max's Kansas City has been *the* bar and restaurant of the New York art world. At Max's everybody plays Hollywood opening night. Status is mirrored by where you sit. At 5 o'clock, secretaries take off their Peck and Peck dresses, put on their Paraphernalia outfits and head for Max's. From the beginning it was a place that wanted to be talked about in *Harper's Bazaar* and *Esquire*. Gradually, in the last two years, many artists have grown tired of such voyeurism, gladly accepting the unpretentiousness of St. Adrian's, a bar located closer to the loft district. Here communication is with other people, not with the environment.

As Levine explains it, Mickey Ruskin, Max's owner, asked him to become involved in a competing restaurant. "It was a fantastic blow to his ego when St. Adrian's opened and some of his people started going there. I was an ideal choice for Mickey because primarily he wanted to punish his customers for daring to go against pontifical orders, for daring to move to a new church, and in punishing them he presented them with the thing they most hated—Les Levine."

From the beginning, Levine's had a tackiness that exemplified bad faith between the owner and his figurehead. Levine saw it as a kind of space-age Howard Johnson's for the tourists, while Ruskin still had illusions of cornering the meat-and-potatoes artists' trade. The result was an abortion of white plastic bucket seats, kelly-green tablecloths, charcoal walls, a juke box filled with 1950s rock, dreadful colored plastic lighting fixtures, environmental TV that never worked, waitresses in bowling team T-shirts, Jewish memorial candles at every table, and third-rate Op paintings which Mickey Ruskin had put up in desperation to draw the artist trade. "The paintings are camouflage," Levine insists.

But perhaps the prime element of masochism on Levine's part was the menu itself. "They should have gone further with the ethnic thing, *implying* that the food was Irish-Jewish-Canadian and then having nothing to do with it, in fact creating software. As a joke, 'Lobster Levine' only lasts one day." No doubt the best software was the staff itself. "I wanted a very straight bartender. I don't know if you knew Rudy who was our night bartender; he was fantastic! He's just a complete art work in himself because he's totally mundane and ordinary. He's the ultimate cliché. Rudy cracks a joke you've heard 500 times before; in fact everything he says you've heard 500 times before. There's not a hip bone in his body. No matter what he says, it's never smarter than you. As a rule bartenders are always putting the customers down, you know, always letting customers know how stupid they are." But as an *environment* Levine's proved something that gallery environments and street art had only touched on in a very heavy and nonaffirmative way, namely that every environment, good or bad, is worth attention as a work of art. Focused intelligence makes an environment, which is the reason most art environments end up as predigested experiences.

In January, 1969, upwards of 25 writers, artists, and critics were invited to fly, by chartered airplane, to the Cornell Earth Art Show. As part of the ensemble Levine took over 200 photographs of the trip. He observed that relatively few people would actually see any earth art first hand and that the tangible reality of the show was "media appraisal." Levine's incessant picture-taking of critics looking at art produced a very up-tight situation. But the artist's selection of 31 photographs for "Systems Burn-off X Residual Software" in Chicago made its own point. These depicted not only the assorted piles of sand, rocks, and markers that made up the show, but also critics behaving as critics, endless landing fields, forests, cloud

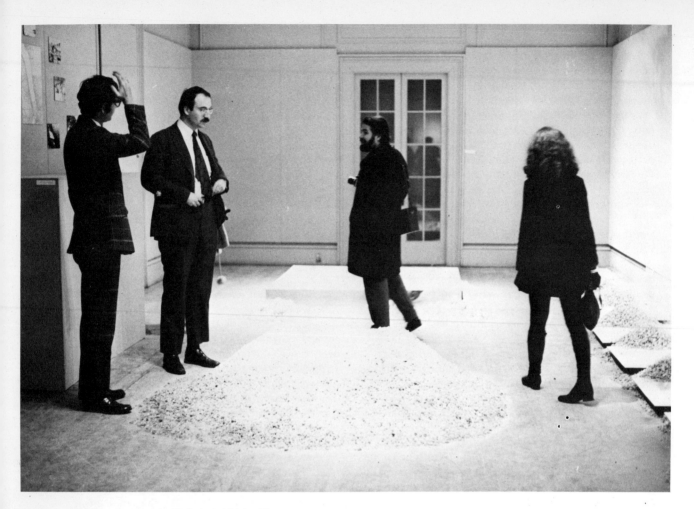

4. Above: the Cornell University Earth Art Exhibition No. 14 from *Systems Burn-Off X Residual Software*, 1969. Levine: "What I am trying to point out is that art is a locked-in system at this stage, so much so that it doesn't need to be done because all locked-in systems prechoice themselves. From now on you don't have to make art because art will make itself."

5. Right: *Paint,* Molly Barnes Gallery, 1969. Levine: "With the development of the art supply industry, it is clear that anyone in the world could be an artist, as nothing else could be made from art supplies . . . The work of art in its finished state is information. The result of a process. It describes what the art experience was like. The productive activity involved in the act of making a work of art in this kind of society must be considered of more value than the results of production. As all information is in itself neutral and without 'taste' therefore qualitative judgments are unnecessary."

banks, and other more or less normal phenomena —as if to say all these naturalistic attempts at anti-art are really self-defeating; why not make art out of the intentionality of anti-art?

The 31 photographs of "Systems Burn-off" became 31,000 typewriter paper offset copies. In Chicago these were distributed about the floor and raspberry Jello was poured over them. Copies of the 31 photographs were affixed with chewing gum to the walls, explaining that as the earthworks disappear back into the ground, residual software would be its only remainder.

Some months later Levine did an exhibition in Los Angeles entitled "Paint." Within a 30-by-14 foot space the artist had assistants pour fifty gallons of colored house paints on the floor. The results were photographed by automatic camera, and framed as color sequence photographs for sale—similar to the "So and So Paints a Picture" series that Art News ran for so many years. Again the point was not wet paint too thick to become a painting, but information about pouring paint. In a preprogrammed society no one has to experience an art exhibition, since the only real

experience is making the art. Levine insists that many viewers were relieved to find that he used something as visceral and normal as paint.

Duchamp maintained that to neither make nor lose money was to come out ahead in art. Levine, through "Profit Systems I," doesn't agree; his Cassette Cartridge stock, purchased at $2375, made over $5000 in eight months. Obviously the idea of an unprofitable work of art is a contradiction in terms. As Levine sees it, the ideal fusion of power, money, and art is personified by the museum trustee, an occupational goal still in the development stage for Levine.

Very likely the artist's *chef d'oeuvre* is his "Your Worst Work" show held at the Architectural League of New York this past fall. To my mind it was no accident that this exhibition took place only ten blocks away from Henry Geldzahler's "New York Painting and Sculpture: 1940-1970." Frequently, when the human mind strives for the sublime over the vulgar, it is left with very little choice. Of course the "art" is Levine's willingness to depolarize the issue of *quality* in an atmosphere which already has all the answers. Levine's own piece was a rejected poetry reading poster complete with Turkish bath snapshots of the poets. This was documented with hot exchanges of letters with the Wave Hill Performing Arts Committee who rejected the poster design. The exhibition made a shambles of the Architectural League and almost dissolved its Board of Trustees.

As a general interest topic, *Newsweek* and *Life* did articles on "Your Worst Work." In fact the artist claims that Geldzahler was going to use his "White Sight" sodium vapor lamps over the entrance stairs to "New York Painting and Sculpture," but thought better of it when he realized that Levine would get all the publicity for his show too. When asked why he thought "Poetry Poster" was his "worst work," Levine replied, "I didn't get paid for it."

Possibly since Duchamp no artist has challenged the infrastructure of artistic taste with as much rigor. The substance of Levine's approach is essentially this: esthetic choices and categories are to an overwhelming extent defined by communication structures. Thus what we define as "Art" in the art historical tradition is no more than neo-Darwinian "survival of the fittest." This principle is tautological since by definition whatever survives obviously *must* be the "fittest"; analogously, "Art" is what remains after everything else is destroyed or forgotten. Levine's art is not "Art" but rather it is about the mechanisms of esthetic speculation which produce arbitrary notions of immortality and worthlessness.

1. Greenberg, Clement, "The Avant-garde and Kitsch," (1939), in *Kitsch: The World of Bad Taste*, by Gillo Dorfles, Universe Books, N.Y., 1969, p. 121.
2. Sontag, Susan, "Against Interpretation" (1966) in *Against Interpretation*, Dell Publishing Co., N.Y., 1969, p. 22.
3. Adorno, Theodor W., "Veblen's Attack on Culture" (1967), in *Prisms*, Neville Spearman Limited, London, p. 79.
4. Brockman, John, *By The Late John Brockman*, The Macmillan Co., N.Y., 1969, p. 119.

ALICE'S HEAD

"Did you say 'pig' or 'fig'?" said the cat.

"I said 'pig,'" replied Alice, *"and I wish you wouldn't keep appearing and vanishing so suddenly; you make one quite giddy."*

"All right," said the cat, and this time it vanished quite slowly, beginning with the end of the tail, and ending with the grin, which remained some time after the rest of it had gone.

"Well! I've often seen a cat without a grin," thought Alice, *"but a grin without a cat! It's the most curious thing I ever saw in all my life!"*

Alice's Adventures in Wonderland, by *Lewis Carroll*

Conceptual art resembles literature only superficially. What it really characterizes is a decided shift in sensory ratios. As a result Conceptualism poses a paradox: Can art free itself from the effects of the page in type only by adopting the printed form?

The problem with vulgar McLuhanism is that it makes more sense than any refined theory of media. Our civilization, according to McLuhan, was "founded upon isolation and domination of society by the visual sense."[1] Thus printing is tied to the limits of perspectival space. He hypothesizes that in the last century vestigial illusionism has slowly been supplanted by the synesthesia of "tactile space," culminating most recently in a desire for total environmental involvement or, specifically, a "reality high." For McLuhan, reality is more than the immediate environment; it is extended by "field space" or all the electronic devices that provide global awareness. Moreover since field space is pervasive, invisible, and noncausal, it makes no logical separation between the mind of the perceiver and the environment. "Live in your head" means that the printed page is to Conceptualism what the picture plane is to illusionistic Realism: an unavoidable belaboring of the point, inelegant communication. Printed proposals are make-do art; Conceptual art's ideal medium is telepathy. Analogously, at the present time conversational computer programs function through typewriter terminals; eventually computer communication will be verbal or direct neural relay. Notably, no one considers a terminal print-out to be literature.

Reasons for the emergence of Conceptualism vary in complexity and deal mainly with the historical development of art. They range from Joseph Kosuth's functional reductivism to the practical consideration that gallery and museum exhibitions are increasingly planned, not through the selection of existent work, but on the basis of submitted proposals, implying that the artist's private or gestural relationship to his materials is secondary and that intellectual cognizance is in many cases adequate. Quite often execution is redundant or at best for public elaboration.

A yet more basic motive may underlie Conceptualism. The biologist Ludwig von Bertalanffy writes of a growing schism between biological drives and symbolic values. One of the reasons for rapid technological change is increased proficiency in *symbol manipulation,* in philosophy, art, religion, literature, mathematics, and various forms of scientific logic. Belief in symbols and ideologies compels man to commit acts ordinarily against his biological well-being. We seem to be the captives of our symbol-making capabilities and their inconsistencies, as evident in such areas as the religious stand on birth control, the dynamics of thermonuclear war, economic perpetuation of harmful industrial effects, and cases for and against computer data banks. As Bertalanffy states, "The symbolic world of culture is basically un-

nature, far transcending and often negating biological nature, drives, usefulness, and adaptation."[2] Beyond a fundamental reevaluation of the meaning of art, Conceptualism inadvertently asks, "What is the nature of ideas? How are they disseminated and transformed? And how do we free ourselves of the confusion between ideas and their correlations with physical reality?"

"In a preliterate society," says McLuhan, "art serves as a means of merging the individual and the environment, not as a means of training perception of the environment."[3] Conceptual art presents us with a superspatial grasp of the environment, one that deals with time, processes, and interrelated systems as we experience them in everyday life, forcing involvement with non-art habits of perception and thus fulfilling both McLuhan's models.

Last spring at the Bern Kunsthalle exhibition *When Attitudes Become Form,* not only was there considerable interpenetration between the works of young European and American artists but also among artists involved with objects, arrangements, outdoor situations, and conceptual ideas. As a prime antecedent, Duchamp's post-Cubist output is conceptually oriented, while a few of the proposals in his book, *Marchand du sel,* are purely conceptual works. Among the New Realists of Europe in the late 1950s both Yves Klein and Piero Manzoni clearly produced examples of Conceptual art. A good case could be made to support the fact that the currents of Conceptualism began considerably earlier in Europe than in the United States—quite likely because American exuberance and invention supported the notion of art objects a decade longer. Joseph Kosuth stresses that the present American tendency had its impetus from the thinking of Jasper Johns, Ad Reinhardt, Robert Morris, Sol LeWitt, Edward Kienholz, Carl Andre and Donald Judd; and in the same article he gives the names of about fifteen artists, some of whom have been working in the conceptual area since 1966.[4]

But only by the end of 1968 did the organizing and public relations ability of Seth Siegelaub—through the artists Barry, Huebler, Weiner and Kosuth—place Conceptual art in a context worthy of notice. (No doubt by 1968 there were more than a few artists working with extragallery proposals or nominally conceptual ideas, so in talking about those exclusively connected with Siegelaub it is only fair to mention that the work of many other conceptual artists may be of equal significance.)

Of interest are the issues of *0 to 9* (after the third issue) published by Vito Acconci in New York City. Since the end of 1968 these have dealt less with literature and poetry and more with street art and language as plastic art. Acconci has also published some valuable statements on conceptualist theory.

Robert Barry, Douglas Huebler, and Lawrence Weiner were originally connected with Siegelaub's Gallery and with his efforts as a private dealer. Prior to 1968 Weiner and Barry were systemic painters with no real connection to Huebler, a Minimalist sculptor. They agree this changed with two joint symposiums and group shows held early in 1968. The first took place at Bradford Junior College in Bradford, Massachusetts, in February. Barry, Weiner and Carl Andre were involved in structuring a series of indoor situations. A similar symposium and outdoor exhibition ("exterior situations") held that May at Windham College in Putney, Vermont, began an exchange of ideas between these three participating artists and Huebler. None of the pieces were transportable, yet they were structured so as not to impose upon the environment. Andre worked with bales of hay, Barry with nylon monofilament strung from buildings, and Weiner with string and stakes hammered into the ground. When his string was cut by irate students Weiner realized that the piece did not have to exist, that its effect had been in suggesting it. Earlier at Bradford Barry had placed small painted panels throughout the rooms. These were replaced at Windham by four nylon monofilaments stretched between the two main buildings (about 300 feet) all the same height (about 30 feet). Barry's piece defined "specific location,"

1. Lawrence Weiner, *A Square Removal from a Rug in Use,* 1969. Wolfgang Hahn, Cologne.

Weiner's piece was planned (and conceived) before Windham and could have been made anywhere.

At the time of the Bradford show and symposium Huebler was still working in formica sculpture, with plans for some earthworks which were never made. Later that winter Huebler attended a seminar on art and technology at the Massachusetts Institute of Technology, reacting negatively when one artist on the panel suggested that he would like to build a sculpture larger than the Empire State Building. For Huebler these forays into giantism began to take on some of the gestural assertiveness of the last stages of Abstract Expressionism. Making one's autobiographical presence felt on the landscape seemed to be a dying gasp. By May and the Windham exhibition Huebler realized that his thinking was clearly at cross purposes with his sculpture. That summer he and Seth Siegelaub worked together preparing a catalog that appeared in November, representing entirely new work.

Early in 1968 Joseph Kosuth met Siegelaub through his friendship with Weiner. Siegelaub began to help Kosuth financially in the spring of 1968. Gradually Siegelaub's time and interest were taken up by these four men—at the expense of some of the other artists under his commercial sponsorship. Kosuth's involvement with Conceptual art had begun two or three years before this. As early as 1965 he sensed that "organic and geometric shapes were used up" and started to experiment with formless and ephemeral materials. The same year, after giving up painting, he produced a 5-foot pane of glass, followed by his *One and Three Chairs*. In 1966 and 1967 the artist made a series of photostats with definitions of water and hydrogen compounds. Kosuth began to view abstraction as a philosophical-linguistical problem, no longer dominated by visual-formal considerations. However, an interesting aspect of art writing is that whenever a critic fails to understand new work the safest approach is to label it a "Dada gesture," and let it go at that: Kosuth's work met this reception. That the levels of

abstraction embodied by words could legitimately challenge the notion of art escaped just about everybody. Late in 1968, Kosuth stopped making enlarged photostats of dictionary definitions when he found that these were interpreted as a kind of Pop mannerist painting.

"My first catalog was for Doug's November show," Siegelaub notes. "We worked on it all summer, organizing the information so that it could all be contained in the catalog . . . there was no public space . . . they (the works — not the catalogs) were lying around in book mailing envelopes for protection. Some sold but I didn't think in terms of what it would bring in. It was too much work for that . . . I was just interested in doing that kind of show."

The following January (1969) Siegelaub organized an exhibition in a rented office building for the four artists: Barry, Weiner, Kosuth and Huebler. "As an organizer I believe in giving every man the same situation, same money, same pages in a catalog, and the same physical space. I asked *them* how they wanted to show their work — that's how it was done — and discussions continued for one and a half to two months. We decided on the catalog format: four pages for each man, two pages each of photographs, one page statement, and one page listing the works shown. There was also a presentation on the walls of two works by each artist. But in my mind the show existed quite completely in the catalog. After about a week and a half you really didn't have to point out the room. It was used as an office."

What is most surprising is the diversity in background and philosophy among the four artists. In 1968 Seth Siegelaub sponsored a small book by Lawrence Weiner entitled *Statements*. Many of these statements embody works already undertaken by the artist, and an introductory acknowledgement reads: "Certain specific statements are reproduced by kind permission of the people who own them." Some of the statements include acts which have had their residual effects upon more formally oriented artists:

2. Joseph Kosuth, *One and Three Chairs*, 1965. Collection, The Museum of Modern Art, New York: Larry Aldrich Foundation Fund.

1969 MARCH 1969

SUN	MON	TUE	WED	THU	FRI	SAT
						1
2	3	4	5	6	7	8
9	10	11	12	13	14	15
16	17	18	19	20	21	22
23/30	24/31	25	26	27	28	29

3. One Month. An International Exhibition of the work of 31 artists for each of 31 days of March 1969.
The invited artists and their dates are: March 1: Carl Andre 2. Michael Asher 3. Terry Atkinson 4. Michael Baldwin 5. Robert Barry 6. Rick Barthelme 7. Iain Baxter 8. James Lee Byars 9. John Chamberlain 10. Ron Cooper 11. Barry Flanagan 12. Dan Flavin 13. Alex Hay 14. Douglas Huebler 15. Robert Huot 16. Stephen Kaltenbach 17. On Kawara 18. Joseph Kosuth 19. Christine Kozlov 20. Sol Lewitt 21. Richard Long 22. Robert Morris 23. Bruce Nauman 24. Claes Oldenburg 25. Dennis Oppenheim 26. Alan Rupperburg 27. Ed Ruscha 28. Robert Smithson 29. De Wain Valentine 30. Lawrence Weiner 31. Ian Wilson.

"One sheet of plywood secured to the floor or wall"

"One standard dye marker thrown into the sea"

"Common steel nails driven into the floor at points designated at time of installation"

"An amount of paint poured directly upon the floor and allowed to dry"

"A series of stakes set in the ground at rectangular intervals to form a rectangle. Twine strung from stake to stake to demark a grid"[5]

These are general proposals and not necessarily the most elegant. At the time of the statements Weiner applied the following stipulations to the art, but chose not to print them in the book:

"The artist may construct the piece
The piece may be fabricated
The piece need not be built
Each being equal and consistent with the intent of the artist, the decision as to condition rests with receiver upon the occasion of receivership"[6]

Once a piece is stated *publicly* it exists, according to Weiner. Yet the path by which Weiner arrived at this conclusion is not so evident. "In the fall of 1959 I went to California from New York to build some structures and think. A year later in California I created a series of fields, of craters formed by high explosive charges. It was by far my best art, but since they were set off in a state park, I was caught. There being no malicious forethought involved, I was given a suspended sentence and a $20 fine. My major interest at that time was in the nature of the *specific* craters formed. I went back to New York confused. My problem was a hangup on specifics . . . and so I made innumerable specifics . . . Back in New York I worked on a vast series of canvases—all the same subject, but different sizes, colors, and materials. But somehow it wasn't getting across . . . or connecting. Finally I realized I was dealing with the *idea* of the explosions or paintings—forgetting specifics. So the new series of my works are traces of what an artist does. Somehow the shit residue of art history made me make paint-

ings and sculptures. But now I feel no contact with or relevance or need of a place in art history."

Robert Barry's works have adopted the most drastically ephemeral quality — he has moved from placed paintings to space-defining materials and energy forms to conceptions about conceptions. One of the most noted of the second types was a collection of works in the artist's bare

4. Robert Barry, *Labels on Gallery Wall*, January 1969. Courtesy Robert Barry.

ROBERT BARRY

4. 88 mc Carrier Wave (FM)
 1968
 88 megacycles
 5 milliwatts
 9 volts DC battery

Collection: Mr. and Mrs. Manuel Greer, N.Y.

ROBERT BARRY

5. 1600 kc Carrier Wave (AM)
 1968
 1600 kilocycles
 60 milliwatts
 110 volts AC/DC

Collection: Mr. and Mrs. Robert M. Topol, Mamaroneck, N.Y.

5. Robert Barry, *Inert Gas Series: Site Being Occupied by Helium, 2 cu. ft. to Indefinite Expansion*, March 1969, Mojave Desert, California. Courtesy Robert Barry.

studio: 1) *1400 KH2 Carrier Wave (AM)*, 1968 2) *1100 KH2 Carrier Wave (AM)*, 1968 3) *98 MH2 Carrier Wave (FM)*, 1968 4) *40 KH2, 8.25 MM Ultrasonic Installation*, 1968 5) *Phosphorous-32 Radiation Piece*, 1969 6) *Cesium—137 Radiation Piece*, 1969 7) *Electro-magnetic Energy . Field, E = 110V, 6.2 meters 2*, 1969.

Barry is quite reluctant to indulge in esthetic speculation about the nature of his art. When asked for photographs, he replied, "I can't think of any way to use photographs or anything visual in relation to some of the recent work. It doesn't have a place, or the place is unknown." Some of these include a proposal sent to the Institute of Contemporary Art in London: "Something which is very near in place and time, but not yet known to me." Another sent to Leverkusen, West Germany: "Something which affects me and my world, but is unknown to me."

For the "PROSPECT '69" at the Kunsthalle in Dusseldorf this past October Barry presented his work in the following form:

Questioner: Which is your piece for PROSPECT '69?

Robert Barry: The piece consists of the ideas that people will have from reading this interview.

Q.: Can this piece be shown?

R.B.: The piece in its entirety is unknowable because it exists in the minds of so many people. Each person can really know only that part which is in his own mind.

Q.: Is the unknown an important element in your work?

R.B.: I use the unknown because it's the occasion for possibilities, and because it's more real than anything else. Some of my works consist of forgotten thoughts, or things in my unconscious. I also use things which are not communicable, are unknowable or are not yet known. The pieces are actual but not concrete. . . .[7]

As far as the receiver is concerned, some of these newer works involve a conceptual process which triggers off a dilemma known in philosophy as *logical regression,* or a series of propositions that have no beginning and thus provoke circularity. But this cannot be said of some current works: "I'm doing some gallery shows in Europe in December and January . . . Exact dates at Sperone in Turin and Konrad Fischer in Dusseldorf have not yet been set. All the shows will consist of closing the galleries during the exhibitions."[8]

In some ways Douglas Huebler's approach involves a more familiar esthetic, making it less rarefied but perhaps of greater interest. He relies upon documents and techniques which, perhaps more than the others, Huebler feels are necessary to substantiate the existence of the work. These are broken up into various systems which are titled and numbered as "Duration," "Location," and "Variable Pieces." Examples were first included in Huebler's November, 1968, catalog. The artist specifies that all geographical, temporal, and process lines of demarcation limit only the conceptual boundaries of a piece; but since most of Huebler's art is embedded in ongoing reality, he places no physical boundaries around a work's beginning and end or actual location.

Problems of boundaries and limitations naturally affect participants but particularly affect any collector interested in Huebler's work. Through the history of art there have been certain tacit relationships between dealer, audience, collector, and artist, establishing degrees of control over the production and dissemination of a work of art. These however break down with Conceptualism, and part of an art work becomes the assignment of new control variables over the life duration of a piece. Certainly this has been the tendency in the last ten years. All previous notions of an object's intrinsic qualities have been challenged to the point where it would be the simplest matter to reproduce some recent objects with or without the artist's consent. As Huebler states, "Anyone could reproduce an Andre or a Flavin for instance. What would he have? I believe that the sensibility behind a work of art should be broadly accessible. At the same time I believe that the collector is someone who enters into a conspiracy with the

artist that is beyond the issue of accessibility, an agreement that the sensibility is an important one. This agreement may be really what the owner has that is 'original'."[9]

It might be added that the artist is still looking toward the collector as a source of legitimacy, if not as a means of sustaining solvency. The artist is asking the collector to pay for ownership; but in the case of most Conceptual art, the commodity is pure information. Here a dilemma appears. The point of owning information is to control knowledge and use of it. Efficacious ownership of art objects depends upon sophisticated dissemination of information about those objects. What does it mean to own a piece of information that must be in the public domain to exist as art?

Among Huebler's first pieces, *Duration Piece #2* consisted of a series of photographs of tire impressions made by automobiles running over a fine line of sand across a highway. *New York Boston Exchange Shape* dealt with a large-scale hexagonal form superimposed on downtown areas of Boston and New York so that the corners of the hexagons provide site locations for photographs. In regard to such photographs Huebler notes that, "I use the camera as a 'dumb' copying device that only serves to document whatever phenomena appear before it through the conditions set by a system. No 'esthetic' choices are possible. Other people often make the photographs. It makes no difference. What may be documented that has appearance in the world actually is returned to itself as only that and as nothing that has to do with the piece."[10]

Previous art usually demanded exacting control —artistry—over the parameters of production. But gradually art has become a matter of releasing control over these parameters, permitting exposure of an art situation to different intervening forces. What happens as the structure of an artist's conception is modified by unpredictable social processes is, in effect, a part of the art statement.

In another Huebler work, *Duration Piece #13*, one hundred United States dollar bills were listed by serial number and put back into circulation throughout the world. In 25 years from last July (1994) the serial numbers will be reprinted in an international art publication. $1,000 will be paid to any bearer who presents a dollar bill with a correct serial number to Huebler. This will be completed with the announcement in an art publication of all the Federal Reserve Notes actually redeemed. Part of what is crucial are the social, economic and historical conjectures which the artist brings to bear by subjecting himself to the remote possibility of grave economic loss. One could speculate that the proposal might be found absurd 25 years from now, in which case documentation of such crucial change would also complete the work.

A problem that arises is that there are pieces and aspects of pieces of Huebler's which cannot be discussed because of their on-going nature, or because secrecy is necessary to preserve the integrity of their evolution. With this essay appears the proposal and a photograph of a "wanted" bulletin for *Duration Piece #15*. Here intervention in an emotionally charged social situation is very calculated and tied to the purchase of the piece. In considering *Duration Piece #15*, either to buy it or to collect the reward or to simply think about it, one is placed in a strangely questionable relationship with the fugitive—as Weiner mentioned in another context, "this is Genet's existentialism, not Sartre's or Camus's." The art game aspect is very much undermined and it automatically forces the issue of social values. In the "PROSPECT '69" interview Huebler elaborated on this:

The essential quality of existence concerns where one is at any instant in time: that locates everything else. Location, as a phenomenon of space and time, has been transposed by most art forms into manifestations of visual equivalence: that is, as an experience located at the ends of the eyeballs. I am interested in transposing location directly into "present" time by eliminating things, the appearance of things, and appearance itself. The documents carry out that role using language, photographs and systems in time and location.[11]

In many ways Joseph Kosuth's "pure" Concep-

tualism is the most challenging and intellectually demanding. It is doubtful that one might develop a sensitivity for Kosuth's art without first reading his very important three-part essay, "Art after Philosophy."[12] As the artist sees it, art's "art function" or ability to clearly reflect upon itself as philosophical endeavor, became apparent coincidentally with the early 20th-century demise of metaphysical speculation. He explains why decoration and taste provide a critical basis for much contemporary art, as morphological considerations define art itself for Formalism (*i.e.*, what does not look like painting and sculpture most certainly cannot be art). Hence Kosuth places a very high priority on art as a means of continual redefinition, an act of which Formalism is incapable because a *priori* it knows what art is. "Artists question the nature of art by presenting new propositions as to art's nature. And to do this one cannot concern oneself with the handed-down 'language' of traditional art, as this activity is based on the assumption that there is only one way of framing art propositions."[13] Conceptually speaking, the "value" of a work of art cannot lie in its physical presence, but only in its power to generate concepts and thus influence other artists.

Drawing parallels between art and language, Kosuth defines art as a series of analytic propositions which have no value as information outside the context of art. Here his investigations into linguistical analysis and Logical Positivism are crucial. Like logic and mathematics, Kosuth views art as a system of tautologies which, while self-contained, depend upon the context of the real world for social meaning but not verification. He doubts the validity of phenomenological considerations which have been attached to the art experience. Certainly these, he states, have been more than duplicated by the normal environment. This "calling attention to," or any private motivation of the artist, can never replace the "art function." Kosuth sees this as art's inherent function of *not* performing service — whether philosophical, decorative, or entertainment—but remaining relevant only to itself.

During the past four years the display and entertainment value of Kosuth's art has been considerably reduced, inviting disinterest from viewers —as witness the tiny elegant line of labels on the walls of the *557,087* show in Seattle or in the *Art by Telephone* show in Chicago. Few gallerygoers want to read a series of typed riddles or thesaurus entries. It is as if Kosuth is saying, "Since my art is not about all the things which art is not about, it is art." By the artist's functional definition of art, he places art on a metalevel, one that transcends the Duchampian negation of visual esthetic criteria. In blunt terms he insists that he is an artist rather than a philosopher by virtue of his productions (or as he calls them "art investigations") which are incredibly trivial, in iconic terms, but which may achieve validity *only* through their eventual effect on future art.

Kosuth's attempt to escape identification with iconic art is seemingly preposterous, until one realizes that the weight of his argument depends upon having shows which are known to have taken place. After the mounted photostats, he entered his thesaurus categories into various media: magazines, newspapers, television, billboards, etc. In many cases only a catalog notation defines a work's existence. If newspaper entries are shown in a museum, they are most likely presented as a pile of newspapers on a table. As he explains, "All my work exists when it is conceived because the execution is irrelevant to the art . . . the art is for an art context only . . ."[14] Of course an irony of Kosuth's work is that he *is* forced to produce it physically. The reification is invariably mistaken for art. As pure conceptual investigation Kosuth implies that his subject matter is substantially irrelevant, but that its assumptions provide meaning or context as art. By the act of giving definitions (tautologies) for terms other than "art," Kosuth creates art and therefore functionally defines it.

The writings of Ludwig Wittgenstein are a prime basis for Kosuth's methodology. Like Wittgenstein's relation to philosophy, Kosuth stresses art as a process rather than as a set of truths, subject matter and method mirroring each other in any set of propositions. Kosuth's dictionary definitions

BANK ROBBERY
WANTED BY FBI
EDMUND KITE MC INTYRE

I.O. 4268
4-10-69

FBI No. 342,327 F

14 O 27 W III Ref: 11 12 28
M 32 W M I I 18 32 32 32

ALIASES: Charles W. Embick, Edmund Kate McIntyre, Edmund Kice McIntyre

Photograph taken 1966 Photographs taken 1968

DESCRIPTION
AGE: 22, born September 7, 1946, Pleasantville, New Jersey
HEIGHT: 6'1" to 6'2" EYES: hazel
WEIGHT: 170 to 180 pounds COMPLEXION: medium
BUILD: medium RACE: white
HAIR: blond, brown NATIONALITY: American
OCCUPATIONS: automobile mechanic, commercial artist, laborer, silk
 screen worker, truck driver
SCARS AND MARKS: scar right wrist, tattoos Maltese cross and "13"
 left forearm, 3 dots left hand
REMARKS: may wear mustache, reportedly uses narcotics
SOCIAL SECURITY NUMBER USED: 545 66 4355

CRIMINAL RECORD
McIntyre has been convicted of resisting arrest

CAUTION
MC INTYRE IS BEING SOUGHT FOR BANK ROBBERIES WHEREIN A
HANDGUN WAS USED. CONSIDER DANGEROUS

Federal warrants were issued on December 31, 1968, at Los Angeles, California, and on January 17, 1969, at Miami, Florida, charging McIntyre with bank robbery (Title 18, U.S.
Code, Sections 2113a and 2113d).

IF YOU HAVE INFORMATION CONCERNING THIS PERSON, PLEASE CONTACT YOUR LOCAL FBI OFFICE.
TELEPHONE NUMBERS AND ADDRESSES OF ALL FBI OFFICES LISTED ON BACK.

Identification Order 4268
April 10, 1969

J. Edgar Hoover
Director
Federal Bureau of Investigation
Washington, D.C. 20535

Duration Piece #15

Global

Beginning on January 1, 1970 a reward of $1,100.00 will be paid to the person who provides the information resulting in the arrest and conviction of Edmund Kite McIntyre wanted by the Federal Bureau of Investigation for Bank Robbery (Title 18, U.S. Code, Sections 2113a and 2113d). On February 1, 1970 $100.00 will be reduced from that first offer making it $1,000.00; it will be reduced another $100.00 on the first day of each subsequent month until there will exist no reward at all on January, 1971.

I, (Douglas Huebler), guarantee (by my signature below) the full payment of the reward offered above. In the event that this piece has been purchased from me at any time between September 1969 and January 1971 the then owner will have assumed responsibility for payment of such a reward.

(The price for this piece is $1,000.00: from that sum I will reimburse its owner any amount that he pays as a reward in completing the destiny of its design).

This statement and the "Wanted" publication (FBI No. 342,327 will constitute the finished form of this piece on January 1, 1971 unless Mr. McIntyre is apprehended and convicted in which case copies of all attendant documents concerning his conviction will join altogether to form the piece.

September, 1969

6. Douglas Huebler, *Duration Piece #15, Global,* 1969. Courtesy Douglas Huebler.

and thesaurus categories (his synopsis of categories) are predefined and doled out for each art exhibition until they are completed, purposely severing all connection between conception, execution, and presentation. The inadequacy of such orthodox reference materials is demonstrated by purposely taking them out of the context of ordinary language use. All of this corresponds to one of the most debated theses in Wittgenstein's *Tractatus:* "Propositions cannot represent logical form: it is mirrored in them. What finds its reflection in language, language cannot represent. What expresses *itself* in language, we cannot express by means of language. Propositions *show* the logical form of reality. They display it."[15]

Kosuth has made a unique and valuable contribution to the dialectic of modernist art. In so doing he poses a rigorous alternative to the existing morphological idealist model. No artist involved in more than craft can fail to understand this—if he hopes to surmount Kosuth's challenge. In this respect Wittgenstein observed about the propositions of his *Tractatus:* "My propositions serve as elucidations in the following way: anyone who understands me eventually recognizes them as nonsensical, when he has used them — as steps — to climb beyond them."[16]

The Conceptualists have objectified the dissemination of art information —that is to say, the best have rethought the artist's role relative to media, museums, and collectors. This is the result of not centering interest on content but, as in information theory, on the nature of information itself. Questions of information's *predictability, improbability, complexity, message structure, dissemination, delay,* and *distortion* are factors not only for consideration, but for a work's viability as art competing with other art forms. Optical art, Kinetic art, Luminous art, and various types of environmentalism have sought to convey standard art information by new technical means. These were usually attempts to break out of an exhausted format, but with little thought given to the relationship between methods of transmission and the art context. One of the transcending realizations of Conceptualism is that *any form of energy can or may be used to convey art information, that the sender or carrier is in fact a secondary problem to that of formulating a significant reason for its use.*

Redundancy is a necessary property of all communication systems. Uniqueness in a message is created in part through redundancy. But Conceptualism has reduced the need for redundancy in art information. This was clearly shown by its articulation of large-scale works and environments, often minimized to a few descriptive directions. The fact that such directions do not have to be carried out leads to a further decrease in redundancy. But the Conceptualists implicitly understand that the power in art today resides in the mass duplication of data; hence they stress redundancy of the message itself rather than its content. A message's uniqueness on the other hand is in direct proportion to the needs, desires, and anticipations of the party receiving the message. Uniqueness as a consequence is not defined in art by deviation or strangeness. All important art formulates *need*—this creates uniqueness, as with all successful advertising.

Conceptualism demonstrates that art as communication has much of the unverifiable consistency of a rumor. Unlike direct mechanical communication, the content of a rumor is not a specific body of information transmitted at the highest practical rate of fidelity, but rather something "shaped, reshaped and reinforced in a succession of communicative acts. . . . A rumor may be regarded as something that is constantly being constructed; when the communicative activity ceases, the rumor no longer exists."[17] Art functions not unsimilarly. Thus if and when artists cease their activities, all previous art will automatically disappear — as art.

Perhaps the future of Conceptual art is tied more to its power for influencing artistic behavior than to any success as commodity art, although Seth Siegelaub certainly does not think that way: "My influence in relation to the artists seems magnified because no one else was interested in this kind of art . . . but this is no longer true. My

interest as a businessman isn't in circumventing the commercial system. I've just made pages of a book comparable to space (art situational space). Artists having their work go out as printed matter can be just as viable as selling Nolands." Yet in a more profound sense Siegelaub sees the effect that media and business have upon Conceptual art *as idea.* "Anything, any person, any idea has a focus . . . which is located in the world . . . just radiating outwards, losing strength at the edges. Watering down comes with the intermediaries between the artist and the public. That's what culture's about . . . culture is probably about watering down."

1. McLuhan, Marshall and Parker, Harley, *Through The Vanishing Point: Space in Poetry and Painting.* New York, Evanston, and London: Harper & Row, Publishers, 1968, p. xxiv.
2. Bertalanffy, Ludwig von, *Robots, Men and Minds,* New York: George Braziller, 1967, p. 27.
3. McLuhan and Parker, p. 243.
4. Kosuth, Joseph, "Art After Philosophy: Part I," in *Studio International,* Oct., 1969, pp. 160-161.
5. Weiner, Lawrence, *Statements,* New York: Seth Seigelaub, 1968, pages unnumbered.
6. Weiner, Lawrence, *5 Works,* exhibition catalog Nova Scotia: Nova Scotia College of Art, April, 1969. Pages unnumbered.
7. Barry, Robert, "PROSPECT '69", exhibition catalog statement, Düsseldorf, West Germany: Kunsthalle Düsseldorf, 1969, p. 26.
8. From a letter by the artist to the author, November, 1969.
9. Huebler, Douglas, "PROSPECT '69", exhibition catalog statement, Oct. 1969, p. 26.
10. *Ibid.*
11. *Ibid.*
12. Kosuth, Joseph, "Art After Philosophy: Parts I, II and III" in *Studio International;* October, November, and December, 1969.
13. Kosuth, Joseph, "Art After Philosophy: Part II", p. 135.
14. Kosuth, Joseph "PROSPECT '69", exhibition catalog statement, p. 27.
15. Wittgenstein, Ludwig, *Tractatus Logico-Philosophicus* (1961 edition translated by D. F. Pears and B. F. McGuinness) (London: Routledge & Kegan Paul) p. 51.
16. Fann, K. T. (ed.), *Ludwig Wittgenstein: The Man and His Philosophy,* New York: Dell Publishing Company, 1969, p. 381.
17. Shibutani, Tamotsu, *Improvised News: A Sociological Study of Rumor,* Indianapolis, New York: The Bobbs-Merrill Company, Inc. 1966, p. 9.

WILLOUGHBY SHARP INTERVIEWS JACK BURNHAM

W.S.: The *Software* exhibition which you organized for the Jewish Museum has already been involved in considerable controversy. The Software film has been destroyed and several artists have threatened to withdraw from the show. Exactly what is happening?

J.B.: I can't really go into it because of possible litigation.

W.S.: Well, perhaps we can discuss your forthcoming book, *The Structure of Art.* Could you say something about *that*?

J.B.: What I've realized in trying to provide a Saussurian structural analysis of art — and it's a condition recognized by everyone interested in semiology — is that society is composed of a series of language-based systems. Any language comes into being by means of a kind of social contract. That is, people agree to observe certain rules. Perhaps the rules are inculcated automatically, like parental mores or syntax. But art is probably something more consciously learned at a later date; you have to be educated to like or appreciate so-called high art. It seems to me we've gotten to the point now where all the social conventions and tacit agreements between artists and dealers and museum people, entrepreneurs and critics, are totally breaking down. Nobody either wants to or can understand the other person.

W.S.: What is an example of that?

J.B.: I read more and more criticism in *The New York Times* and in magazines which totally misses the point of the art, certain types of art in particular.

W.S.: Could you clarify that?

J.B.: Perhaps it centers on the fight that's been going on, especially in *Artforum*, between so-called literalists and formalists — if that's the way you want to characterize the two points of view. Essentially the literalists claim that the formal values of an art object need not be taken into account. From their point of view the making of the object is irrelevant. The object comes into being through a kind of serial process, as with Stella and Judd. The formalists say that all those internal manipulations of values, colors, and forms are very important. It's the difference between people who want to forsake canvas stretchers and those who can't reject them. And all those stupid fights about how thick the frames of Stella's canvases are, whether they're two or three inches, and whether it means anything to make them thicker or thinner. It's probably a tempest in a teacup. That fight was established around '64, '65. And two or three years later there are still critics who can't swallow process art, ecological art. Not only has the hiatus grown between movements but also between the methods of criticism, between criteria. No one that I know of ever really set up a criticism of surrealism. Probably no one ever will.

W.S.: Few critics seem interested in theorizing over larger esthetic questions. That's one of the

tasks you've set yourself, isn't it? How did that come about?

J.B.: Well, two years ago when *Beyond Modern Sculpture* came out, some people praised the book and others violently attacked it. There must have been over fifty reviews, but James Ackermann's in the *New York Review of Books* was the only one that hurt me, really stung, an academic's attack. There were two or three sentences that hit home, at least enough to make me reply. He said something to the effect that I was the reincarnation of Wölfflin. I asked myself how this could be. My god, I reject his cyclical theories, his theories of opposition, practically everything he stands for. At the time I began to read Lévi-Strauss in a tough way, while examining my own prejudices. I also began to read Freud, *Totem and Taboo* and *Civilization and its Discontents,* and other writers extremely critical of historical thinking. I wondered if what Ackermann was really against was the idea that I proposed—a viable historical model. I asked myself what, if any, the mythic tenets of *Beyond Modern Sculpture* could be. Obviously the illusion of progress is one. The idea of anthropocentricism is another—that is the notion that man can control all animals and earthly resources. Another, of course, is the concept of a technological utopia. All these premises are implicit in the book. Frequently I editorialize against them; at the same time I say to the reader, look, the changes that technology has effected on the culture affect art just as well.

W.S.: But what about Wölfflin?

J.B.: Wölfflin is essentially an art historian who totally encompasses a Hegelian model: progress embodying a kind of cyclical reincarnation of styles and forms. I realized I'd picked out the scientific framework of the past hundred years and applied it to art; I'd tried to superimpose a specific historical model onto the historical model of art. It produced some results, but I've had to ask myself exactly what they meant. What I'd done was to impose the myth of progress onto the notion of avant-garde art.

W.S.: How does your experience in organizing a museum exhibition affect your thinking about the structure of the art world?

J.B.: The idea of arranging an art exhibition is increasingly untenable. Until a few years ago curators went to galleries and lofts, looked at work and said I'll take this, this, but not that, and that was the end of it. However, as art becomes more problematic more "undone," existing only in the artist's head, the curator is forced to say to the artist, what have you got in mind? Take an example: the artist says, I want fifty steeplejacks to be climbing up and down the Empire State Building for three hours a day during the month of November. The curator hires the steeplejacks, pays for the use of the building, goes through hassles with the city. Finally, the piece costs the museum $25,000. This is exaggerated, but not much. Then the artist says, "You didn't include any Mexican American steeplejacks. The museum is prejudiced. I'm pulling out."

W.S.: You're saying that the artist relegates much of the execution of the work to the exhibition organizer. And that it's a rather self-defeating enterprise. Will *Software* be your first and last show?

J.B.: It's the first and last show where, with the help of many others, I've had to organize an incredible amount of equipment, technical help, and commitments. Many artists are extremely conscientious and follow through every aspect of their pieces that they can. But it seems as though there's bad faith or misjudgment about everybody's motives, at least concerning some shows. Take finances: museums in capitalist society traditionally function as secular temples in which money is never seen or talked about but appears at the proper times automatically. The secular temple idea is fine because it assuages the needs of artists, who have to feel that they are dealing with very clean people. But as you know every museum in the city has money in trusts, war industries. . . .

W.S.: A lot of dirty people connected with it.

J.B.: Yes, people working for industries that artists probably disapprove of. Museums get money from all kinds of sources. They have to. But the esthetic illusion is that as long as artists don't know where the money is coming from, many latently guilty consciences are relieved. Just

as long as a show is structured through a disbursement of museum funds, checks payable through the museum, it seems to be clean money. In the last few years, Maurice Tuchman, Kepes at MIT, and myself among others have used money from visible outside sources, electronics companies and such. So the artist is put in the compromising position of making pieces with money whose source he knows. Somehow the fact that the Guggenheim Foundation's grant come from the copper mines of South America doesn't bother artists half so much as openly working with American Motors money.

W.S.: Are you saying that all the exhibitions done across the country are similar to the *Software* show, in that, directly or indirectly, they're backed by dirty money?

J.B.: Freud said that money is feces, in psychoanalytical terms. The term filthy lucre indicates that people are referring to money in terms analogous to their bodily functions.

W.S.: Isn't money just an energy source used to feed the socioeconomic system so that it can produce something valuable in its own terms. . . . What are other areas of bad faith that occur?

J.B.: Well, another is caused by the fact that artists don't really know whether they want to be associated with museums or not. For instance, most members of the Art Workers' Coalition have no hesitation about showing in a museum. At the same time there are various psychic complications produced by associating with an organization and fighting an ideology behind that organization — you know, saying these are pig museum people who are simply representing the chief pigs.

W.S.: So you think art is at an impasse?

J.B.: Yes, in terms of breaking rules.

W.S.: Wouldn't you say that body works — works in which the artist uses his own body as sculptural material — constitute the most significant development since elemental art?

J.B.: I think they're significant, but it's a kind of dead end significance. Body works are probably one of the last things that can happen in avantgarde art. Because once artists totally externalize their bodily activities into a work, and then docu-

ment it, that's as far as it can go. What every artist is acting out is his own autobiography; in fact all gestural or personal trademarks are autobiographical. As far as I can see, body works say, let's get the fact that art is autobiographical out in the open and deal with it for what it's worth.

W.S.: That may be partially true for some of Acconci's recent works, and a few of Wegman's pieces of last winter, but I don't think it applies to the body works of Oppenheim, Nauman, Sonnier or even Fox. But let's go back to what you said about art being at a dead end.

J.B.: Art as we know it from the beginning of avant-gardism has been breaking down mimetic conventions, the structure of pictorial illusionism, in favor of reality free from illusionism. The only way this can be done is by dropping signifying conventions. The sequence is generally step by step, but various artists include or exclude different groups of signs. However, an artist may drop a sign, while retaining it latently in his work. Say an artist drops color, or texture as many of the minimalists do. Texture then latently remains in the object, but it's suppressed: it is no longer perceived as part of the work nor does it carry any expressive content. What happens today is that many works have very transparent structures insofar as the artists have a specific idea of what they're doing. But ideologically they have to explain their work so precisely, with so many cues, that you know exactly what to omit in looking at the work. The artist tells you what to perceive in order to see his things as works of art. That's why so many critics miss the boat. They're still looking at those latent or neutralized signifiers as though they meant something.

W.S.: You posit a beginning of "avant-gardism." Where do you place that and how do you see its subsequent development?

J.B.: The area that's most congenial to art historians is the high Renaissance, because it establishes a peak of optical illusionism on a two-dimensional surface. Art historians spend a great deal of time trying to pinpoint within two or three years the beginning and end of that period. Shortly after, with Mannerism, you begin to see the decline of that illusionistic ideal. With histori-

cal mythic structures you have to have an optimum, a point of time by which to judge the present.

W.S.: But where do you think it started?

J.B.: I think it's a continuum from the high Renaissance onward. Then obviously you get to people like Courbet and Manet who are conscious of what they're doing, in reducing shading and the laws of perspective. It's not just wider brush strokes or another interpretation of color; rather they're asking, how can we make this painting work on another level? You know Baudelaire's famous letter to Manet when he writes, you're only the first in the decline of your art.

W.S.: But you're not agreeing that everything since Michelangelo constitutes a decline of art.

J.B.: Not really. There are two ways of looking at art. One is as a series of magical events which are psychically connected. And the other way is to take art as a social language. Linguists insist that all language forms are always coming into being and passing away. I think art was once essentially iconic, objects imbued with magical efficacy. By the time of the High Renaissance this notion was losing ground. People needed something more — a mimetic illusion of the real world. From Manet to 1914 or 1915 the development of art does seem to show a kind of linear progression. And from there onwards it begins to vacillate, so that artists absorb once-rejected signs and reuse them in new contexts.

W.S.: But if artists are not able to exhaust previous modes of expression doesn't that indicate a greater richness in recent art?

J.B.: For me it means they have to search harder. First of all they understand that the rules of the game presuppose that they must become innovators.

W.S.: That's a rather recent idea.

J.B.: Well, a few people had it around the turn of the century, but by 1955 it had become pretty dominant. I was under a great delusion from '55 to '65, when I was making light art, both static and moving. I thought that by adding a new formal element or a new signifier to art I was enriching my art and producing a situation where experimentation could take place. That was a total illusion.

W.S.: In other words in 1955 you saw possibilities of expressing yourself significantly as an artist, and now you don't.

J.B.: No, I'm putting it more specifically than that. It was not only myself, but a number of other people, Tinguely, Pol Bury, Takis, Shoeffer and other artists working with light and mechanics as well. Although using new elements — and the emphasis was always on the new — I didn't realize that those elements had always been present in art. The only innovation you can make in art is by removing a signifier. If you can suppress a signifier effectively, you can produce new art.

W.S.: But is Minimalism any more minimal than Kineticism?

J.B.: It is, yes.

W.S.: And therefore you feel that it's more valuable?

J.B.: It's only more valuable in terms of the art historical myth. From my point of view, anything that has a continuous time dimension is absolutely unfeasible in terms of the mythic structure of art.

W.S.: Is this the discovery that has made you so pessimistic?

J.B.: Right. Tinguely and others felt that they were entering into a realm where music had held sway for centuries, and that they could produce cybernetic structures, all kinds of public phenomena which would incorporate a temporal dimension, perhaps in ways unperceived by musicians. This was their hope. I think those phenomena are still important, and perhaps they will result in fantastic public displays or something. But they can't produce anything valid within the framework of art history.

W.S.: Why is that?

J.B.: Art works have to be static; that is, they have to have an end. There can be process works which take place over a period of time, but they have to have a beginning and a completion point that's understood by the spectator.

W.S.: But isn't there an understanding of that, say, in a water work of Haacke's?

J.B.: Right, the only exception is work which

utilizes gravity, and Duchamp understood this quite well. Works which utilize gravity presuppose an ultimate point of rest, just like Haacke's water works or Calder's mobiles. They may be pushed or jarred, but they always move towards equilibrium.

W.S.: What about Len Lye's *Flip and Two Twisters* which has a timing sequence with rest periods?

J.B.: Well, I think cyclical works don't function within a mythic structure either. However, this is all relative. Any work which has to be tripped off into motion contains a pretty bad flaw.

W.S.: Then you see this mythic structure as pivotal in determining the value structure of art works. Could you explain that a bit more?

J.B.: Some anthropologists, predominantly Lévi-Strauss, who've examined myths have doubted whether mythic structures can exist historically. They've claimed that these function only in cultures possessing no sense of history; in cultures such as our own, myths are destroyed because we're too aware of change. But I believe that mythic structures do exist within a historical context. If you look at a series of objects from 1912 through 1970 and identify those which are works of art, there must be an underlying logical reason for your decisions.

W.S.: You're talking about esthetically significant works of art?

J.B.: Yes. And they're all significant because they have the same conceptual structure. I see this structure as an inversion of signs. I won't go too deeply into this now because it's in my new book. What I try to prove is that every artist sets up certain conditions and then in order to make a work he inverts those conditions. Take *Maze,* the work Oppenheim did in Whitewater, Wisconsin, this year with a pasture and cows. He took a standard maze from a psychology textbook and got students from the college in Whitewater to construct it out of hundreds of bales of hay. All the cows were placed at one end; at the other end, Oppenheim placed all the corn. The cows found their way through the maze and ate the corn. If you study the order in which this problem is laid out and solved, you'll see an inversion.

W.S.: How does this relate to formalism?

J.B.: The whole idea of formalism is to make people appreciate art by looking at it. But mythic structures and totems, as Lévi-Strauss points out, are not only good to look at, they're always good to think about. This is the homological character of all art. What artists are always doing is superimposing one structure on another through analogy. The structure is always dependent on the intentions of the artist; a single structure can define many different problems depending on what the artist is up to.

W.S.: But how does that explain the inversion of signs that you mentioned earlier?

J.B.: You can explain it in terms of making and conceiving. An artist's concept always has priority over its subject, unless the subject is a ready-made object. In other words, such a sign is motivated. If the artist can be seen carrying out the work, this information will dominate the result of his act. All this goes back to the concept of ritual through the efficacy of magic and religion.

W.S.: So instead of producing an object in which no traces of the artist's activity are left, you have the activity assuming precedence over the finished object, as in body works.

J.B.: This is right in some instances. The making of the object was once of paramount importance, whereas in this past decade, unmade or made by somebody else, choice assumes precedence. Also the context in which a work is placed becomes crucial in certain cases. This is what Kosuth is trying to point out. The only thing that's important for understanding art is the conceptual ordering of the procedure itself. Duchamp was the first person to realize how you invert signs in art. He did this with the *Fountain* and the *Bicycle Wheel.*

W.S.: How did he carry out an inversion in the *Fountain?*

J.B.: What he did was to select a standardized object, a urinal. When people attacked him at the Independents' Exhibition in 1917, he said, remember I *chose* it. In the Notes from *The Green Box,* Duchamp explains how the artist is involved in choice and action or choice alone. He was try-

ing to establish, in effect, what I call the inversion of signs.

W.S.: By reversing the order of unmotivated signs and motivated signs?

J.B.: Right, that's exactly what he did. Let's take *Dissipate*, a work by Heizer, in which he first drops matchsticks on a piece of paper, thus giving him the placement of the trenches in the desert: Duchamp's *Three Standard Stoppages* is just such a random arrangement. There are three signs in Heizer's work. First he chooses the matchsticks. Second he "makes" the simplest work possible, by dropping the matchsticks. In the same way, Duchamp, by dropping the threads, was asking what is the simplest way of composing given the formal possibilities which dominated art. Heizer's third sign can be called a second "naturalization of the cultural" in which the matchsticks pattern, transposed into wooden forms, are put in the desert.

W.S.: But one sense of what you call a sign here is what one would normally refer to as a value: simplicity is an instrumental value in creating a work.

J.B.: No. In Saussurian structural linguistics a sign always has two parts. When you see an object which someone claims to be a work of art, you have to decompose it conceptually, and separate the result into categories, for our purposes the *natural* and the *cultural*. I've arrived at those by referring to Lévi-Strauss, taking the oppositions he's defined, and trying to find analogies in art.

W.S.: You've said that certain pieces in *Software* are not necessarily art and that certain normal artistic concerns aren't relevant in terms of that exhibition.

J.B.: One of the things I was very conscious of when I developed the show was that there's virtually nobody working with computers who's producing even reasonably low-level art. So very early in the planning stages I saw that it would have to have a focus other than how artists use advanced technology. At the moment, technology is only used as an elaboration of the ready-made. Haacke does this frequently. His best works are pure ready-mades that have certain twists to them.

One thing I was trying to establish was the right to put non-art into an art show, and to call it non-art. You know, every curator operates under a kind of fear. He worries that the art magazines, all the judges and bishops, are going to castigate him for showing all that "trash." But I was sufficiently convinced, by the time I chose the show, that my book *The Structure of Art* was correct in principle so that I could put non-art into a show with impunity. My reputation rests on the book.

W.S.: Is the exhibition an application of the ideas in your latest book?

J.B.: To a certain extent. Some of the pieces are. There are several chapters in the book that deal with the iconography of Duchamp's *Large Glass*. I tried to justify preliminary theories and structural analysis by a number of Duchamp's statements and the iconography of the *Large Glass* itself, including the title *The Bride Stripped Bare by Her Bachelors, Even.* This can also be interpreted in French as *The Bride Stripped Bare by her Bachelors Loves Me,* something that Octavio Paz points out. With the *Large Glass,* Duchamp was trying to establish that artists, in their lust to produce art, to ravish art, are going to slowly undress her until there's nothing left, and then art is over.

W.S.: Which corresponds to the thinking of a lot of contemporary artists like Dan Flavin, who has said, "We are pressing downward toward no art —'a mutual sense of psychological indifferent duration — a neutral pleasure of seeing known to everyone."

J.B.: Right. I think Flavin has good instincts in that respect. But to my mind the *Large Glass,* which is probably the epic work in modern art, is deliberately a piece of non-art. And Duchamp of course could afford to do one piece of work which was totally non-art. Actually, though, it functions like some of the true-false propositions set up by Bertrand Russell around the turn of the century.

W.S.: How can any esthetic work be "a piece of non-art"? Wasn't Duchamp's *Large Glass* made with artistic intention?

J.B.: Well, no, because he definitely didn't follow a structural procedure which would lead

people to accept it as art, but he perversely sets out to produce something which, as Lévi-Strauss would say, culturalizes the cultural. In order to produce art, you have to culturalize the natural, then naturalize the cultural. What Duchamp has done is to take a cultural activity, i.e, the historical myth of modern art, deduce what the structure is, and then, in a series of fantastic allegories, put into strange images the whole history of modern art. This is what the *Large Glass* really represents. It has a lot of machines in the lower section — scissors, grinders, gliders, etc. That's on purpose: it represents the patriarchical element, the elements of reason, progress, male dominance. The top of the *Large Glass* is the female component: intuition, love, internal consistency, art, beauty, and myth itself. As a kind of personal joke, and I haven't told this to anybody, I tried to recreate the same relationships in *Software*. I've produced two floors of computers and experiments. Then upstairs on the third floor, conceptual art with Burgy, Huebler, Kosuth, and others, which to my mind represents the last intelligent gasp of the art impulse.

W.S.: I thought Acconci's body works were.

J.B.: Yes. Actually Acconci was supposed to be placed upstairs, but for visibility he was placed downstairs. That was an iconographical error. He is there with a bit of malice. The show is simply a recapitulation of Duchamp's allegory.

W.S.: So this is an exhibition which takes as a model a work of art which you find a paradigm for all works of art. What did you attempt to prove?

J.B.: Several things. None of them are welcome to the art world. I had to have a collective theme for the show. I said communication, information, processing. That can mean virtually anything. I tried to include various conceptual artists, some of whom are lyrical, others not. Some are very tough in terms of insight and logic. I tend to look at those conceptual artists — and they're not all in *Software*, because I couldn't get them, or for other reasons — as being the last conscious step between art and non-art. In other words, I would say the last complete art is body art. On one side of a logic structure the last incomplete art is process art: that's on the action and natural side, because the process of making art also becomes a signified for the art. Conceptual art is its opposite, where the most rigorous conceptual artists intuitively or intellectually understand the logical structure of art. What the artists are doing is similar to those great train race movies, where the train is in a race and suddenly runs out of coal, so they start chopping up the coaches to fire the engine furnace and keep it going. This is what conceptual art does. It feeds off the logical structure of art itself as material, taking a piece of information and reproducing it as both a signified and signifier.

W.S.: Do you see art dissolving into nothingness in the near future?

J.B.: No, it's dissolving into comprehension. The reason art exists in the first place is that it's a mystery. The greatest artists are always those around whom there's the greatest mystery and because unconsciously they produce art without knowing a thing about it.

THE PURPOSES
OF THE
"READY-MADES"

PIERRE CABANNE: "What determined your choice of ready-mades?"
MARCEL DUCHAMP: "That depends on the subject, because, at the end of fifteen days, you begin to like it or hate it. You have to approach something with an indifference, as if you had no aesthetic emotion. The choice of ready-mades is always based on visual indifference and, at the same time, on the total absence of good and bad taste." [1]

Duchamp's Gnosticism

We are beginning to realize that Marcel Duchamp's famous "aesthetic indifference" or "indifference of choice" suggests more than a superficial reading would allow. Through the years the Ready-mades have been grudgingly incorporated into art history; and although granting them the imprimatur of "art," virtually no critic or historian has attempted to formalize or rationalize their place in art theory. Just as they defy analysis, they maintain their strange hold upon art and artists of the past decade. Too often to be coincidental, the Ready-mades have revealed the consistency of many art works attempted during the 1960s, while chronologically predating these same works by ten to fifty years. Adding this to the fact that Duchamp was the chief adviser for three of the best modern art

collections in the United States, one might suspect that this singular artist possessed some kind of prescience of the future and ultimate value of art. But the question remains, how?

Duchamp's various collections of notes have been published in several editions. Aside from some vague allusions to their role in the iconography of his art works, it is generally conceded that they remain a mystery. Read more carefully, these notes represent a series of stepping stones in some of the more venerable areas of mysticism. These traditions have their various roots in Gnosticism; in the occult religion of Egypt; the Orphic mysteries of Greece; the cabalistic studies of the Jews; the Masonic Orders; and, in the East, in the doctrines of Tantric Buddhism and the Golden Flower of Taoism. These branches of mysticism concur with a single hidden idea, namely that all the languages, arts, sciences, rites, and communicated traditions of man have a common historical and ahistorical pattern derived from the unique composition of the human brain, and the brain in turn reflects the plan of universal organization. Once given the keys, an initiate into the hermetic arts comprehends the range of psychological archetypes and the limits of human creativity with mathematical precision.

For the ancients, initiation into one of the hermetic traditions stood as the highest honor, one that came only after years of strenuous examination. Complete reintegration of the per-

sonality remains the goal of hermetic initiation. And it seems probable, given Duchamp's young age (twenty-one to twenty-five), that his penetration into the recesses of hermeticism resulted mainly from self-study and not membership in a secret organization. At times Duchamp's iconography and terminology refer to alchemical processes, but on the whole they depend upon the Hebrew tradition of Cabala. Nevertheless, his personal philosophy parallels pre-Christian Gnosticism.

The *pneumatic* believes in one ultimate salvation: *Gnosis,* or perfect knowledge which protects him from the ignorance (*ignor*-ance) of an unreflected existence, including religious orthodoxy. The gnostic god, like the cabalistic diety, is not a separate power but rather the universal scheme of organization — simply nature as we understand it. Its light is comprehension, just as darkness is withdrawal of that comprehension. Its Being is emanated through universal laws. Comprehension or *Gnosis* demands uncompromising logic and clarity of spirit — rather than faith. Gnosticism's paradox may be found in its assertion that the "historical systems" of culture stem from a fundamental illusion deep in the collective unconscious, while gradual dissipation of these same systems is the inevitable result of ignorance of the mechanisms which originally produced the systems. The Gnostic regards our mundane world as a set of interrelated involutional systems, all gravitating toward eventual chaos. What protects these conventions from public exposure or repair is the psychological blindness of those participating. And as Duchamp wittily commented, there is a particular kind of erotic fulfillment attached to destroying art by making "new" art. Through similar means all historical cultures recapitulate their primal state by gradual but pleasurable self-destruction — in our case under the banner of "progress."

Traditionally in the West the serpent (Uroborus) is the symbol of cyclical social evolution where the skin of the animal signifies periodic rejection of material creation, in this case the arts and decorative acquisitions of culture. This dragonlike beast shown biting its tail embodies the realization that as societies become preoccupied with their own historical presence — in lieu of a sacred sense of the present — they descend into the "Sea of Darkness" or chaotic social condition. Gnosticism alludes to one inescapable fact: all culture is predicated upon more or less stable sets of myths; in fact, *culture is myth*. Myth in turn, as demonstrated by Structuralism, may be defined through the organization of language itself. For the Gnostic or Cabalist, *Logos* or the light or reason is the wellspring of language. "In the beginning was the Word and the Word was made flesh . . ." begins the Gospel of St. John, meaning that the consistencies of human language and cosmological organization are one and the same. Thus the act of telling or writing for the Cabalist becomes the means by which the inner structures of creativity are conveyed; as a result, meaning, syntax, and expression are equally means for conveying pneumatic truths. Duchamp's extraordinary use of puns and alliteration alludes to this fact.

The Platonic and Christian desire to find moral justification for human acts is alien to strict Gnosticism. In this light we might interpret Duchamp's legendary "indifference." The concepts of superior quality and moral preference imply alternatives. But for the Gnostic, "looking toward God" means assuming the rigorous impartiality of the Supreme Diety, rather than being obsessed with the enormous range of obligations, choices, and temptations that constantly try the virtue of a normally religious person. Hence, he harbors considerable amusement for the relativistic struggles encountered by those morally bound. The Gnostic either allows his psyche full corporal indulgence, or he stringently denies himself even the pleasure of resisting temptation. He views moral struggles as simply more games with shallow rules. Armed with a total command of the Truth, he leaps across centuries of "cosmic shells" (those manifestations of material and psychological bric-a-brac that consume the minds of most of us) toward intellectual communion with a god whose only *pneuma* is its absolute sense of neutrality. Human law is thus merely a reflection of human priorities: "Here we

have beyond the mere indifference of the 'subjectivist' argument and beyond the merely permissive privilege of freedom, a positive metaphysical interest in repudiating allegiance to all objective norms and thus a motive for their outright violation." [2]

We have in the above a partial explanation for Duchamp's avowed intention *to make every kind of art,* and beyond that to transcend all the permissible types for the temporal Roto–Reliefs and other sources of mechanization. Quite simply, if the secrets of the Cabala allow him to understand the permutations of the Hebrew letters used in creating every permissible form of art (or other semiotic), then his creation of the Ready-mades serves two purposes: first, he shows that "art" can be made in spite of all the canons of beauty, since art's concern with visual elegance is only superficial, not fundamentally cognitive; and second, Duchamp understands that art is created through emotional preferences and compensations on the part of the artist — by making *all* forms of art he reveals the Cabalist's ability to operate above human emotional dependency, thus virtually acting as a god.

In light of Duchamp's enormous self-discipline, one might still account for his erotic and alcoholic excesses during his early years in the United States by remembering two facts. For the Gnostic abstinence and indulgence hold the same meaning, or lack of meaning. Initiation into the hermetic arts is usually a matter of someone reaching full maturity in all senses of the word. Youth and possible neurosis would place a terrible burden on anyone who stumbled upon the hermetic keys. Nevertheless an "esthetics of indifference" also consists of asceticism or "freedom by nonuse." With Duchamp's sparce living and eating habits, his reluctance to own property, and for a long time his decision not to make art for profit, we have an example of self-imposed denial unparalleled in art. Moreover those who knew Duchamp well realized his personal shortcomings and understood that he had no taste for sainthood. Extremism is merely a perverse form of libertinism. However, it must be reiterated that Gnosticism destroys the craving for beauty as we understand it, the need to surround oneself with "surfaces" and reflections. This rejection stems from a higher commitment to natural balance and equilibrated organization, the essence of *Gnosis.* Thus for the Cabalist and Gnostic, "All ignorant ones are 'Egyptians'," and so Egypt remains the symbol of this world, the sphere of ignorance and bent ideals. On many levels Duchamp remained an artist and continued to play the artist's game. In daily contact with friends he "clothed himself in the afflictions of the world," and in outward form became an "Egyptian" himself.

Structuralism and its Relation to the Occult

If, as Claude Lévi-Strauss maintains, myths function phonetically at the most basic level of discourse, syntactically and semantically at the next level, and through unconscious cultural exchange at the highest level, then we will accept the possibility that Western art operates on the same premises. Perhaps human communication is structurally the same on all levels or, and this would be most unlikely, the human brain processes information by a number of alternate decoding processes. Nevertheless there are fundamental differences between visual and verbal communication. All writings and strings of spoken words subjected to linguistic analysis are considered ordered and finite texts. Stories recounted to anthropologists in their field work, sometimes second and third hand, are only partially ordered and provisionally fixed texts, since verbal myths undergo constant variation. Analytically, visual works of art should be considered unordered but finite texts. Because of the discrete consistency of verbal and written texts as opposed to the continuous quality of a picture plane, art works resist purely physical partitioning.

The linguist responsible for systematically segregating texts into contrasting and analogical components is Louis Hjelmslev. His *Prolegomena to a Theory of Language* attempts to extend the pioneering concepts of Ferdinand de Saussure so

that a true "algebra of signs" is possible in the analysis of sentence structure and larger texts.[3] While his "Glossamatic" techniques have not been sufficiently developed since his death, thus proving limited for contemporary linguists, their real value lies in a symmetry, elegance, and simplicity that except for the science of phonology is possibly unmatched in linguistics. This approach recognizes that languages consist of *content* (semantics and syntax) and *expression* (phonological analysis), both levels being connected through *commutation* (i.e., reciprocal relationships and analogies). These are also, it is this writer's contention, some of the secondary principles behind the methods of analysis which are the hermetic arts.

It would seem that the principle of double articulation which is integral to spoken language is just as vital to the organization of a picture with recognizable content. This also corresponds to the single most important law of occultism: "What is below is similar (NOT EQUAL) to what is above, and what is above is similar to what is below in order to insure the perpetuation of the miracle of the Unique Thing" — the Unique Thing being all forms of organic growth and morphogenesis, ranging from human life and human speech to the evolution of planetary systems. In other words, the code of nature maintains consistency and flexibility by repeating itself from one level to the next.

Yet a one-to-one relation between content and expression never exists, even when both planes are reduced to their smallest distinguishable components. Most important for linguistic distinction is the algebraic consistency between the signifieds and signifiers of the planes. To use Hjelmslev's words, "It turns out that the two sides (the planes) of a language have completely analogous categorical structure, a discovery that seems to us of far-reaching significance for an understanding of the structural principle of a language or in general of the 'essence' of a semiotic."[4] Hjelmslev continues by saying that it appears that such an analysis does not yield up "a syntax or science of the parts of speech,"

meaning, as we shall see, that such divisions do not make complete distinctions between syntactical, semantic, and phonological components, but tend to select from each according to the semiotic equation.

Within the past ten years "cognitive anthropology" has developed as a field for the purpose of defining culture in terms of linguistically connected conventions. Taxonomies, or conceptual categories, relate groups of things both hierarchically and by contrast. What is important within a particular environment not only defines the range and consistency of the taxonomies for a given language, it helps to establish semantic relationships.[5] In essence this means that words in a language possess value-functions rather than truth-functions. As Jerrold Katz states in *The Philosophy of Language*,[6] the reason logical empiricists failed in their analysis of natural language is that they mistook the rules of formal logic derived from metamathematics for the syntax of grammatical forms in natural language. But the difference between the two is fundamental and critical. Avoiding an involved explanation, the difference can be explained by observing that algebra and all other forms of mathematical logic are semiotic systems employing a *single level of articulation*. This means that a symbol in algebra can be assigned a single fixed meaning for all contexts. On the other hand, the signs employed in natural language (phrases, parts of speech, words, morphemes, etc.) are connected by a double system of oppositions (syntagmatic and paradigmatic partitioning on both the planes of content and expression) so that they normally possess a double articulation. Thus the taxonomic principle or language allows for shifts in the meaning of words according to contextual and positional arrangement. Doubly articulated systems, while more flexible and efficient than singly articulated systems, are accordingly more imprecise. But because human semiotic systems are graduated we can make art from one or both articulations. The "analogous categorical structure" mentioned by Hjelmslev assumes the following form.

SIGNIFIERS	SIGNIFIEDS	
Surface structure (the form of an art work's content)	*Deep structure* (the meaning and intention of an art work)	PLANE OF CONTENT
Phonetic analysis (description of the art-making process)	*Significant paradigmatic feature* (dominant formal convention of an art work)	PLANE OF EXPRESSION

In a sense these quaternary relationships provide the generative basis for the alchemical and cabalistic arts, being the elements Air, Fire, Water, and Earth. In part, the origins of modern chemistry were an attempt to rectify mistakes held by alchemists concerning the properties of physical substances and processes. Some of these false notions are simply literal interpretations of the correspondences between metaphysical symbols and their material equivalents. Essentially, alchemy was designed as a philosophy for the perfection of the human soul, a series of proscriptive processes that take the alchemical apprentice toward a clear comprehension of natural law. Duchamp was quite aware that occult methods have little to do with the vague and airy mysticism found in most popular books on the subject but instead demanded enormous concentration and mathematical ability — powers of analysis requiring mastery of obscure forms of knowledge, but which were nevertheless the key to the language-based cognitive systems that define human thought.

More importantly, the purpose of Duchamp's Ready-mades, and particularly *The Large Glass,* is re-creation of a path that looks into the future, outlining a certain trajectory for the fate of modern art and culture in general. In his first collection of notes, the *Box of 1914,* he writes:

A WORLD IN YELLOW

The Bridge of Volumes
On top of and under the volumes
In order to see pass the small passenger
 steamer[7]

In esoteric symbolism pure yellow is the color of illumination and intellectual penetration — it is also sometimes the color of alchemical AIR and EARTH. The word "bridge" often denotes the link between the earthly, mundane world and the world of the spirit. The "volumes" referred to are the particular arrangements of geometrical forms which help to define the powers of the Hebrew letters in cabalistic use. The bridge establishes a number of perspectives, both "on top of and under the volumes," defining art through its evolutionary stages. The term *"le bateau mouche"* (the small passenger steamer) also refers to a "beauty patch," Duchamp's ironic way of referring to any passing bit of cosmetics that would tend to enhance culture, such as a painting. In essence, *The Large Glass* defines the means by which the powers of the Hebrew letters may be established whereas the Ready-mades use the powers of the letters in producing art yet to be made.

The central idea of alchemy and Cabala revolves around the relationships between the four

primal elements: AIR, FIRE, WATER, and EARTH, with the fifth and quintessential element, AETHER, standing as the perfect fusion of the first four. All entities are thought to be combinations of these elements in varying proportions. Such transmutations are based on the "eternal principle" and are not the result of physical admixtures of the elements. A set of four contingent properties is situated between the elements: Wet, Hot, Dry, and Cold. Their function is to influence elements adjacent to each. For instance Heat may change WATER into vapor, thus making it a form of AIR. Or the Wetness of WATER has the power of dissolving EARTH. Also heat may drive the moisture out of AIR, making it ignite as FIRE.

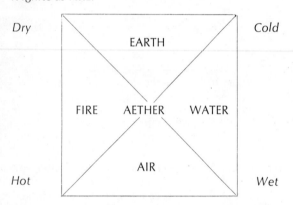

In the center of the diagram above there exists a fifth element referred to as AETHER or the UNIVERSAL LIGHT. Looked at from the side this configuration would appear to be a four-sided pyramid. The back of the Great Seal of the United States contains such a pyramid with an illuminated eye at its apex. This eye signifies the discovery that Duchamp made concerning the semiotic boundaries of art. Notice that only the front of the pyramid and a portion of the left side in shadow are seen. In the occult arts, right is the favored side and left is problematic and illusionary. However, left appears to be the past and right represents the unknown future. Life is represented by heat and dampness — prerequisites of mortal existence — while death is

defined by dryness and cold. Here it is helpful to return to the preface of the notes to *The Large Glass* where Duchamp inscribes:

> Given: 1. the waterfall
> 2. the illuminating gas [8]

As in the title of Duchamp's last major work, the enclosed tableau installed at the Philadelphia Museum, *Etant Donnés: 1. la chute d'eau 2. le gaz d'éclairage* (1946–1966), one is left with several clues to the ultimate determination of the four vital elements. Peering through the door of the *Etant Donnés,* one's eyes are fixed upon a reclining female nude holding a gas lamp in her left hand, her only completely visible limb. To her left in a wooded background is a motorized waterfall. In a sense the "illuminating gas" represents human enlightenment, the attainment of true wisdom through understanding the fusion of AIR and FIRE. The "waterfall" on the other hand is the steady pace of entropy as it operates in all natural systems, that is, WATER falling toward EARTH, or the effects of gravity. But the junction of AIR and WATER produces its own kind of precarious perfection. We might quote the great nineteenth-century hermeticist Eliphas Levi on the obscurity of these symbols: "One does not invent a dogma, one veils the truth, and a shade for weak eyes is produced . . . Analogy is the key to all secrets of Nature and the sole fundamental reason of all revelations." [9]

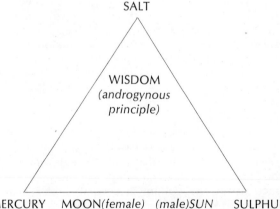

For the alchemist the triad above represents the wedding of the indestructible principles. Hence Sulphur, the fixed indrawing principle, utilizes FIRE and EARTH; Mercury, the volatile dispersing principle, unites WATER and AIR; while Salt is the necessary medium for conjoining Sulphur and Mercury, the union of soul and spirit through the body. Chemically, salt incorporates the octahedral and cubic structures that represent the elements of salt. Chlorine and sodium are both poisonous, and yet together they produce one of the chemical staples of all life. In alchemy Sol (sun) and Luna (moon) represent the King and Queen, those two polarities which spiritually merge in order to complete the alchemical process. This last process is facilitated by the use of the alchemical Salt, and it is here that one must not forget that in the 1950s Marcel Duchamp adopted the phonemic inversion of his name, *Marchand du sel* (merchant of salt), as the title for his published writings.[10] This lends credence to the possibility that the Ready-mades were, indeed, the Salt that Duchamp used and traded freely to those artists with the wisdom to understand their meaning.

It is enough to say here that the alchemical process or the progressive reduction of light within the sephiroth of the cabalistic Tree of Knowledge is, in essence, the permutative ordering of the four elements. Just as each sentence in speech or writing is made up of the four elements, each of the elements represents a dominent sentence type, and the four together define a chain of possibilities. These do not comprise the semiotic of human communication, but they suggest its trajectory.

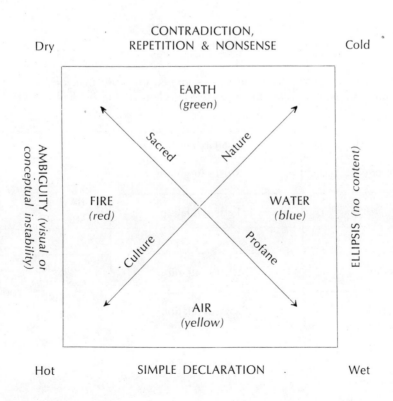

/77

Aside from the fact that various juxtapositions of the alchemical elements provided Duchamp with numerous in-jokes for the Ready-mades, the elements themselves suggest certain associations according to their alchemical characteristics. For instance EARTH connotes falsehood, evil, materiality and impenetrability; WATER is associated with creativity, emotionalism, intuition, death and eventual rest; AIR is related to the good, the spiritual, the essential and intellectually vital; while FIRE defines the formative principle, impulsiveness, life, constant motion, and instability. These attributes, however, are general; in different contexts the elements can undergo extreme changes.

Basically AIR refers to simple, unambiguous statements, similar to the previous diagram outlining the Planes of Content and Expression for text partition.

SIGNIFIER	SIGNIFIED	
Content	Artist's Intentions	PLANE OF CONTENT
Making process	Formal Relation	PLANE OF EXPRESSION

Sentences syntactically or semantically ambiguous resemble works of art that can be interpreted on more than one level; this is the moving element, the alchemical FIRE:

SIGNIFIER	SIGNIFIED		
Content	Artist's intention	PLANE OF CONTENT	1st Statement
Making process	Formal relation	PLANE OF EXPRESSION	
Content	Artist's intention	PLANE OF CONTENT	2nd Statement
Making process	Logical relation	PLANE OF EXPRESSION	

A third element, WATER, draws close in consistency to the finite, numerical nature of geometrical arrays, gnomons, and Gestalt configurations. It produces the conceptual underpinnings of vision and the basis for all abstract art. The peculiarity of WATER is that it is responsible for art in which subject matter is implicit in the semiotic description through a Plane of Denotation, but absent from the work itself and its Plane of Content. WATER provides the underlying formal basis of art.

SIGNIFIER	SIGNIFIED		
Description of Art	Metalanguage Explanation of Art		PLANE OF DENOTATION
			PLANE OF CONTENT
	Making process	Formal relation	PLANE OF EXPRESSION

For the hermeticist historical cultures are a series of permutative combinations of the four elements. Gradually, though, the first three elements — AIR, FIRE, and WATER — progressively lose their influence within the semiotic equation. Nevertheless, even at the lowest level of EARTH (which is, if seen in its proper context, the highest level) all the elements are present in some degree. For example, in 1958 Duchamp had a facsimile rendered of a metal sign which appeared in Parisian apartment buildings in the 1890s. It reads, "EAU & GAZ A TOUS LES ETAGES"(Water & Gas on Every Floor). As a good hermeticist, Duchamp is indicating that the structural equivalents of the *Waterfall* and the *Illuminating Gas* exist on every level of the Universe, from the most physical manifestation of being to psychic realms far beyond human imagination. Perhaps he is also implying that we are all temporary "boarders" in these universal dwellings.

Within the lore of cabalistic literature various permutations of the four elements represent *bound forms,* that is, they possess a mathematical and psychic cohesiveness that makes it impossible to separate or isolate the parts of language or artistic forms. This "principle of indeterminancy" is responsible for our feeling that true works of art are organically consistent, and beyond a certain point they completely evade rational analysis. The reasoning behind this is bound up with the "Measure of Light." Duchamp deals with this both in his *Large Glass* and in the smaller glass painting of 1918, *To Be Looked at (from the Other Side of the Glass) with One Eye, Close to, for Almost an Hour.*

Temporary loss of the Hebrew "Measure of Light" denotes cessation of historical momentum within culture; it is analogically equivalent to personal death, to dispersion of the corporeal body; and religiously, to the torments of Hell. Many of Duchamp's notes are allusions to this condition, and the Ready-mades specifically deal with art leading up to the darkness and art stemming out of that period. Cabalistically this last process is concerned with purification of mineral matter, those physical compositions most resistant to change. Color changes are induced toward the goal of complete transparency, that is, the consistency of glass. In this respect the picture planes of Duchamp's two glass paintings are key clues. The notion of vitreous firing with absolute purification in mind, and thus comprehension, is perhaps best brought out in this particular note:

The question of shop windows
To undergo the interrogation of shop windows
The exigency of the shop window
The shop window proof of the existence of the outside world
When one undergoes the examination of the shop window, one also pronounces one's own sentence. In fact, one's own choice is "round trip." From the demands of the shop windows, from the inevitable response to shop windows my choice is determined.
No obstinacy, ad absurdum, of hiding the coition through the glass pane with one or many objects of the shop window. The penalty consists in cutting the pane and in feeling regret as soon as possession in consummated.

Q.E.D.[11]

Duchamp ends his observations with the abbreviation for *quod erat demonstratum,* a term applied in mathematical and logical assertions meaning *which was to be shown* or *demonstrated,* indicating that the Ready-mades are a demonstration of various esthetic and cognitive principles. One must begin by remembering that the word in French for "shop windows" is *vitrine,* also meaning glass or showcase. Rather than using words for the window that imply an opening to be seen through rather than walked through, the actual existence of an intermediate, transparent barrier between the artist and the objects behind the window pane goes to the very heart of cabalistic wisdom. Art, in fact all historical culture, is a mechanism for sustaining *images* (mythic succession) where the true realities lie beyond, visibly apparent and waiting.

Not only do shop windows embody the artistic convention of the picture plane, but as Michel Foucault points out in his analysis of Velasquez's *Las Meninas,*[12] what transpire both behind and in front of the picture plane are mutually inferential. Hence the artist's understanding of the external situation, vis-a-vis history, critically affects the construction of pictorial space — one follows from the other. By examining the goods within the shop window, the artist unknowingly creates the shop window, and in doing so, he "pronounces [his] own sentence." As in English, the French *sentence* has the double meaning of a prison term and a group of words with a subject and predicate. By creating a "shop window" the artist, in effect, creates a style of artistic "seeing," and his vision, regardless of his choice, is semiotically circular. Duchamp further compares the act of artistic synthesis with that of sexual union — a very common alchemical concept, as all forms of cognitive synthesis are forms of *coition.* That Eros is the instigator of all human culture is one of Duchamp's constant themes. But only then does he admit that there are certain drawbacks to comprehending the ultimate artistic meaning of "shop windows." One substitutes a greater intellectual and spiritual synthesis for the sexual pleasures of artistic creativity, and in so doing: "The penalty consists in cutting the pane and in feeling regret as soon as possession is consummated."

In a real way the consistency of cabalistic EARTH represents the stage initiating the penetration of the "shop windows." Such "shop windows" always represent the most important artistic conventions for maintaining illusion i.e., the picture plane, tonality in music, rhyme and meter in poetry, and the stage in theater. As each moves closer to destruction through progressive historical subtraction of conventions, its art becomes entirely "liberated" and made free to operate in everyday life — and yet this same liberation from the most fundamental conventions induces a sense of meaninglessness in all attempts to exert esthetic judgment. What is more, the Ready-mades present art with a fundamental paradox. How can everyday objects, some joined to others or slightly altered, qualify as art? By 1912 Duchamp discovered that at a certain point in cultural evolution the simple juxtaposition of qualities within an object, rather than the object's conformance within a historical pattern, would qualify it as an art object. Such juxtapositions of qualities and attributes may be described with the aid of a rather simple drawing of circles called a Venn Diagram.

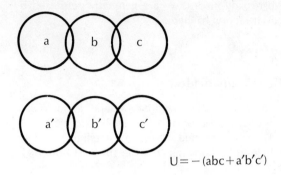

$$U = -(abc + a'b'c')$$

Each set of circles in the above diagram represents three intersecting classes, that is, three qualities or properties of an object sharing one or more features in common. It is the nature of the cabalistic EARTH that there be at least two sets for a given art object. The two sets may intersect or recombine in a given number of ways. The rectangle surrounding the two sets is defined as "U" or the "Universe of Discourse," or whatever is *not* in abc and a'b'c' but within the conceptual area under examination, in this instance the art work itself. The sets of circles unite color and numerical progressions, similar properties in different objects, mediated polarities, conceptual relationships, and logical contradictions. These logic modes represent the residue of AIR, FIRE, and WATER in EARTH; they communicate linguistically but not "grammatically" in the sense of fine art.

In his conversation with Pierre Cabanne, Duchamp notes that it was not until 1915 that he expropriated the term *ready-made* because it seemed to him "interesting." We know that for several years between 1908 and 1914 Duchamp was occupied with petty jobs that insured survival with a minimum of effort. As a library clerk Duchamp read omnivorously: anthropology, philology, linguistics, and literature are a few of the fields that occupied his time. Since the linguist Ferdinand de Saussure published from the late 1870s, it is altogether possible that Duchamp discovered the term *"locutions toutes faites,"* meaning "ready-made utterances," in one of Saussure's articles. Albert Sechehaye and Charles Bally did not present their teacher's notes in the form of the *Course in General Linguistics* until 1916, but some of Saussure's articles on the ethnological origins of language and language's relation to chess would have been of vast interest to Duchamp.

Saussure's "ready-made utterances" refer to idiomatic expressions which lack the structure of a sentence but are nevertheless *"unanalysable wholes." Rest in peace* or *how do you do* are ready-mades, as are *good-bye* and *good morning.* Language ready-mades, unlike grammatical sentences, are only contextually logical; standing alone they make no sense. Yet they mediate stock situations by employing conventional forms. The linguist John Lyons admits that ready-mades seem to have a behaviorist origin since they signify the acting out of fixed parts in socially prescribed rituals. However Lyons takes exception to B. Malinowski's assertion that the communication of information is one of the more specialized functions of language, that even the expression of commands, hopes, and emotions does not convey the purpose of ready-made phrases. As Malinowski proposes, those phrases serve as "phatic communion": they remain a way of establishing and maintaining "social solidarity and well-being." Anthropologically, one might make a case for the possibility that many human activities and biological functions have ultimate mythic-linguistic significance within the neurological assembly. All tools, objects, and utensils become, in effect, liturgical implements, and hence art objects serving useful functions in normalizing ritual. Ready-mades are in fact ordinary objects with overlays of meaning. Duchamp realized that many of these primal associations reach far back into the subconscious mind; so that given the commonness of

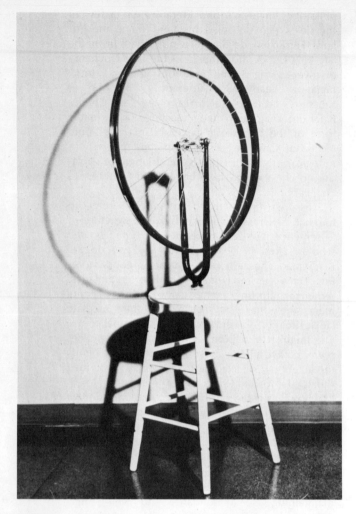

1. Marcel Duchamp, *Bicycle Wheel,* 1951, third version after
lost original of 1913. The Sidney and Harriet Janis Collection.
Gift to The Museum of Modern Art, New York.

most ready-mades, we are generally perplexed by
our attraction to them.

The 'Ready-mades'

At this point it would be useful to look at a
few of the Ready-mades. A classic, *Bicycle Wheel*
(1913) remains one of the most enigmatic. One
is helped by knowing that the simplest nonobjec-
tive art — art just preceding the Ready-mades —
depends heavily upon all forms of symmetry,
numerical series, randomness, gravity, and iner-
tia. Some of the Ready-mades are meant to be
transitional, since they possess both formal at-
tributes and the conceptual properties of ready-
mades. A 1951 version of the *Bicycle Wheel* was
eventually dated and signed with green ink — an
indication that it inhabits the region of EARTH.
In conversations with Arturo Schwarz, Duchamp
emphasized the chance aspect of this "assisted
ready-made" — which is both misleading and
helpful. On one level, inertia plays a part since
the inverted bicycle wheel may be spun by
hand, being one of the first kinetic sculptures.
But a contradiction of functions is also present.
In philosophy one encounters "analytic" and
"synthetic" propositions. Briefly, synthetic sen-
tences are statements whose truth is contingent
on facts or conditions external to the sentence
itself. Analytic sentences are true by virtue of
their internal consistency. In the statement *All
bachelors are married men,* for example, the two
terms *bachelors* and *married men* are mutually
exclusive; therefore the sentence is semantically
false. By definition a kitchen stool is something
to sit on, while a bicycle wheel moves along the
ground supporting the weight of a rider. But
inverted and joined, the seating function of both
objects is nullified. Moreover, the *Bicycle Wheel*
contains several other allusions that are purely
cabalistic. The cabalistic universe consists of
three concentric wheels spinning at right angles

to each other. The outer wheel is AIR, the element of merger and chance. Duchamp, to show this, has simply removed the pneumatic tire from the rim of the bicycle wheel. Also the historical trajectory of art in Cabala is made possible by the powers of the King's Throne and the powers of his Chariot. By nullifying both, Duchamp proclaims the final forces of EARTH.

The *Bottle Dryer* of 1914 was Duchamp's first pure Ready-made. Alternately entitled a *Bottle Drainer*, *Bottle Rack*, and *Hedge-Hog*, this piece was selected by Duchamp without the addition of other items or alterations. Essentially this object appears to be a work of "open" abstract sculpture, a symmetrical form that could have been made by some artist anywhere from the 1920s to the late 1960s. But in titling it by its literal designation "Bottle Dryer," Duchamp was simply reinforcing an internal contradiction already established in many viewers' minds. These facts simply define its claim to be called art. But Duchamp's appellation of "hedgehog" for this restaurant appliance runs somewhat deeper. In an essay by Isaiah Berlin there is a comment on a line written by the Greek poet Archilochus, ". . . 'mark one of the deepest differences which divides writers and thinkers, and, it may be, human beings in general.' The one type, 'the fox,' consists of men who live by ideas scattered and often unrelated to one another. But the man of the other type, the 'hedgehog,' relates 'everything to a central vision, one system more or less coherent or articulate . . . a single, universal, organizing principle . . .'"[13] Not only does this appliance resemble a hedgehog, apparently it suggests a unified vision.

In *A Dictionary of Symbols* the Spanish writer J. E. Cirlot says of the Ready-mades that "[Duchamp] . . . showed that it was possible to see in a bottle-stand, for instance, the very mystical structure that governed the gothic spires rising in the form of a cage, or the lamps in Islamic mosques with their multiple descending hoops; and that the foregoing are related to the hollow

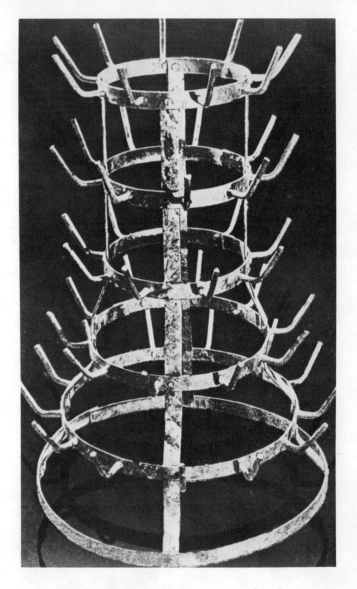

2. Marcel Duchamp, *Bottle Dryer*, 1914. From *Marcel Duchamp* by Robert Lebel © Trianon Press.

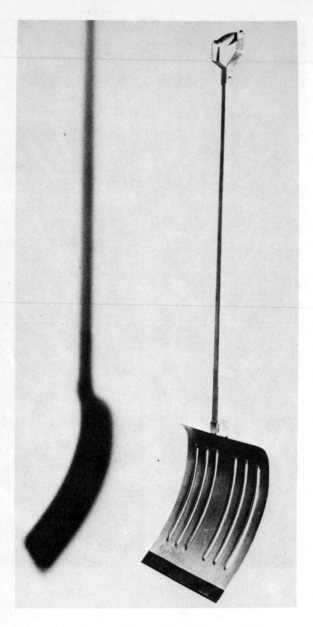

3. Marcel Duchamp, *In Advance of a Broken Arm*, 1915.

pyramid of the Primitives. . . ."[11] What is more, the *Bottle Dryer* resembles some engravings of the alchemist's oven or athanor. It is in fact a miniature representation of the alchemical universe. Its hollow, circular center creates a womb where the transmutations of life take place. Around the periphery of the circular hoops are mounted erect phallic-shaped pins holding the wine bottles. These pins are the cabalistic *Yods* or male elements of the Tree of Knowledge. All this is another way of indicating that energy is male, but the substance and physical space of the universe are female. Even the literal function of the *Bottle Dryer* recapitulates the processes of EARTH-ly purification. Wine (FIRE) is emptied from the bottles, the bottles are washed in WATER and turned upside down to dry (AIR), leaving a hollow, transparent container to be refilled. The best Ready-mades are the most symbolically evocative.

A baffling work is Duchamp's suspended snow shovel, *In Advance of a Broken Arm* (1915). When Duchamp was questioned about hanging certain Ready-mades from the ceiling, he usually made the excuse that he was tired of seeing sculptures always situated on pedestals. Hanging or apparent suspension is a function of gravity. Hence it not only anticipates the fate of all nonobjective art, it also alludes to the role of the Hanged Man, a Tarot card playing an essential part in the illusionary aspects of nonobjective art. Secondly, the shovel is usually shown with its shadow cast by a strong light. This produces the set: *light source — shovel — shadow*. The shadow refers to the *opaque* and spiritually murky consistency of the shovel, a symmetrical object. Fairly frequently in Duchamp's symbology the idea of ice, snow, and freezing arises. In cabalistic terms these allude to the nature corner of the semiotic pyramid, the conjunction of WATER and EARTH that produces Cold. Snow and freezing come with the gradual disintegration of nonobjective art. In occult terminology a *fracture* indicates the final breakup of a unified whole, sometimes connoting a way out. The "Broken Arm" in this case may mean the termination of the element

WATER on the mystical cross. Therefore the shovel acts as a cultural forewarning.

By far one of the most sophisticated of the semi–Ready-mades is *Why Not Sneeze, Rose Selavy?* (1921). This is not an easy work to analyze because it alludes to certain ideas unrelated to its physical consistency. The title is a nonsense sentence since there is an inherent contradiction in asking a person to commit an involuntary action such as sneezing. So the structure again is EARTH with an admixture of WATER. Hence we have several sets referring to classes outside the Universe of Discourse. An ancient tradition also connects the cabalistic Tree to the process of breathing. Nonobjective art represents the final phases of inhalation or filling the lungs with air.

4. Marcel Duchamp, *Why Not Sneeze/Rose Selavy?,* 1921. Philadelphia Museum of Art: The Louise and Walter Arensberg Collection.

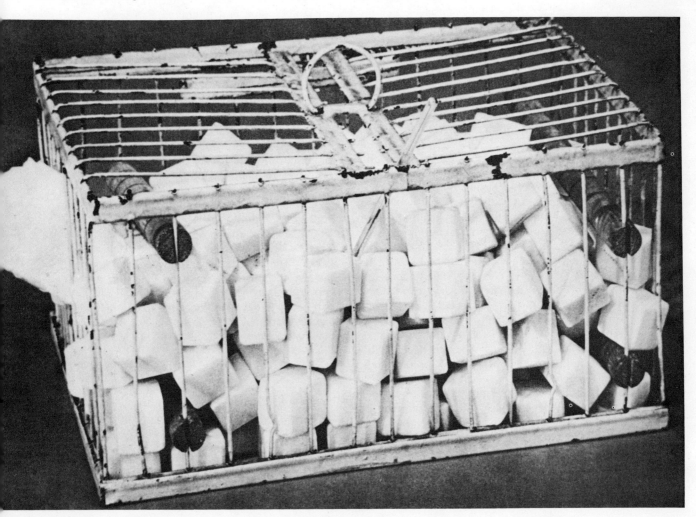

So that the involuntary act of sneezing is a release of inward tension and the expelling of air and moisture from the nasal passages and mouth. These droplets of liquid from the mouth are one symbol of the cabalistic EARTH.

Much has been made of the fact that the bird cage contains 152 sugar cubes which were actually carved of marble especially for the Ready-made. This deception plus the number of cubes comprise two sets. Duchamp has stressed the differences between the weights and heat coefficients of sugar and marble. These are important clues, but they should not be taken in the sense of mere discrepancies. The false sugar cubes in the bird cage are absurd by themselves. But the cage contains two other items: a French rectal thermometer and a cuttlebone. All of the objects together form a series of connected sets and they function by virtue of the cage's excluded occupant. Not infrequently in alchemical and surrealist literature there are references or pictures of a bird cage; the empty cage symbolizes the missing dove, the Holy Spirit or WATER in its full meaning.

It is necessary to know that a cuttlebone, the hardened skeleton of a cuttlefish, is used as a mineral supplement for the bird's diet. Thus various intersections between classes become evident. First, the cuttlebone is composed of minerals — just as the marble cubes are essentially limestone. However, the cuttlebone is organic matter which has assumed the consistency of mineral matter, just as the sugar cubes are not really food but cut stone. Such a set relationship is considered "interconnected," since there is symmetry and circularity to it. Secondly, the rectal thermometer — in spite of Duchamp's suggestion — does not measure the heat of the sugar (marble) cubes, which are approximately room temperature, but rather it is meant to measure the body heat of the missing bird. Again, the resulting "coldness," which Duchamp refers to in conversation with Arturo Schwarz, is the corner of the Great Pyramid between WATER and EARTH. For reasons too complex to explain in this essay, *Why Not Sneeze, Rrose Selavy?* makes allusions to a critical stage in high-energy physics, mirroring the alchemical process. One might add that the Rrose Selavy (*eros c'est la vie*) was the artist's alter-identity and a neologism for Rose-Cross, symbol of the great synthesis, the alchemical androgyne, that which will bring about the culmination of the alchemical process.

Perhaps it is best to end this critique of the Ready-mades by referring to one of the simplest items, the work of a young friend of Duchamp's during his early years in the United States, the Dadaist Morton Shamberg. Shamberg's Ready-made *God* (1918) is now installed with many of Duchamp's works in the Arensberg Collection of the Philadelphia Museum. It consists of a length of copper pipe and plumbing trap wedged into a simple carpenter's mitre box. Along with its unusual and irreverent title, this work symbolizes the Christian Holy Trinity: the Father, the Son, and the Holy Ghost. The mitre box, of course, expresses Christ's early profession; the copper pipes allude to water which sometimes is used to represent the Holy Ghost; the Father is, of course, the title, *God*. Other analogies can be made. For instance, the *wooden* cross and the *metal* pipes correspond to the last two parts of the triplicity: Animal, Vegetable, and Mineral. Also the Christian Trinity is comparable to the cabalistic Great Unmanifest: Ain, Ain Soph, and Ain Soph Aur, that is, the Unknowable (God), the Limitlessness or spatial infinite (Son), and the Enlightened Limitlessness or Infinite Light (Holy Ghost). The Son mediates between the first and the last because he is capable of spiritual growth and of exerting love. God in Cabala and in Christian eschatology has no palpable origin, but reaches out of the Unknown like words with no material signifier.

Marcel Duchamp in an interview with James Johnson Sweeney:
". . . art is produced by a succession of individuals expressing themselves; it is not a question of progress. Progress is merely an enormous pretension on our part. There was no progress for example in Corot over Phidias. And "abstract" and "naturalistic" is merely a fashionable form of talking — today. It is no problem: an abstract painting may not look at all abstract in fifty years." [15]

5. Morton Schamberg (assisted in construction by Elsa von Freytag Loringhoven), *God*, 1918.
Philadelphia Museum of Art: The Louise and Walter Arensberg Collection.

1. Cabanne, Pierre, *Dialogues with Marcel Duchamp* (translated from the French by Ron Padgett), New York: The Viking Press, 1971, p. 48
2. Jonas, Hans, *The Gnostic Religion*, Beacon Press, Boston, 1958, p. 273
3. Hjelmslev, Louis, *Prolegomena to a Theory of Language* (1943) (translated by Francis J. Whitfield), Madison, Milwaukee, and London: The University of Wisconsin Press, 1969
4. Hjelmslev, *op. cit.*, p. 101
5. Tyler, Stephen A., *Cognitive Anthropology* (Stephen A. Tyler, ed.), New York: Holt, Rinehart, and Winston, Inc., 1969, pp. 1–23
6. Katz, Jerrold, *The Philosophy of Language*, New York: Harper & Row, 1966, pp. 15–68
7. Duchamp, Marcel, *Marchand du sel*, (Michel Sanouillet, ed.), Paris: Le Terrain Vague, 1958, p. 31
8. Duchamp, Marcel, *The Bride Stripped Bare by Her Bachelors, Even* (typography by Richard Hamilton and translation by George Heard Hamilton), New York: George Wittenborn, Inc. (no page numbers)
9. Levi, Eliphas, *Transcendental Magic* (1896) (translation by Arthur Edward Waite), New York: Samuel Weiser, Inc., 1970, p. 180
10. Duchamp, *Marchand du Sel op. cit.*, 1958
11. Duchamp, Marcel, *A l'infinitif* (1912–1920), New York: Cordier & Ekstrom, Inc., n.d., p. 5
12. Foucault, Michel, *The Order of Things (Les mots and les choses)* (1966), New York: Pantheon Books, 1970, pp. 3–16
13. Redfield, Robert, "Thinker and Intellectual in Primitive Society" in *Primitive Views of the World* (1960) (Stanley Diamond, ed.), New York and London: Columbia University Press, 1969, pp. 34–35
14. Cirlot, J. E., *A Dictionary of Symbols* (1962) (translated from the Spanish by Jack Sage), New York: Philosophical Library Inc., 1971, p. 239
15. Duchamp, *Marchand du Sel op. cit.*, 1958, p. 109
 The Fool, first Key to the Major Arcana of Tarot, from the *Rider Deck* by Arthur Edward Waite and drawn by Pamela Coleman Smith.

1971-1973

DUCHAMP'S BRIDE STRIPPED BARE:
The Meaning of the "Large Glass"

In the summer of 1912, Marcel Duchamp began to prepare the *Large Glass* as a predictive device designed to chronicle all the final stages of art. At the time, this would involve all the movements of nonobjective art and those of its elemental-material sequels. Like a proper hermeticist, the artist prepared the *Glass* with several covering ruses, the most popular of which is the idea that the *Glass* portrays modern unrequited sexuality and mechanical sexuality. Indirectly, both themes have their place in the *Glass* and Duchamp never went out of his way to correct critics with fertile imaginations. The aim of every skilled hermeticist is not to lie, but to veil his messages in themes so obscure or universal that the possibility of a true identity is never apparent to the public.

The *Glass*'s bipartite structure reiterates the single most important law of occultism: from the Emerald Tables of Hermes Trismegistus one reads, "What is below is similar (NOT EQUAL) to what is above, and what is above is similar to what is below in order to insure the perpetuation of the miracle of the Unique Thing." This axiom is mirrored in the division Duchamp makes in the title of his work which appears on the reverse side of the Chocolate Grinder: LA MARIEE MISE A NU PAR / SES CELIBATAIRES, MEME / MARCEL DUCHAMP / 1915-1923 /. . . inachevé / . . . cassé 1931 /. . . réparé 1936.

The entire message of the *Glass* is encapsulated in the numerology of the title. The sum of letters up to the first slash, *La marieé mise à nu par*, is eighteen. While the section after, *ses celibataires, même*, adds up to nineteen. Eighteen reflects the eighteenth Arcanum of the Tarot, The Moon, which governs the period of complete decay. Since the Moon is female and controls the power for the forces of WATER, Duchamp attaches his Arcanum to the Bride. Nineteen, on the other hand, signifies the first physical beginnings of regeneration through the male Sun. If the Bachelors are the cause of all the trouble, they will also help overcome it. The additional and seemingly superfluous *même* at the end of the title could mean same, even, themselves, or possibly, as Ulf Linde suggests, be a verbal pun changing *même* to *m'aime*. It implies that what happens in the Bride's area is recapitulated by the Bachelors' Mechanisms. *Même* also contains four letters in sets of two, not unlike the male-female repetition found in the Hebrew letters of the Tetragrammaton. As a principle of cognition, *même* 'completes' the Bachelors, bringing their number from fifteen, the key of the Devil, to nineteen and redemption.

In Gnosticism and the Tarot, two key words addressed to the number nine are horizon and ocean. The ocean represents chaos, disunity and contrasting elements, while the horizon acts as the infinite boundary separating chaos from the unity of the sky (see the artist's *Handmade Stereopticon Slides* of 1918-1919). So the *Glass* contains a horizon line in the three Gilled Cooler fins suggested by glass strips. Symbolically this middle

1. Marcel Duchamp, *The Bride
Stripped Bare by Her Bachelors,
Even*, 1915–1923. Philadelphia
Museum of Art: Bequest of
Katherine S. Dreier.

2. *The Fool*, first Key to the Major Arcana of Tarot, from *The Rider Deck* by Arthur Edward Waite and drawn by Pamela Coleman Smith.

THE FOOL.

region makes possible the hermaphroditic association of the female and male panels: in hermetic systems this is described as unity above and division below. Within the *Glass* this separation of qualities is both relative and absolute. On the level of art-making, division implies all discrete psychological and historical mechanisms responsible for art; unity in the Bride's domain depicts the unified consistency of nature. Its antithesis is "The World of Forms," i.e., the Bachelors' Odyssey. On the level of spiritual attainment, the Bride's union with the Bachelor reresents total cultural oneness — the goal of the esoteric foundations of all religion.[1]

In order to view Duchamp's *magnum opus* in the largest perspective, it will help to restate its message in a description taken from Tantric Buddhism:

Image an illimitable ocean in which there are innumerable vials. Each vial is filled with sea-water belonging to that very ocean and each is composed of a substance that gradually thickens or dissolves in response to circumstances. Under suitable conditions it dissolves altogether, whereupon the water it contains becomes indistinguishable from the rest of the ocean. Not one drop of water ceases to exist; all that is lost is its apparent separateness. In this analogy, the water in each vial represents a so-called individual being and the gradually thickening or dissolving vial symbolizes his mental and physical characteristics . . .[2]

In quite the same way, the bottom half of the Glass is an illusionary version of the top half; but even this is more complex than it seems.

When in his notes Duchamp depicts the *Glass* as an "Agricultural Machine" or an "Apparatus . . . instrument for farming," he refers to one of the crucial properties of hermetic FIRE. In alchemical terms, FIRE represents the lesser sacred element. It signifies the constant refocusing of attention on the opposing forces which make life possible. As Claude Lévi-Strauss and Emile Durkheim have indicated, the sacred in part constitutes what is crucial but inescapably ambiguous to the welfare of a culture, that is, perpetual cognizance of the natural dichotomies (life and death, abundance and famine, hot and cold, etc.).

On the other hand, AETHER necessitates supreme awareness of culture as a mythic system *par excellence*. No writing, no public art, no commercial enterprise, or making art is without its subconscious significance as a sacred performance. Ideally, culture exists with this knowledge intact. Every relation becomes a symbolic act of religious expression, a sign of a pervasive set of holy truths. All AETHER (*Yod-Hé-Vau-Hé* / *Elohainu* / *Yod-Hé-Vau Hé*) involves a two-part consistency: the first is recognition and instigation of some sacred truth concerning the unalterable order of the Universe; the second involves the eventual fulfillment of this cognition by naturally assisted occupations. Consequently procreation, husbandry, baking, agriculture, and wine-making are a few of the activities possessing a sacred nature; in the same sense as sacred myth, they recapitulate the symbiosis of human impulse (*Yod*) joined with the fecundating impulse of Nature (the second *Yod*). The two *Yods* are complimented by the two *Hé's* of materialization. Duchamp alludes to this basic cycle. His "delay in glass" is simply the time period between depicting the natural fate which will befall nonobjective art, and its inevitable enactment by artists in years to come. Just so, the farmer plants seed so his crop will grow to be harvested.

Visual Perspective in the Bride and Bachelor Machine

Prefatory to the iconography of the *Glass*, there must be some understanding of the graphic modes employed by Duchamp. Here again, the artist gives us a lesson on the nature of cultural delusions. *Ars perspectiva* derives from the Latin verb *perspicere*, meaning "to examine," "to see clearly," "to see through," and "to regard mentally." Duchamp understood Renaissance perspective as a pyramid with its apex at the observer's eye, truncated by the canvas or picture plane which acts as a transparent window. The fact that perspective suggests mirror reflection led to a

metaphysical idiom, also incorporated in the *Glass,* which circumscribes the particular cosmology involved in seeing evidences of God in terms of finite, rectilinear, and relational space. Not until Erwin Panofsky's illuminating article of 1924, *Perspective as 'Symbolic Form,'* was it evident that the conventions of perspective are in significant disagreement with the physiology of vision. Duchamp grasped this as early as 1913. One of the illusions of perspective rests on the assumption that depth in relation to a point of view presupposes a "psychic distance" from the scene depicted. In occult terms this "psychic distance" reflects human alienation, major symptoms of which are rationalism and value-free science raised to guiding principles. So in the hermetic scheme followed by Duchamp, the notion of feeling the presence of God in an icon is vastly inferior to sensing the presence of God in everything — just as witnessing the presence of God in perspective is a degraded form of iconization. The "point of view" presupposes, as Panofsky understood, the fiction of two separate egos: God's and the human beholder's.[3] Hence, as strict reliance on geometric perspective was gradually undermined through the seventeenth and ensuing centuries, there appeared with that "involution" an opportunity to rectify the delusions of a millennium.

The schema which Duchamp maintains throughout the *Glass* is contained in an introductory note for the Bachelor Machine:

> The *principal* forms of the Bachelor Machine are imperfect: rectangle, circle, parallelepiped, symmetrical handle, demi-sphere = i.e. they are mensurable (relation of their dimensions among themselves, and relation of these principal forms to their destination in the Bachelor Machine). In the Bride, the *principal forms* are *more or less large or small,* have no longer, in relation to their destination a mensurability: a sphere, in the Bride will be of some radius or other (the radius given in the representation is fictitious and dotted).[4]

The differences elaborated in the above description may be summarized as the attributes of a picture with perspective (the Bachelor Machine) and as those of a picture without perspective (the Bride). In the first everything conforms to an internal system of measurement; hence perspective implies a doubly articulated system, forms and colors regulated by a visual syntax.[5] The forms of the Bride are just as elaborately described by Duchamp in his notes, but they conform to no system of measurement or perspective; he remains quite clear about that. Consequently, the Bride implies all the attributes of perspective, i.e., internal consistency, spatial depth, modeling, and separation, but in reality none of these qualities is present. The Bride is a singly articulated system of forms and colors without a true visual syntax; its virtual syntax is implied from various three-dimensional circumstances attributed by the artist, just as the real syntax of the Bachelor Machine is implied through the perception of four-dimensional activities to be carried out in real time.

In terms of spatial organization the *Glass* stresses the occult theme of unity above and division below. All of the forms of the Bachelor Machine focus in one-point perspective on a point exactly in the center of the three glass parting strips. The Bride section is virtually free of perspective. In effect, the rear of the *Glass* forms a hypothetical half-pyramid. The Gilled Cooler or isolating plates act as a psychical horizon line, one that separates forms in the occult and visual sense.

The Cabalistic Tree of Life (or Tree of Knowledge)

The mechanisms of the Bachelor Machine, and their interrelations, are principally an interpretation of the cabalistic Tree of Knowledge as the secret unwritten Cabala describes the evolution of art. Frequently the *sephiroth* of the Tree and their paths are supplemented with imagery borrowed from the Arcana of the Tarot.

The extremely deceptive structure referred to as the Tree of Knowledge commands a central position in the Judaic hermetic tradition. Within the past thousand years, hundreds of books and

charts have been written on this single diagram which is reputed to contain all the important structures and sequences of human existence. The system of *sephiroth* (*sephira* being the singular) is based on the primary, androgynous manifestation called Kether. Kether represents the highest cosmic abstraction, the One Light, or what one might call in Christian terminology, the Godhead. As a fusion of 1 and 0, Kether defines being and nonbeing, self and selflessness together. This first manifestation is matched by two other members, one positive and one negative, which make up the Supernal Triad. The superior Ternary is twice reflected in two inverted triads, and finally manifested in a single *sephira* called Malkuth. To the right of Kether stands Chocmah, or wisdom, the positive manifestation of the illusion of Self, personified as change in stability. To the left of Chocmah stands Binah (understanding), the negation of Self and vehicle of sorrowful realization through unstable change. Because of its generative function, the Supernal Triad is referred to as the World of Emanations.

Directly below it resides the World of Creations where we encounter the first active *sephira*, Chesed (Grace and Charity), reflecting a desire for knowledge in Chocmah. Chesed is considered to be paternal and authoritative. To Chesed's left stands Geburah (Severity and Strength) deriving the quality of Endurance from Binah above. Just as Kether combines the qualities of Binah and Chocmah, Tiphereth (Beauty and Harmony) joins Chesed and Geburah so that they are neutralized (the process of neutralization involves borrowing some qualities from two or more related sources so that a synthetic result substitutes for the originals; neutralization is the essence of significant change as it occurs in the second articulation of all semiotic systems; it is also the mechanism of the Hegelian synthesis).

The second reflection of the Supernal Triad is called the World of Forms, since it deals with the purely formal manifestations of all systems. Netzah represents the forward thrust of Victory over the stability and perfection of Tiphereth. To its right stand Hod (Glory or Peace), the emissary of life without movement, an apparent con-

tradition. Their synthesis in the *sephira* Yesod (Foundation) is transitional since it signifies stability in change. Directly below Yesod lies Malkuth (Kingdom), the World of Objects or Relative Reality. Unadulterated materialism is finally reached through Malkuth.

The ten *sephiroth* are represented as a five-part family divided into upper and lower planes.

Macroprozopos:
 (I) Kether (1) — The Upper Androgyne
 (II) Chocmah (2) — Father
 (III) Binah (3) — Mother

Microprozopos:
 (IV) Chesed (4), Geburah (5), Tiphereth (6), Netzah (7), Hod (8), Yesod (9) — The Children of the Macroprozopos and the Lower Androgyne
 (V) Malkuth (10) — The *Bride* of the Microprozopos

This basic structure is redivided into four different sephirothic trees or worlds, entitled respectively the Atziluthic World, the Briatic World, the Yetziratic World, and finally the World of Assiah. Presently, we are living at the very end, in fact, the completion of the tenth sphere of the Assiahic World. Outwardly, these four superordinate Worlds represent the transition from complete integration and implicit belief in a single cabalistic Godhead, the source of all earthly structures, to the most extreme depletion of spiritual values, resulting in absolute materialism. The four sephirothic worlds define the stability of a culture at any period in its development. The more monolithic and tightly bound its mythic structures remain, the closer a culture comes to perfect self-knowledge about the nature and validity of its own beliefs. In theory, complete knowledge allows total personal freedom. Moralities, religious doctrines and legalisms denote states of less than perfect knowledge. One of the three great books of cabalistic interpretation, the *Sepher ha Zohar*, speaks of the "garments," or logical rules and

THE QABBALISTIC SCHEME OF THE FOUR WORLDS.

3. The Qabbalistic Scheme of the Four Worlds, from *The Secret Teachings of All Ages* by Manly Palmer Hall, Philosophical Research Society, Inc., Los Angeles.
The diagram above represents the divisions between the four Sephirothic Trees as they are revealed in forty concentric circles. Each of the four trees with its ten subdivisions discloses the organization of the hierarchies controlling the destinies of all creation. The trees are the same in each of the four worlds, but the powers vested in the globes express themselves differently through the substances of each world, resulting in endless differentiation. X1, X2, and X3 respectively denote Ain, Ain Soph, and Ain Soph Aur. Ain Soph constantly encloses upon itself, thus producing what is called the "primitive dot." This dot encloses all the emanations from A1 to D10. A1 controls the powers of the 39 rings located within it, just as each ring controls a decreasing degree of power within the Sephirothic Worlds. As the greatest spiritual solidarity, or permanence, is at the circumference of the circles and the greatest material density, or impermanence, is at the center of the diagram, the rings as they decrease in power become more material and substantial until the center sphere D10 symbolizes the actual four chemical elements of the earth.

/95

allusions, visible to every man in reading the Cabala. Of course more meaningful than the garments is spiritual comprehension of the underlying code. This can be gained in one of two ways: either through intellectual perseverance tempered by the necessary mental attitudes, or through realization precipitated through the eventual self-destruction of the sephirothic worlds. Thus the Cabalistic Bride is unadulterated materialism, brought about by the gradual decay of existing mythic structures which bind culture together.[6] *Stripping the Bride* symbolizes the gradual transition towards materialism. This in turn forces a traumatic acceptance of the fact that myth is an indispensable ingredient of culture. Central to every hermetic philosophy stands the realization that cultures cannot exist without myths; consequently the message of the Cabala and gnostic thought is an understanding of the continuity between human cognition and all natural creation.

Within the scope of the gnostic-cabalistic tradition the last phases of the Atziluthic World probably occurred during the twelfth or thirteenth centuries A.D. The Briatic World, or World of Beauty, reached full power with the Renaissance and continued in diluted form until the sixteenth century. The Yetziratic World, or World of Form, originated in the eighteenth century and is presently disappearing. The World of Materialization, Assiah, most likely had its origins at the end of the nineteenth century and is now in full power. The last spheres of the World of Form define abstract or non-objective art, those types of art that strictly depend upon formalist esthetics.

Considerable overlapping occurs between the sephirothic worlds and their spheres. Each sphere embodies one or more 'new' or avant-garde tendencies, each implying further materialization, hence a point closer to the absolute stripping of the Bride of Microprozopos, the center of the cabalistic worlds. The *Large Glass* specifically refers to the beginning of the World of Assiah, to the complete destruction of painterly and sculptural principles as they have evolved historically.

The Bachelor Mechanisms

Many students of Duchamp's work have commented on the repetitious use of the triadic theme in the iconography of the *Glass*. Its appearance is not accidental. This triangular structure is the basic tenent of cabalistic theogony and is known as the First Three Principles. By themselves, the First Three Principles are stable and absolute. When a dot is placed in the center of a triad, the new four-pointed figure becomes unstable, precipitating further evolution. Such a structure, relating to the four points of the Tetragrammaton, represents the origin of all dialectical progressions. Duchamp summarizes these Principles as:

Wind — for the draft pistons
Skill — for the holes
Weight — for the standard stops to be
 developed [7]

In cabalistic terms these are represented by:

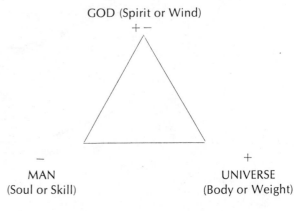

GOD (Spirit or Wind)
+ −

−
MAN
(Soul or Skill)

+
UNIVERSE
(Body or Weight)

The Bachelor Apparatus is a machine, and like all machines, it contains a power source, parts which function in unison, and an output. There are actually three sources of input energy.

The most generally understood is the Waterfall emanating from the Bride and powering the Water Mill. The Mill Wheel turns on a long rod-like axis extended to the rotating mechanism of the Chocolate Grinder. Duchamp's Waterfall is simply a pseudonym for the joint effects of WATER and EARTH on the Nature side of the Alchemical Pyramid. Hence, the entropic effects of Nature are extremely important in wearing down various cultural systems once they have begun to decay through illusions of rationalism and progress. Similarly, unstable semiotic systems appear to 'progress' as they are exposed to uninhibited usage.

The vehicle supported by two runners, variously denoted as the Chariot, Sleigh, or Glider, runs back-and-forth on a very short rail from A to B. The Glider is a synthesis of two Arcana of the Tarot: the seventh key, the Chariot, and the fifteenth key of the Devil. The Chariot is a cube-shaped vehicle denoting success or triumph for the artist. Driving the Chariot gives the illusion of movement. Significantly, Duchamp's Chariot or Glider consists of only a half cube, similar to the half cube of stone used as the Devil's throne of the fifteenth Arcanum. This half cube portrays the instability of singly articulated semiotics; in the *Glass* this may be defined as art lacking equality between its Plane of Content and Plane of Expression (e.g., $C=E$ or $n(C)=n'(E)$). This same illusion controls many of the working methods of contemporary science and technology.

From a mechanical point of view, the Glider resembles the balance arms and regulating weights of a Foliot balance, the first escapement used to control wheelworks of 14th and 15th century clocks. As the Foliot swings to and fro, the teeth of the escapement wheel are released one by one. The timing of the swing to some extent, and the weights, control the clock. A Foliot balance (or the Glider) defines visible motion by the passage of time from one tooth to the next (or one art movement to the next), while in fact it simply alternates between two stationary points. Duchamp notes that "the chariot is emancipated horizontally."[8] In respect to occult literature, the arms of the quadrant or Tetragrammaton stand in symbolic contrast to each other. The vertical arm rep-

resents eternity and spirituality while the horizontal arm depicts historical time and worldliness.

A somewhat fork-shaped hook mentioned by Duchamp in the notes drops from the very top of the Apparatus into two holes spanning the Water Mill axis and lying between the Glider and the Chocolate Grinder. The immovable axle represents "the possibility of the existence of illusion," on another level, it simulates the inertia of matter as opposed to the kinetic energy simulated by the outer rim of the Wheel. Duchamp observes that the Hook never touches any of the Mechanisms.

The Hook may be identified with the eighteenth letter of the Hebrew alphabet, *Tzaddi*, representing a fish hook or roof. An esoteric interpretation identifies *Tzaddi* (the Star) with the Fool, the first or last card of the Major Arcana. *Tzaddi* connects the clearly revealed with the image of drawing fish out of water. Fish are equated with transforming reproductive power, while one of the meanings of water relates it to subconscious mentality. Thus *Tzaddi* — the water bearer and sign of dissolution — is concerned with the subconscious powers of artists in discovering new art forms. The Fool, on the other hand, is a man with power which may or may not be used according to the dictates of wisdom. On one level the Fool represents impulsive behavior, a creature without true knowledge. Quite likely then, the Hook is a symbol of any advanced artistic impulse leading towards new esthetic and ultimately spiritual discovery. The fact that the Hook never touches the Bachelor Apparatus is analogous to its symbology as a vessel of unfulfilled hope. (There can be little doubt that Duchamp took the Fool as a personal device. In German, *selig* — related to 'silly' — means holy or blessed; thus holiness and foolishness have been traditionally paired with one another. The Hebrew word for 'silly' [spelled Aleph-Vau-Yod-Lamed] connects the key of the Fool [Aleph] with the spiritual illumination of the Hanged Man [Lamed] by way of the fifth arcanum [Vau], representing the revelation of sacred things, and the ninth arcanum [Yod], the unconscious personification of the Fool's state. Hence a Fool is also someone of extraordinary powers and occult insight

4. Marcel Duchamp, *Chocolate Grinder, No. 2*, 1914. Philadelphia Museum of Art: The Louise and Walter Arensberg Collection.

who hides his wisdom through ridiculous acts.)

In the notes for the Bachelor's section Duchamp writes: "— It is by this oscillating density that the choice is made between the three crashes: according to the strength of the fall of the hook . . . the right is chosen rather than the left or alternatively or the center." [9] "Oscillating density" alludes to the mercurial composition of the hook controlling artistic choice. Suspended from the sephirothic pillars, the fluctuating composition of the hook determines which sephiroth or aesthetic prototype the artist assumes. "The three crashes" refer to the three planes of cognition (Mental-Astral-Physical) that gradually disintegrate through the devolution of the Spheres.

The Chocolate Grinder is essentially composed . . .
The *chocolate* of the rollers, *coming* from one knows
 not where,
would deposit itself after grinding, as milk chocolate. . . .
The necktie (insert a letter referring to a diagram) with
 brilliant shimmering
would have been of aluminum foil stretched and
stuck down, *but the 3 rollers always turn beneath
the Bayonet—(X) Helps* to hold the compression bar
and the large scissors and the isolating plates.
 First-class article.

*The grinder is mounted on a Louis XV nickeled
chassis.*
Principle of [Spontaneity] (which explains the gyratory
 mt of the grinder without other help)
The bachelor grinds his chocolate himself

An aesthetic device, the Chocolate Grinder functions as a dialectical program. Its three revolving rollers determine the devolution of the triadic structure controlling nonobjective art. Its Louis XV nickeled chassis is a direct allusion to that monarch's craving for splendid art. This title also happens to coincide with another ruler enslaved to unstable thought, the Devil of the fifteenth Arcanum. The "nickled" chassis reminds us that iron, the Alchemical metal of lust and blind craving, is an underlying element of this machine. While the onanistic implication of Duchamp's maxim, "The Bachelor grinds his chocolate himself," has always amused critics, its real message is simply that the Bachelor (or artist) defines his own

content while creating nonobjective art; his "content" is a metalanguage with no direct visual reference to painting or the physical world.

The progressive involution of nonobjective art (the seven lower Spheres of *Levanah*) operates through dialectical relations. The Chocolate Grinder turns seven times in descending order. (See Diagram 1)

Each triad represents the subtraction of a particular visual relationship from the complex of Gestalts used in nonobjective art. The nature of these relationships is prescribed by the Sieves. The end of nonobjective art is signaled by the fact that the Hook (Tsaddi, The Star) no longer drops into the two holes on either side of the Mill Wheel axis. As this happens, the Grinder and Scissors stop, the string *temporarily tied* to the Glider becomes undone, and except for the grand finale on the Tobaggan Slopes, the Bachelor Mechanism ceases completely. (It thus becomes evident why Duchamp never completed the *Glass* and labeled it "-1923/ — unfinished." The *Glass* is, after all, a "work in progress," only consummated in the last few years.)

A few words should be said about the Bayonet. This "First-class article" is, according to the artist's description, a kind of decision device, supporting the large scissors and isolating plates. The Bayonet protrudes vertically from the top of the Grinder and portrays the Ace of Swords in the Tarot deck. This card is "the primordial energy of Air," a male descendent of Fire, Sun, and the Phallus. The Ace of Swords lacks the purposefulness and decisiveness of its related court cards. But by transforming the Sword into a Bayonet, Duchamp is reaffirming its aggressive and analytical character, its desire to strike without any clear idea of its goals.

Given an *object in chocolate.*
 1st its appearance = retinal impression (and other sensory consequences)
 2nd its apparition
The *mould* of a chocolate object is the *negative apparition*
 of the *plane* (SURFACE) (with one or several curvatures) generating 1st (by
 elementary prillllism) the *colored* form of the object

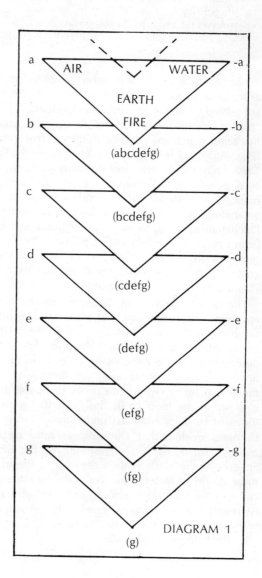

DIAGRAM 1

2nd. the mass of *elements of light* (native colors)
 (chocolate type
elements): in the passage from the *apparition* (mould)
 to the *appear-*
ance, the plane, composed of the elements of *choco-*
 late type light
determines the apparent chocolate mass
 by PHYSICAL DYEING

"Appearance" and "apparition" refer to singly articulated paintings (nonfigurative) and doubly articulated paintings (representational). The "mould" in this instance is the illusion of a negative relief which any painting in perspective simulates. Again, as in the case of perspective in the *Glass,* color can be interpreted in two ways: either as a purely optical stimulus emanating from a plane surface, or as reflected and/or parent color emanating from objects described in a painting. Duchamp goes on to say that in the transition from figurative to nonfigurative painting there is a tendency to interpret detached or free areas of color as if they were parent (local) colors affixed to illusionistic surfaces *in* the painting.

The second group of Bachelor mechanisms represents the conversion of specific art ideas into finished works, and includes the Nine Malic Moulds, the Sieves, and the Toboggan Slide. The description for the Nine Malic Moulds is partly derived from a critical essay by Baudelaire on modern painting, where the poet compares the clothing of the modern businessman to the uniforms of so many brainless underlings.[12] While it becomes evident that Duchamp is referring to modern artists, he is also referring to the nine Spheres of the ninth Sephira *Levanah* in the ultimate World of Materialism. These define the crucial span of transition between the most abstract representational art and materialist art uninvolved with painting and sculpture. Duchamp characterizes this state psychologically.

Progress *(improvement)*
 of the illuminating gas up to the planes of flow
Malique moulds. (Malic(?))
 By Eros' matrix, we understand the group
of [8] uniforms or hollow liveries

destined to give to the (receive the) illuminating gas
 (which takes) 8 malic
forms (gendarme, cuirassier etc.)
 The gas *castings* so obtained
would hear the litanies sung by
the chariot, refrain of the whole celibate machine,
but *they* will never be able to *pass beyond the Mask =*
 They
would have been as if enveloped, alongside their
own complexity to the point of their being hallucinated
 rather
onanistically. (Cemetery of [8] uniforms or liveries) [13]

Duchamp proposed eight moulds in 1913 and subsequently added a ninth (the Stationmaster), which he said represented himself as "one of the boys." Was Duchamp planning to omit Kether and Malkuth? Or did he think that nonobjective art belonged to the eighth Sphere, *Kokab*? There is no sure answer except that his final choice was the correct one. The term *Malic* has many connotations: "male" and "evilness" in both French and English; "painting" or "painter" in German, but more significant is one of the Hebrew words for "angel," *Malach.* Here Cabalistic meaning refers to the World of Formation's almost robotic beings, sent to Earth to fulfill a prescribed task not requiring much wisdom or self-knowledge. The avant-garde artist is precisely such creature. Using the plan view of the Bachelor Apparatus, the placement of the nine figures resembles the structure of the Tree of Life. (See Diagram 2)

In a most irreverent fashion, Duchamp replaces the Sephirothic Spheres with relatively menial occupations, conforming to the conditions of *Assiah* in *Levanah.* Since Kether is the highest fusion of self and selflessness, it rightfully belongs to the Priesthood. Binah is the lowly Department-store Delivery Boy whose main task is "change in stability" or carrying other people's goods. As Stationmaster, Duchamp becomes Chocmah, the positive male force embodying wisdom. The Supernal Triad is reflected first by Chesed, manifesting paternalism and authority. Duchamp plays off the milder role of the Policeman against the Gendarme (Geburah: Severity and Strength) who uses arms and soldierly tactics. Tiphereth, the Sphere of Beauty and Reconciliation, is given the title of Bus Boy,

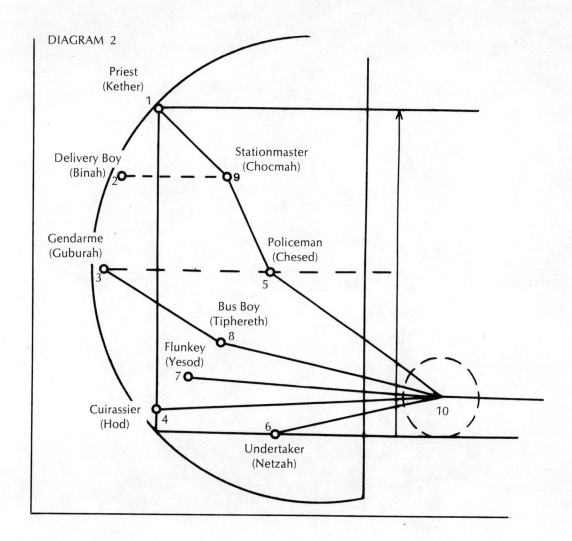

DIAGRAM 2

Priest
(Kether)
1

Delivery Boy
(Binah)
2 9 Stationmaster
 (Chocmah)

Gendarme
(Guburah)
3 Policeman
 (Chesed)
 5

Bus Boy
(Tiphereth)
8

Flunkey
(Yesod)
7

Cuirassier
(Hod)
4 10

 6
Undertaker
(Netzah)

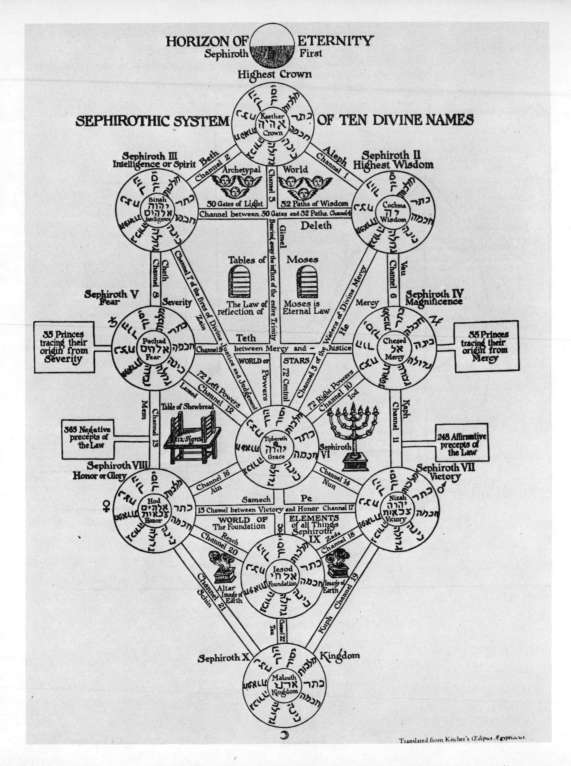

5. Sephirothic System of Ten Divine Names. From *The Secret Teachings of All Ages* by Manly Palmer Hall.

most likely because Tiphereth clears up the "dirty dishes" left by Chesed and Geburah. Netzah's Victory over the stabilizing forces of Tiphereth is illusionary since its role is another step towards defeat and death, making Netzah the Undertaker. The Cuirassier is outdated but brilliantly costumed for the role of horse soldier, which is in keeping with Hod's Glorious lethargy. Finally, Yesod acts as the lowly transition to absolute materialism; Yesod follows the orders of the higher Sephiroth as Flunkey. The paths of each of these Spheres lead eventually to the tenth position of Malkuth indicated by a dotted circle.

The Malic Moulds (artists) or "gas castings" are filled with culture's last vestige of "illuminating gas." While destined to hear the praises of critics and collectors, they are, as Duchamp cryptically states, never able "to *pass beyond the Mask*." The Mask platonically refers to the ego; as a rule few artists penetrate their own self-images into their actual selves.

In several drawings and paintings the artist has depicted the journey of the Illuminating Gas from the Malic Moulds. From a needle-like consistency, the Gas becomes "a fog made of a thousand spangles of frosty gas" ready to enter the holes of the Sieve. At this point a kind of race or "spangle derby" is implied. Since the Illuminating Gas is of a most rarefied kind, a better interpretation would seem to be frozen or nearly frozen Alchemical WATER. Cut into tiny pieces, the Gas, retaining its *"malic tint,"* begins to rise toward the Parasol Trap. Like the Grinder, the Traps or "network of Standard Stops" are crucial mechanisms. They operate as a kind of superego or art history-making device. Once emitted by the Malic Moulds (artists), the "gas cut in bits" (individual paintings) seeks the approval of society.

(parasol TRAP)
The spangles are stopped in their ascent by the 1st parasol (sieve.)
The sieves (6 probably) are semi-spherical parasols, with holes. The holes of the sieves parasols should give in the *shape of a globe the figure* of the 8 malic moulds, *given* schematic, by the 8 summits (polygon concave plane). by subsidized symmetry.

Orientation of the parasols:
The 1st is horizontal, and receives the spangles as they leave the tubes.
If one joins the centers of the parasols with a line one obtains a half circumference from A to B.
As in a Derby, the spangles pass through the parasòls A, CD. EF . . . B.
and as they gradually arrive at D, E, F . . ., etc. they are *straightened out* i.e. they lose their sense of up and down ([more precise term]).—The group of these parasols forms a sort of *labyrinth of the 3 directions.—* The spangles dazed by this progressive turning imperceptibly lose *provisionally* they will find it again later their designation of left, right, up, down etc, lose their awareness of Position [14]

Most interesting is the "dust-breeding" process by which Duchamp cultivated the Parasols: "To raise dust on Dust-Glasses for 4 months. 6 months. which you close up afterwards hermetically.= Transparency — Differences. To be worked out."[15] He then suggests that the resulting dust will be "a kind of color (transparent pastel)." The Parasols have their origin in Gnosticism's *Dark Cone of the Earth,* that heavy darkness of the lower earth conveyed in metal and giving us Duchamp's last allusion. The Cone represents a rather painful and lonely area of the *uroborus,* the circle of human redemption. The Dark Cone(s) are the means by which an individual analyzes his imperfections one by one. Such soul-searching finally results in the individual coming to terms with the Dark Cone. This Cone is often depicted as a kind of dungheap or *dustbin* of the World's astral (manifested) region. Cabalistically, "the products of dust" of the Garden (carnal gratification) are the areas of non-sacred science, philosophy, and art. Passage through the last Cone brings art to the "threshold of the second death," which Duchamp irreverently terms the Toboggan Slide.

Duchamp changed the number of Sieves to seven, more than likely adding the material Sphere of Malkuth. Going from *A* through *C, D, E, F* to *B,*

6. Marcel Duchamp, *Scale Drawing for the 'Parasol Sieves,'* Spring 1914, Paris. Private Collection.

DIAGRAM 3

D TIPHERETH E NETZAH F HOD

C GEBURAH G YESOD

A CHESED B MALKUTH

Duchamp allows more dust to collect on the later Sieves, implying a kind of chronological succession in which the last stages of nonobjective art are trapped one by one in the last Sieves. The fact that the holes in the Sieves are in the "shape of a globe" simply alludes to the Sephirothic Spheres. (See Diagram 3)

In almost cinemagraphic terms, Duchamp describes the progress of the "spangles" (painterly elements). They *"straighten out,"* "lose their sense of up and down," and reach a point where they "can no longer retain their individuality." The artist is not referring to a single painting, but to the involutionary sequence of pictorial changes common to nonobjective art. Ideally these crucial shifts take place in chronological succession, although historically there have been exceptions to this. The process of *straightening* out reduces the boundaries between forms and the residual horizontal and vertical elements of perspectivistic painting. Finally all formal elements disappear except for paint itself which flows naturally according to gravity. Duchamp's intention in allowing the first Parasol Sieve to be A (Chesed) and the last to be B (Malkuth) becomes more evident if we remember his insistence that the second (or formal) articulation is merely an illusion of truly syntactical communication, therefore an elabor-

ately worked or highly complex nonobjective painting has as much meaning, or as little, as a drip painting.

Under Kether are nine Sephiroth or nine permutations of the basic triad. Cabalistically, human existence operates on three distinct planes: the Mental Plane (incorporating spirit, concepts, and ideas), the Physical Plane (all material manifestations), and the Astral Plane (including the "soul," energy, and the forms of operation). The nature of the Astral is particularly difficult to grasp because it represents a synthesis transcending and not typifying the Mental and Physical Planes. The essential binary relation between the Mental and Physical Planes may be neutralized by the Astral Plane, but it cannot be destroyed. Changes occurring in each of the Sephira are defined by a series of permutations called the "Law of Reflection."

1) Kether: Unknowable

2) Chocmah: Reflection of the Mental in the Mental

3) Binah: Reflection of the Astral in the Mental

4) Chesed: Reflection of the Physical in the Mental

5) Geburah: Reflection of the Mental in the Astral

6) Tiphereth: Reflection of the Astral in the Astral

7) Netzah: Reflection of the Physical in the Astral

8) Hod: Reflection of the Mental in the Physical

9) Yesod: Reflection of the Astral in the Physical

10) Malkuth: The Physical in itself

Duchamp's seven Parasol Sieves equal the last seven Reflections. Triadically, they reveal the following form. (See Diagram 4.)

As surmised from the above diagram, there is a direct relation between the Cabalistic Triad and the basic binary of Structural Linguistics consisting of the Paradigmatic and the Syntagmatic Planes. Added to the last we find an intermediate mode of perceptual organization — Gestalt or "formal" relations. Gestalts automatically mediate between our conceptual capabilities and our unfocused physical senses. These two neural areas divide our responses and perceptions into definite evolutionary stages. Syntagmatic associations are fundamentally instinctive, while the paradigmatic features of the brain are associated with mechanisms of higher reasoning. Structural Linguistics never developed diachronic techniques of analysis because of its dependence on a binary scheme of segregating linguistic elements. Gestalt association has to be the transitional step between the two. (See Diagram 5.)

In his *Green Box* notes Duchamp simply i-dentifies the Sieves. He does dwell upon the final liquid consistency of the material passing through the Sieves, although he offers no particular description of the stages of nonobjective painting. The permutations of the Cabalistic Triad represent a kind of cyclical logic which distinguishes each of the stages of nonobjective art — yet without actually defining their underlying semiotic properties (e.g., in what structural sense does a painting by Kandinsky differ from one by Malevich or de Kooning?). The Sieves symbolize the seven conceptual attitudes possible for any artist to adopt in making nonobjective art. In a sense these mirror the levels of consciousness encountered by a child learning to speak its first complete sentences.

Chocmah and Binah are not an active part of the declination of the nine Spheres. In terms of the evolution or involution of semiotic systems, the *Mental,* or the Paradigmatic Plane, cannot be described by itself; neither, as in the case of Binah, can the *Astral,* or Gestalt relations, define conscious ideas — except at the highest level of the Sephirothic Worlds. There we see them as the relations between point, line, triangle, square, circle and the more complex configurations of hermeticism. As for the other seven, they assume a cyclical pattern common to all Spheres according to given conditions and analogies.

DIAGRAM 4

| | GESTALT RELATIONS (Astral) − + | |
| PARADIGMATIC (Mental) + | | SYNTAGMATIC (Physical) − |

1)	+ and −		6)	− +	− +
2)	+	+	7)	−	− +
3)	− +	+	8)	+	−
4)	−	+	9)	− +	−
5)	+	− +	10)	−	−

SYNTAGMATIC	GESTALT	PARADIGMATIC
Continuous time	Related events organized periodically	Concepts of time in cyclical progressions
Emotional associations	Eidetic associations	Meanings and abstract thought
Ground	Figure-Ground	Figure
All elements as they are found in nature, a continuum with only minimal differentiation	Unconscious perception of Gestalt relations	Conscious classification of elements into conceptually useful systems
Unexamined contrasts and random groupings	Contrasts hierarchically determined according to dominant attributes	Distinctive oppositions divided into sets and sub-sets according to selected criteria
Perceived whole	Unconscious parts-to-whole perception	Conscious analysis of parts as a whole

DIAGRAM 5

Chesed: ruled by JUPITER; generates Wisdom, paternal authority, a desire for knowledge, and mercy; reflects the Physical in the Mental; Chesed deals with emotions given a quasi-programmatic format in nonobjective art; in terms of technique and implied perspective this structure contains all the attributes of recognizable content.

Geburah: ruled by MARS; generates Severity, intelligence, impulsiveness, strength, punishment and mental limitations; reflects the Mental in the Astral; Geburah defines those artists inspired by specific concepts from various disciplines (e.g., scientific, technological, geographic, architectural, etc.); such concepts are tied to Gestalt thinking; the forms used by these artists are condensed into clearly defined geometrical configurations.

Tiphereth: ruled by the SUN; generates Beauty, harmony, eternal truth, and virtue; reflects the Astral in the Astral; such artists assemble eidetic constructions of the real world and apply these to art through a profound understanding of Gestalt principles; in every cycle, Tiphereth represents the highest degree of artistic synthesis.

Netzah: ruled by VENUS; generates Victory, powerful desire, vitality, and activity over passivity; reflects the Physical in the Astral; this art stems from the origins of human behavior and adapts itself to the basic perceptual Gestalts; the physicality of the painter's techniques reflects his emotional impulse.

Hod: ruled by MERCURY; generates Glory, splendor, peace, praise, ecstasy, and life without movement; reflects the Mental in the Physical; this art depends upon the most elementary perceptual laws; its painting is supported by eloquent assertions of abstract ideals.

Yesod: ruled by the MOON; generates Form, foundation, entry into the material world, and stability in change; reflects the Astral in the Physi-

cal; semiotically such art conceals a double structure: the first points to it as an object, while the second insists upon the object's formal manifestation; Yesod signifies the last legitimate stage of any art movement.

Malkuth: ruled by the ELEMENTS; generates materiality in all of its manifestations; reflects the Physical in itself; Malkuth represents both the last step in the involutionary sequence of the Tree of Life and the final level after nonobjective art; Duchamp's many references to liquid at the end of the Sieves may be identified with various fluid techniques in painting, expressing pure materiality.

After the Sieves, Duchamp supplies three short notes which are worth studying. The first simply indicates: "AFTER THE 3 CRASHES=*Splash.* and not vertical channeling of the encounter at the bottom of the slopes."[16] The next note is accompanied by a small sketch of the curving slopes which ends with a suspended object, entitled *mobile,* directly above the point of termination. It reads: "Study the 3 falls: After the center one, the *mobile* will splash the gas which has become liquid and arrived at the bottom of the slopes."[17] Circumstances indicate that the three "crashes" or "falls" represent the three types of perception: Paradigmatic relations, Gestalt relations, and Syntagmatic relations. By the final permutation and the "fall" (elimination) of the Astral or "center one," painting is destined to assume the various types of free-forming liquid application that have become so prevalent in the past twenty years.

Malkuth, or the final reign of materialism in art, maintains its own quadruple inversion in three dimensions. While painting shows the effects of less and less control through dripping, dyeing, spraying, and staining, art completes a parallel involution in the areas of *neural, animal-physical, vegetable* and *mineral* existence. These also pass through the seven reflected Spheres of the fortieth Sphere, *Cholom Yosodoth,* to a hypothetical point of zero vibration. Affected only by the forces of gravity, this is referred to as the *Primum Mobile* — the mobile in Duchamp's drawing. What follows is a third note on the *Planes of flow. . . .*

in the form of a toboggan
but more of a corkscrew. and
the splash at A is an uncorking
the group may be described in the sense
of model-uncorking.
 The fall to A of the three-crashes helps
the uncorking—
 The splash (nothing in common with
champagne) ends the series
of bachelor operations and transforms
the combination of the illuminating gas and the scissors
into a single continuous support, support
which will be regularized by the 9 holes.[18]

Descending into the lower regions of the World of Assiah, the Cabalist reaches that nadir containing the *shells,* denoting purely materialistic attitudes in a World unleavened by love, ideals, or aesthetic beliefs. Eventually extreme materialism provides the crisis necessary for a radical re-evaluation of all culture. When Cabalists insist that Malkuth and Kether resemble one another, they are implying that the highest consciousness depends upon the relation between human spiritual comprehension and the material basis for existence. In a society aspiring to Kether, cycles of normal growth and decay become the basis for all ritual and natural law. This explains Duchamp's remark about "the model uncorking." The complete involution of art is a "model" or prototype for realizations signifying a gravitation towards Kether at the level above the Atziluthic World. "Uncorking" is a portmanteau word coined by Duchamp to indicate the double meaning of the Hebrew word *Sod* (mystery) whose letters in Gematria add up to 70, as do the letters in the word for wine. So the "wine of the Torah" refers to secret mysteries of the Law. The "uncorking" allows for that delirious aroma characteristic of good wines, just as recognition of Kether provides its own spiritual intoxication. As we comprehend that society's substance is based on interlocking mythic structures, the bachelor operations (in the form of avant-garde art) cease to function. Gradually the illuminating gas forcefully returns in the form of intellectual comprehension.

The Bride

Remembering the Hermetic axiom that "what is below is similar (NOT EQUAL) to what is above, and what is above is similar to what is below . . . ," it seems probable that the Bride, or upper section of the *Large Glass,* will be involved with the same activities as The Bachelor Mechanisms. Marcel Duchamp has cleverly distributed the details for decoding the progression of nonobjective art between both the upper and lower sections, so in fact one must piece the notes of both together in order to learn the means and the effects of the "stripping process."

The major portion of the Bride takes the form of the *"Pendu Femelle"* or Female Hanged Body. In a sense this "hanged bitch," as she is called by Duchamp, is the female equivalent of the twelfth Major Arcanum of the Tarot, the Hanged Man. This card signifies the adept's or hero's initial period of crisis. Identified with the Hebrew letter MEM (relating to Woman and the Alchemical WATER), the Hanged Man begins the psychological transformation towards egolessness, but on another level it exemplifies nonobjective art. WATER is the element of mental illusion, the revealer of images *upside-down.*

Significantly, the painting of the Bride is nearly monochrome with pastel tints of shading; thus she reflects *Kether* (white), *Chocmah* (gray), and *Binah* (black), these begin the Macroprozopos of the Tree of Life. For all her fine details and consummate draftsmanship, *it remains doubtful that the Bride contains imagery of any kind.* She represents the concrete World of Manifestations as opposed to the World of Illusions. Duchamp's notes for the Bride have a kind of spurious air. Decked out in cubist forms, the Bride radiates "ignorant desire" — she is, in essence, the stuff that all nonobjective art is made of: colors, forms, technique with an added Metalanguage. Visually and iconographically, she has no meaning.

The notes for the Bride inform us intellectually and deceive us visually. Duchamp begins by describing the Bride in automotive terms: "a reservoir of love gasoline" distributed to the "motor with quite feeble cylinders." Combustion in the Bride's motor takes the form of a double explosion.

Hence, this motor with quite feeble cylinders has 2 strokes. The 1st stroke (sparks of the desire-magneto) controls the immobile arbor-type. This arbor-type is a kind of spinal column and should be the support for the blossoming into the bride's voluntary stripping. The 2nd stroke (artificial sparks of the electrical stripping) controls the clockwork machinery, graphic translation of the blossoming into stripping by the bachelors. (expressing the throbbing jerk of the minute hand on electrical clocks.) [19]

This "immobile arbor-type" is undoubtedly the Cabalistic Tree. The "sparks of the desire-magneto" correspond to the Cabalistic "sparks," that is, the attributes or letters that fall by the wayside as art reaches Malkuth. "Electrical stripping" alludes to the mental process by which further stages of nonobjective art are eventually perceived and accepted by the public. This last controls the illusion of temporal change, "the throbbing jerk. . . ."

Knowing what we do, it is easy to understand the artist's description of the Bride as "a sort of apotheosis of virginity." The "cinematic blossoming" refers to the necessary optical-formal changes, like a time-lapse motion picture, that will bring nonobjective art to its completion.

No. 1 [first part]

Grafting itself on the arbor-type — the cinematic blossoming . . . is, in general, the halo of the Bride, the sum total of her splendid vibrations: . . . The Bride reveals herself nude in 2 appearances: the first, that of the stripping by the bachelors, the second appearance that voluntary-imaginative one of the Bride. On the coupling of these 2 appearances of pure virginity —

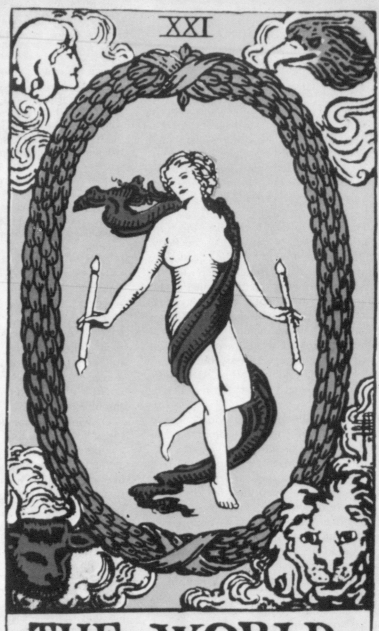

THE WORLD.

7. Left: *The World*, last Key to the Major Arcana of the Tarot. From the Rider Deck by Arthur Edward Waite and drawn by Pamela Coleman Smith.
The dancer above will become the cabalistic "Bride" or Shekinah.

8. Below: Marcel Duchamp, *The King and Queen Surrounded by Swift Nudes*, May 1912. Philadelphia Museum of Art: The Louise and Walter Arensberg Collection.
Here the artist portrays the state of the Sephirothic Crown (King) and his Bride in Malkuth (Queen) before their reunion. The "Swift Nudes" separating the two figures signify those artists (forces of Mercury) who will be responsible for their eventual merger.

On their collision, depends the whole
blossoming, the upper part
and crown of the picture.

In order for the *mirrorical return* to Kether to
happen, two events have to take place. Art itself
must descend to the complete materialism of Mal-
kuth and, second, the spiritual implications of this
fact must be gradually understood generally.

The notes then describe a triple blossoming.
First the "electrical stripping," next that "volun-
tarily imagined by the Bride desiring." Duchamp
here touches on one of the profound Mysteries of
Cabalistic theory, that is, the role of Shekinah in
the return journey to the Crown or Godhead. As
Daughter of the King, then Betrothed, and then
Bride and Mother, Shekinah ascends the Tree to-
wards mystical fusion as Elohim with Jehovah. Mis-
tress of the Celestial School, Shekinah in part
represents the underlying psychological impulses
responsible for the constant need for transcendent
communion through art. Duchamp alludes to this
impulse as the "blossoming" carried on the "re-
fined development of the arbor-type." The
"boughs on this arbor-type" represent the twenty-
two pathways of the major Arcana of the Tarot.
Duchamp sees Shekinah, or the longings of hu-
manity, as a slow blossoming: "this blossoming is
the image of a motor car climbing a slope in low
gear. (The car wants more and more to reach
the top; and while slowly accelerating, as if
exhausted by hope, the motor of the car turns
over faster and faster, until it roars triumphantly)."

No. 1 [second part]

3rd Blossoming-crown (Composed
 of the 2 preceding).
 the 1st blossoming is attached
 to the motor with quite feeble cylinders.
 The 2nd to the arbor-type, of which it is the
 cinematic development.
 The arbor-type has its roots in the desire-
gear, a constituent, skeletal part
of the Bride.
 The motor with quite feeble cylinders
is a superficial organ of the Bride; it is activated
by the love gasoline, a secretion of the
Brides sexual glands and by the electric
 sparks of the stripping. [20]

The whole of Duchamp's note recapitulates the
Bride's (or Shekinah's) ascension up the central
pillar of the Tree. The more mechanical functions
described as The Bachelor Mechanisms below be-
come the Bride's Sex Cylinder or Wasp. Although
there is a drawing for the Wasp, it remains uniden-
tified in the painting. This kind of cone-shaped
carburetor has a turning function analogous to that
of the Chocolate Grinder. One must look towards
one of the oldest treatises in Cabalistic literature,
The Book of Formation (Sepher Yetzirah), to find a
description of a cylindrical or circular device
which is meant to unlock the secrets that the artist
has in mind.

In the Pendu femelle — and the blossoming
 Barometer.
 The filament substance might
 lengthen or shorten itself in response to an
 atmospheric pressure organized
 by the wasp. (Filament substance
 extremely sensitive to
 differences of artificial
 atmospheric pressure controlled by the
 wasp).

[This is followed by a small diagram and brief note
that reads:] *Isolated cage — Containing the filament
substance in which would take place — the storms and
the fine weathers of the wasp.*

the filament substance in its meteorological extension
 (part relating the pendu
 to the handler)
resembles a solid flame, i.e. having a solid
 force. It licks the ball of the handler
 displacing it
 as it pleases [21]

This "filament substance" is a kind of hypo-
thetical thread, invented by Duchamp, which pulls
the eye closer or further away from an inverted
image of the picture plane. Lengthening or short-
ening the "filament substance" alludes to the de-
gree of illusion and sense of depth perceived in a
nonobjective schema. Since the AIR of art semi-
otics is increasingly dominated by WATER, any
impending "rain" (Alchemical WATER) tends to
lower barometric pressure. "The storms and fine
weathers of the wasp" refer to the difference in

choices made by an artist, that is the psychological implications, in choosing either the male, female, or neutral pillars of the Tree. Duchamp implies that there is a causal relationship between the strength or weakness of the gestalts determined by the artist and the emotional consistency of the sublimations controlling artistic decision-making. The phrase, "It licks the ball of the handler . . ." refers to Binah's (female) psycho-sexual effect upon the mental drive of Chocmah (male). The basis for illusion at one point on the Tree is destroyed by being subtracted or amended at a lower sphere.

By far one of the richest components of the Bride (in cross-references and double meanings) is the milky cloud extending across the top of the *Glass*. It is referred to variously as the Halo of the Bride, Cinematic Blossoming, Top Inscription, and Milky Way.

Kind of milky
way *flesh color*
surrounding
unevenly densely
the 3 Pistons (i.e.
there will be a transparent
layer on
the glass then the 3 Pistons
then another layer
of milky way)
This flesh-like milky way
to be used as a
support for the inscription
which is concerned with
the cannon shots (at A) [22]

Ulf Linde observes that the Milky Way *(Voie Lactée)* may also be pronounced *voile acté* (acted veil).[23] As we shall see with the Draft Pistons in the Top Inscription, this curious cloud acts as a background for the real veils. Since a cloud is a mixture of water and gas, Arturo Schwartz is correct in attributing an androgynous character to it. But this is only a small part of the Milky Way's significance.

The "uncorking" at the bottom of the Sieves is related to the Milky Way through one of the mysteries of the Cabala. One must understand that the Milky Way refers to the canopy above the

Charioteer in the seventh Arcanum of the Tarot and to the underlying universal laws determined by the heavens. Four posts support the canopy above the chariot. These provide the mental laws making physical change possible. The canopy is dark blue, containing twelve gold stars signifying the celestial forces. In effect, the canopy defines destiny at its highest plane, the influence of the suns and planets on earthly life. Being a female component, this milky cloud corresponds to the guise of Shekinah in the world above the earthly holy place. As A. E. Waite describes this relation, "The latter [Shekinah] was also that cloud which abode on the tent of the congregation while the glory of the Lord filled the Tabernacle. Alternatively it was a cloud that rose up to veil her presence, and dissolved when she went forth." [24] The ascent of Shekinah tears away these purely conceptual veils.

The Milky Way is penetrated by three rectangular forms variously referred to as the Draft Pistons, the Triple Cipher, or the Nets. Three gauze squares were held up to the breeze, photographed, and the resulting outlines were then transferred to the *Glass*. Several writers have made lengthy descriptions of the process. On one level the three Nets designate the Three Veils of the Tree of Life. The Veils are distorted by the wind because it is the spiritual aspect of intellect (AIR or Ruarch) that penetrates each of the Veils or Nets in turn. In the struggle towards the Supernal Consciousness of Kether, *materiality* is torn aside, then *form,* and finally the illusion of *beauty.* The Draft Pistons are the negation of the Milky Way; Duchamp has depicted them as squares of clear glass. Through the Nets one can easily see into the actual space in back of the *Glass*.

Top inscription.

obtained with the draft pistons. (indicate the way to "prepare" these pistons.). Then "place" them for (2 to 3 months) a certain time. and let them leave their imprint as 3 *nets* through which pass the commands of the Pendu femelle (commands having their alphabet and terms governed by the orientation of the 3 nets [a sort of triple "*cipher*" through which the milky way supports and guides the said commands] [25]

Again, one must refer to the highly arcane directions of the *Sepher Yetzirah* to know that Duchamp has broken the code to that key to the *Zohar* and to the formation of the Cabalistic Tree itself.

In his introduction to the *Green Box* the author notes an "Algebraic comparison" in which the ratio $\frac{a}{b}$ is equal to c. Since he insists that the equation is without "numerical value," it seems to refer to Duchamp's guarded interest in Ferdinand de Saussure's theories of structural linguistics.

The $\frac{a}{b} = c$ equation is Saussure's classical designation for a sign: $\frac{a \text{ (signified)}}{b \text{ (signified)}} = c$ (Referent) which in cabalistic terms reads

$$\frac{A \text{ (Mental)}}{B \text{ (Mental)}} = C \text{ (Physical)}.$$

This A B C motif appears with another note accompanied by a diagram. The drawing indicates two vertical pendular units, one swinging within a horizontal circle.

B and C (as they sway.)
just, strike the
circle A. B below, C
above —The above and the below
should be used in the decisions
or inscriptions transmitted through
the draft pistons. [26]

We may read this diagram on several levels. Figure A, the circle, represents the vagina; figure B, the stick-like pendulum, is the penis; while figure 1 is the testes or the seed. Cabalistic teachings sometimes compare the Sephiroth to the masculine and feminine sexual organs. Unifications of the Sephiroth strive for *Zivvug*, the Hebrew word for complete sexual coupling. Every occult tradition stresses the resemblance between art and male-female copulation resulting in birth. Unification and transference of the seed are the essence of the Life Plan. Duchamp is making an allusion to the plan of the *Glass*. We find C, the

Physical Plane, above in the Bride's section, representing the natural elements of sound, color, texture, value, and feeling. B below defines the assertive *Astral Plane* which, through the Bachelors, gives us the illusions of art and change. And finally A represents the central area of the *Glass*. On the passive *Mental Plane* are located cognition and understanding of the total scheme of things.

Remembrance of Kether

A final note completes the *Large Glass*. The Nine Shots or Pulls involves the use of a toy cannon pointed at an undisclosed target point on the *Glass* and fired nine times. Duchamp repeated the firing operation three times from three positions "not in a plane." Matches tipped with wet paint were used as missles to mark the spots surrounding the target. Duchamp then had small holes drilled in the *Glass* at the nine points of impact. They were circled so that the nearest to the target was painted white while the rest were painted in values of gray towards the farthest hole designated by a black circle. We must perceive in this process the most crucial phase of his cabalistic activities, for it signifies the return to Kether, the reintegration of culture gradually turned upside down over more than two thousand years.

Shots.
From more or less far; on a *target*.
This target in short *corresponds*
to the vanishing point (in perspective.)
The figure thus obtained will be the
projection *(through skill)* of the principal
points of a 3 dimensional body.—With
maximum skill, this projection would
be reduced to a point (the target).
With ordinary skill this
projection will be a demultiplication
of the target. (Each of the new points
[images of the target] will have a
coefficient of displacement. This coefficient
is nothing but a souvenir and can be noted
conventionally (The different shots

tinted from black to white according to their
distance) —

 In general, the figure obtained
is the *visible* flattening (a stop
on the way) of the demultiplied
body [27]

It is important to realize that the inscriptions
from the Draft Pistons and the Bachelor's Gas end
in the region of the Nine Shots. Both emanations,
which are variations of the same force, pass
through the Veils of negative existence toward
the origins of the First Cause or Kether. It is well
to remind the reader that the Tree is not knowl-
edge or facts themselves, but rather a method for
retracing the cognitive mechanisms of thé mind.
In theory the Tree covers the gamut from the
highest forms of consciousness to inanimate mat-
ter. Using the structural order of binary opposi-
tion, it follows the principle of hierarchical orga-
nization to an undefined First Principle, Kether.
Rather than being a position in space, it is called
"the point within a circle" or even less clearly,
"the circle whose center is everywhere and whose
circumference is nowhere," [28] and also the Con-
cealed of the Concealed or the Inscrutable Height
— each definition implying that the universe is
logical and knowable *providing* we do not push
our ontological queries past a given point. At
most, we could see Kether as the source of primal
energy in the condition of pure becoming. Du-
champ's Nine Shots attempt to depict our final
leap across the Sephirothic Abyss towards the Su-
pernal Triad. The Supernal state above the Atzi-
luthic World is, in reality, a new and ultimate sense
of conscious realization, one defined as the high-
est degree of awareness concerning the reoccur-
ring structure of human culture perceived through
countless customs and modes. The Cabala pro-
claims itself through a single idea, namely that our
social customs, arts, legal structures, economic
policies, religions, sciences, architectural modes,
and languages are themselves mythic structures.
These conventions receive stability through the
strength of social consensus. Although ideally it is
possible to formulate a culture on the basis of
perfect knowing or *Gnosis,* such a culture only

becomes possible through a degree of love, na-
tural intelligence, and egolessness very much ab-
sent at present.

 According to Cabalistic doctrine, the devolu-
tion of culture (and art) occurs through the Light-
ning Flash or path of descent down the Tree of
Life. On reaching the final stage in Malkuth, a
more conscious and painful evolutionary ascent
begins. Here the division of Malkuth is separated
into four darkened or impure colors: citrine (AIR),
olive green (WATER), russet brown (FIRE), and
black (EARTH). Within the duration of the first
three Sephirothic Worlds Malkuth is not actually
manifested except as the Supernal Triad of the
following world. Only by reaching the fourth
World of Assiah does Malkuth reveal itself as the
Bride of Microprozopos. A decade ago art arrived
at this stage of total materialization. Hence by us-
ing the principles of classification devised by the
Cabalists, we find the Bride divided into various
"living substances."

FIRE: Art involving complementarity
AIR: Art using indeterminancy
WATER: Art employing causality or implication
EARTH: Art concerned with the principles of
 true physical and spiritual orientation

 The first three elements in their final stages at
the bottom of the tree are called the "shells" or
evil spirits and are further subdivided into their
"husks" represent art totally veiled from the di-
vine Light, that is, simply physical objects con-
ceptually organized as art. The first three shells are
reputed to be evil and destructive, although their
corrosion can be relatively helpful to those posess-
ing the necessary insight. However, the fourth
element, Earth, has the means of converting evil
to good. These final Qlippoth or purely material
manifestations instigate the ascendance of Sheki-
nah. Duchamp reminds us that the return to the
Supernal Triad demands "skill," meaning human
effort and insight.

 Symbolically, the return to the plan of divine
activity takes the form of three concentric parts:

AIN, the vacuum of pure spirit, circumscribes the area of a circle; AIN SOPH, the Limitless and Boundless, focuses in upon itself thus defining AIN; and AIN SOPH AUR, the Limitless Light, is the central point of impact, the primary thrust of existence. Duchamp has translated the creative force, AIN SOPH AUR, as the point of the cannon shot. This is manifested as the objective Universe through the drilled hole, AIN SOPH. Finally, the boundary line of divine existence, AIN, is defined by a painted circle. (See Diagram 6.)

The Supreme Creator in Kether consists of three parts, including the feminine polarity, Shekinah. Since constant variation of the triadic principle is the essence of the Cabalistic method, it is obvious why the triple motif appears so often in the construction of the *Glass*. In effect, the Nine Shots are the nine Sephirothic Spheres emanating from Kether and recreating the rectified Tree of Life, the Tree turned around and substituting Death for Malkuth under the Supernal Triad. Being undefinable, Kether remains a target point in back of the *Glass*, undisclosed by the artist.

Even given some concrete knowledge of the Bride and the Bachelors, Duchamp, it seems, has left us on a higher plane of metaphysical speculation. In philosophy cabalistic doctrine is referred to as "degenerate monotheism." Yet Duchamp compels us to give serious attention to occult disciplines long discredited by scientific skepticism. So in a sense we are asked to see Alchemy not as a muddled prelude to chemistry, but as a very sophisticated psychology of the human mind. Rather than a fortune-telling parlor game, the Tarot seems to be a semiotic description of human spiritual evolution and involution.

Yet in interpreting Duchamp's intentions, it would be the greatest mistake to infer that he prophesied the "death of art." Far from that, he anticipates the inevitable demise of art which takes scientific rationalism and post-rationalist methodology for its model, and this includes nearly all the successful art of the present century. The Cosmic Wheel or Duchamp's Mill Wheel proclaims that all human change is cyclical; art cannot die, but human illusion and the nature of

Diagram 6

AIN (Painted Circle)

AIN SOPH (Drilled Hole)

AIN SOPH AUR (Cannon Shot)

"aesthetic" values do. Ultimately, *The Bride Stripped Bare by Her Bachelors, Even* can only act as a signpost reintroducing the sacred and 'lived ritual' into the realm of everyday existence, thus abolishing art as a separate facet of life.

1. One can speculate on a far more profound meaning for the placement of the Bride above the Bachelor Mechanism. There is some well-founded conjecture that the Tarot cards are an ancient time-keeping device and calendar. One spread of the cards stabilizes the year according to a lunar-solar scheme which is in harmony with the rhythms of menstrual periodicity. Its counterpart is a "male" reading of the Tarot allowing for the interpretation of the great cycles of growth and decay, i.e., historical civilizations. Analogous to this in the *Zohar* we find the diagram:

$$\frac{A H \mid I H}{I H \mid V H}$$

On the lower level, the Tetragrammaton (*Yod-Hé-Vau-Hé*) defines the basic law of man and nature. The formula above (*Aleph-Hé-Yod-Hé*) mirrors the Tetragrammaton except that it signifies the Divine Plan and the Forces of Nature transcending all forms of human intervention. Duchamp's schema for the *Large Glass* involves the cabalistic relationships established within any "male" or diachronic culture. The Bride's panel above represents the Forces of Nature (female and chaotic) constantly eroding the male-dominated mechanisms of culture below. The ideal of a hermeticist such as Duchamp is to aid in the inversion of the panels so that culture is stabilized according to the female biorhythms. Culture below would be "female" and thus in ahistorical harmony with the Divine Plan above. Consequently the Divine Plan (*Aleph-Hé-Yod-Hé*) emerges as the superconscious organizing agency of the cosmos. This allows the "male" Godhead to remain in

stability with the "female" Tetragrammaton below. Hence the "Great Work" is completed. Both formulae reflect a bisexual character which shifts according to the polarities set up by the culture in question.

2. Blofeld, John, *The Tantric Mysticism of Tibet*, E. P. Dutton & Co., New York, 1970, p. 58.

3. Avoiding any deep involvement in the semiotic implications of art as a historical phenomena, one might say that art begins in the ritual act carried out so that it mirrors a cosmic scheme; in time this is equated by symbolic patterns of the same relationship, i.e., the Cross or Mandala. Gradually the symbol is anthropomorphized and given an illusionary pictorial space which recapitulates the sacred dramas. In time genre scenes and material techniques substitute for the depicted archetypal dramas. These seem to have a separate life and purpose, as detached as they appear to be from the sacred noumena.

4. Duchamp, Marcel, *The Bride Stripped Bare by Her Bachelors Even*, a typographic version by Richard Hamilton of Marcel Duchamp's *Green Box*, translated by George Heard Hamilton, Museum of Modern Art Publication, 1960, unpaginated. (All of the following notes are taken from the same source).

5. I have discussed the problem of double articulation in previous articles, the first entitled "Unveiling the Consort" in the March and April 1971 issues of *Artforum* magazine. Briefly, all natural languages seem to operate through a reciprocal code which consists of meaning on one axis and phonetic structure on the other. The idea that an "analogous categorical structure" exists between the two axes or planes of articulation is, to my knowledge, not a very well explored principle. Nevertheless, it seems to be the essence of any semiotic theory, one recognized in certain perverse ways by Duchamp in his notes and by several linguists such as Louis Hjelmslev in his *Prolegomena to a Theory of Language* (translated by Francis J. Whitefield), Madison, Milwaukee, and London: The University of Wisconsin Press, 1969, pp. 73 and 111.

6. The Bride is covered by three veils which Duchamp alludes to in notes for "3 nets" or "3 draft pistons." The first veil is Ain, vacuum of pure spirit, located just below the Supernal Triad of the Tree of Life. The second veil, Ain Soph of limitlessness, spans the Tree below Tiphereth. The third veil falls in front of Yesod, covering Malkuth, and represents the Ain Soph Aur or limitless light. Making art historically strips the veils from the Bride, thereby revealing essential truths about the nature of reality represented by Malkuth.

7. In the triangular structure representing "Wind," "Skill," and "Weight," "Wind" represents synchronic or perfect time from which all art emanates and eventually returns; "Wind" is ritual and balanced knowledge of the semiotic trajectory through history. "Skill" symbolizes the male pulse to articulate and dominate art through innovation; "Skill" signifies the major source of the art impulse through dialectical strategies for maintaining art's historicity. Finally, "Weight" embodies the final phases of the art semiotic, inasmuch as gravity and other natural forces control the consistency of the art made.

8. Duchamp, *op. cit.*

9. Duchamp, Marcel, *op. cit.*

10. Duchamp, op. cit. The Chocolate Grinder is also made to resemble classical descriptions of the Delphian oracle's tripod. This consists of a frame with three feet, a bowl set in a frame, a flat table on which the oracle sits, and a cone-shaped cover. Duchamp has patterned his Parasol Sieves after this last component.

11. Duchamp, op. cit.

12. Burnham, Jack, *Beyond Modern Sculpture*, George Braziller, Inc., New York, 1968, pp. 215-217.

13. Duchamp, op. cit.

14. Duchamp, op. cit.

15. Duchamp, op. cit.

16. Duchamp, op. cit.

17. Duchamp, op. cit.

18. Duchamp, op. cit. This note culminates Duchamp's seven stages of nonobjective painting and sculpture. These are defined by the layers of perceptual structure or Gestalt complexity existing below the level of representational art. Such perceptual steps are concerned with formal simplification in which the painter's mark gradually becomes one with its material support. Historically all nonobjective art evolves towards the three-dimensional object and away from the painted image.

The structure of Chesed dominates the early spiritual abstractions of Wassily Kandinsky (1912-1915). Kandinsky's compositions retain all the elements of representational art, except in his hands they are disassembled to form various programmatic themes. The Sphere of Geburah appears in the painting of Kasmir Malevich (1914-1920s). Suprematism and Constructivism are dominated by the metalanguages of engineering, perceptual psychology, and scientific theory. Here formal elements are reduced to precise geometric components; the separation between figure and ground remains vivid, as the illusion of spatial depth is sustained. Piet Mondrian's painting after 1920 most clearly reveals the ideal structure of Tiphereth. Here horizontal-vertical relations and a picture plane bound by continuous lines appear to be essential. The illusion of depth is considerably lessened. Tachism and American Abstract Expressionism (1947-1960) signal the emergence of Netzah. Netzah defines the simplest forms of asymmetrical balance. Color-field painting dominates Hod. Just as a direct emotional appeal is necessary to sustain art in Netzah, complex historical rationalizations are essential to Hod. The important feature of this painting is its reliance on at least one axis of symmetry. Paintings with the structure of Yesod always retain a double reading. One interpretation at this level involves the painting *qua* object rather than as painted image. The other interpretation provides for a composition and handling which reflects the material character of the painting support. Works by Ad Reinhardt and Frank Stella refer to Hod. In Yesod we find the pure material improvisations of Jackson Pollock and later Morris Louis. Here gravity and fluidity define the parameters of composition; color, as in Hod and Yesod, takes any form the artist chooses, since color becomes an arbitrary parameter. Precise laws for these relationships will be the subject of another essay.

19. Duchamp, op. cit.

20. Duchamp, op. cit.

21. Duchamp, op. cit.

22. Duchamp, op. cit.

23. Schwarz, Arturo, *The Complete Works of Marcel Duchamp*, Harry N. Abrams, Inc.: New York, 1969, p. 155.

24. Waite, A. E., *The Holy Kabbalah* (republished in 1960) University Books: New Hyde Park, New York, seventh printing, 1971, pp. 356-357.

25. Duchamp, op. cit.

26. Duchamp, op. cit.

27. Duchamp, op. cit.

28. Fortune, Dion, *The Mystical Qabala*, Ernest Benn Ltd.: London, 1935, p. 38.

VOICES FROM THE GATE

In the scenarios of initiations the symbolism of birth is almost always found side by side with that of death. In initiatory contexts death signifies passing beyond the profane, unsanctified condition, the condition of the "natural man," who is without religious experience, who is blind to spirit.

Mircea Eliade

We are just approaching the realization that past and future have no real meaning in art, or in life for that matter. How long these will remain the favorite fictions of art historians is anybody's guess.

To my knowledge Robert Morris is not a particularly religious individual, but with his recent tableau he has established an overt and public turning point in the crisis that we refer to as "contemporary art." Morris correctly indicates that this crisis is spiritual in substance, and not technical or formalistic as many would believe. As an artist there remains a curious remoteness-from-self about all of his work. In a virtually obsessive need to penetrate *structures,* rather than ideas or means, Morris has begun the long hard struggle to center his being, to see the pathologies of avant-gardism for what they are.

Hearing is a cruciform tableau accompanied by three hours of dialogue between several actor-speakers. Their voices act as an intermittent background for an arrangement situated on a plinth filled with casting sand. The arrangement consists of a copper chair, a table covered with zinc-coated sheet metal, a bed lined with lead plate,

and six wet-cell storage batteries connecting the table and bed. "Presence," certainly an overworked adjective when it comes to art, is entirely apt here — to the point where there are signs posted on both sides warning visitors of possible burns or electric shocks from touching the above items.

These cautionary signs contain their own intentional irony. The tableau represents in debased form the power of the Tetragrammaton, the Hebrew four-lettered word for God that embodies all the cycles of universal thought and creation. In ancient times, the holiness of the Ark of the Covenant was so profound that touching it was considered fatal for a man; the Ark's powers only diminished with the death of Moses. Ritual strictures against touching sacred works are equally as old. But today they have a purely monetary implication, in so far as if damaged, a work of art is diminished in value. *Hearing* goes one step further by making the dangers *purely physical,* providing absolutely no vestige of ancient spiritual emanation.

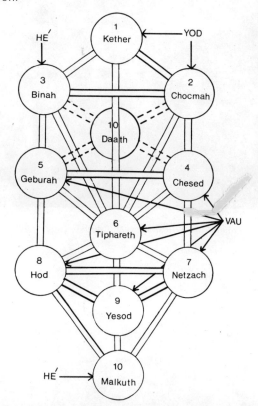

1. Robert Morris, *Hearing*, 1972. Courtesy Leo Castelli Gallery.

Morris's cruciform is a special attribute of the tenth Sephiroth of the Tree of Knowledge of Good and Evil, Malkuth. This "Sphere of the Earth" defines all underlying phenomena on the physical plane corresponding to the material effects of creation, life, and death. It is where art ends in its inward spiral, as it struggles to contain all the world's activities. Out of the mouth (Malkuth) comes the Oral Law (Elohim) — the body of the Law, as opposed to the Written Law of Jehovah. Structurally Morris's *Hearing* is invested in *Earth*, the logic or subtle mode of the element typified through Malkuth. Morris unites the lowest (Malkuth) with the higher (Elohim), but not the highest (Jehovah). *Hearing* is a symbol of the beginning of recognition and return, activated on both psychological and spiritual planes.

The letters Y-H-V-H of the Tetragrammaton imply the entire gamut of the Sephirothic Tree. Y is the initiating element of the Archetypal Realm; the first H signifies the passive receptacle of Binah within the Tree's Supernal Triad; the next six Sephira, Chesed, Geburah, Tiphereth, Netzah, Hod, and Yesod, are represented by V, the active letter instigating logic in thought; and last, the second H is the receptacle Earth or Malkuth where physical manifestation takes place.

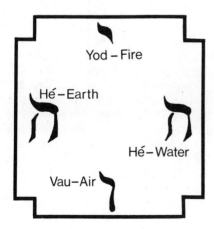

Yod-He-Vau-He produces Father, Mother, Brother, and Sister. Their structure is neurological, as when it is written in the *Book of Concealed Mystery*, Chapter 2:

33. When (the YHVH in cruciform) beginneth, they are discovered in the cranium (namely, these letters, and therein are they distributed in the most supernal part of Macroprosopus).
34. Thence are they extended throughout his whole form (from the original benignity), even to the foundation of all things (namely, as the soul of inferiors).
35. When it is balanced in the pure equilibrium (that is, when the white locks of the most holy Ancient One send down the lights or names) then are those letters equilibrated. (that is from their virtue cometh the light.)

MacGregor Mathers in the above translation observes that "in the cranium or skull," *Begolgoltha*, resembles the place of the Crucifixion in the New Testament, Golgotha. In the Cabala, the Son or the upper Microprosopos, defines the Tetragrammaton in the form of a cross. So we have a diagram where two vertical elements (Yod and Vau) resemble the functions of the forebrain and the brain-stem with cerebellum, while the two horizontal elements (Hé and Hé) approximate the two cerebral hemispheres. Thus the double opposition of the Tetragrammaton's parts are compared to the brain, although there are obvious dangers in applying this geography too literally.

Besides the equal-armed cross, another image of Malkuth is that of a young woman, crowned and enthroned — as with Duchamp's Bride for example. In a very visible dedication, Morris's recent bride becomes that sphere of focus. But this female wants to rise to her rightful place, so she ascends the Tree towards Binah according to the path of the Serpent Nehushtan. This Serpent of Wisdom is made of brass (also a metal of Venus and holy aspiration), and it encircles the Tree towards its highest branches seeking objective consciousness. Hence the base of Morris's cruciform plinth has been bound with plate bronze, a metal closely associated with brass through color and impurity, although he had originally thought of using brass.

The copper chair is not physically connected with the other objects in the tableau. Morris's chair is a tank filled with water heated to near boiling by an electrical immersion coil. Malkuth's version of the Tetragrammaton is made with debased metals. Copper is externally splendid like gold, but internally corrosive. Yet this seat remains a "throne of glory," embracing celestial man who in turn radiates the essence of wisdom, *avir* or ether. Before this throne of God resides the sphere of Schamayim, the fiery androgynous water which affects all things. So we see that heat conducted through copper and carried by the air simulates emanation from the highest source: "They carry the throne and their sweat produces the river of fire."

To the chair's left stands the zinc-coated table of Binah, the passive and dark female element. It helps to know that Binah is the negative force within the Supernal Triad at the Tree of Knowledge, just as zinc is used as a negative electrode in batteries. In effect, this table is a *tabula,* that is, a source of all the mental images which eventually sink into Malkuth. Binah stabilizes and rigidifies thought, while it produces illusions of time and ideal form.

Below Binah six wet-cell batteries in series epitomize the "electric" paths of the active Sephira: Chesed, Geburah, Tiphereth, Hod, Netzah, and Yesod. In the creation of an entire epicycle of art, these stages are crossed over and over again, each time generating "new" art styles, politics, literature, and scientific theory.

And finally to the right of the batteries, but connected to them, Morris places a bed covered with sheet lead. In the Tarot the Empress sits upon a bed-like throne. This Empress (the Hebrew letter Daleth) is given to childbirth, loving, beauty, art, and all the manifestations of actual creation. But if this bed is situated in Malkuth, and in fact is a literal translation of Malkuth, why is it covered with the Lead of Saturn, that sluggish planetary sign attached to Binah? Lead is corrosive both internally and externally. However the reason lies in the mystical transmigration of Malkuth to Binah. This appears to be the real significance of *Hearing,* the return of all materialist sen-sibilities to the Great Sea, away from an involvement with form as demanded by the Sephiroth Daath. Such reasoning would also account for Duchamp's use of lead as the material backing for objects in the *Large Glass.*

The recorded tapes for *Hearing* are composed of many questions, quotations, and retorts compiled by the artist over a period of several months. Quotes and ideas are drawn from E. H. Lenneberg, E. C. Goossen, John Lyons, Albert Speer, Jacques Monod, Ludwig Wittgenstein, Immanuel Velikovsky, Claude Lévi-Strauss, Jean Piaget, Michel Foucault, Noam Chomsky, and others. As dialogue it resembles a kind of courtroom where the artillery of twentieth-century respectable academicism is thrown at one witness (who sounds like Morris). Logical Positivism, Structuralism, Transformational Grammar, Genetic Epistemolgy, and other empirical approaches to cognition and language go to bat. The witness never specifically denies or refutes them, but he repeatedly holds out, implying that there is more to be known. An implicative relation exists between the voices — accusing, asserting, and denying — and the physical presence of the Tetragrammaton.

These voices form a deliberate triad with the metal objects in sand. More than likely, the title *Hearing* is a pun, being both an initiation exercise and a call for the contemplation of unity. In Hebrew, according to the scholar Leo Schaya, the term *"Shema"* (listen, hear, understand, obey) does not refer to hearing as a physical act, but to "faith of the heart." It is a call to man for the awakening of his inner cognitive faculties. *Shema* contains the unitive power of listening and receiving. It is in this respect significant that Morris refuses to give out written copies of his tapes, just as he does not allow tape recordings to be made of them. (After the show he plans to destroy these tapes.) As the mouth in Malkuth represents that Sephiroth's opening, the Oral Law remains the body of life, the Shekinah in Binah. The nature of such a message is received as the heart so desires. Mechanical profanation through tape recording serves as its own reminder of Malkuth.

Here we begin to realize the fruitlessness of calling this a "great" piece of art or even a work

of considerable "quality." The more we perceive the significance of *Hearing,* as is true of the art of Morris's mentor Marcel Duchamp, the less meaning it has as a precious artifact. At this stage of evolution, we are quite far from accepting the moral lessons and epistemological implications of the Tetragrammaton. For at the higher end of the artistic synthesis one finds little evidence of rationalistic mechanisms. Of course, all that has been said about *Hearing* is purely the writer's interpretation. Morris may very well still be doing floor arrangements, using metal furniture instead of lumber and industrial felt.

THE SEMIOTICS OF "END GAME" ART

Structure in the sense of a self-regulating system of transformations is not coincident with form. A stack of pebbles can be said to have form, but this mere heap cannot become a structure unless we place it in the context of the system of all its 'virtual' movements. We are thus brought to theory.

Jean Piaget

The term *'historically transgressive'* in my earlier writings describes the role of Marcel Duchamp's Ready-Mades within the evolution of modernist art.[1] Duchamp deliberately set out to short-circuit the modernist crisis of the 1960s and 1970s by producing works of art which, in fact, structurally anticipate key efforts in the present period. By producing art that had relatively little meaning for its own time — beyond being labeled 'Dada' and 'nonsensical' — the artist deliberately planted a time bomb in history. Duchamp's intention was not so much to outdo his fellow artists, but to reveal to the aware the essentially circular trajectory taken by all historical cultures. Duchamp's motives were anagogic rather than pedagogic or esthetic. When he spoke of being involved with an 'esthetics of indifference,' he was alluding to the mystic's universal axle, namely that principle of neutrality which serves as the true fulcrum for all human volition.

As I have previously suggested, Duchamp was most likely a self-initiate into the Unwritten Cabala.[2] Not only Duchamp's art after 1912 but also various photographs of the artist and much of his terminology indicate a profound understanding of the powers of the letters of the Hebrew alphabet. Armed with such knowledge, Duchamp's life became a metaphor revealing certain illusions masking human creativity. He understood that such systems function not unlike an invisible chess game with unknowing players. The simile of a chess game for various social systems is not particularly new — Saussure used the parallel sixty years ago in comparing rules of the game (ideal syntax) to the relative positions of pieces on a chess board (everyday usage). And this same example has since been expanded by certain linguists and semiologists. It is, nevertheless, difficult to make any generalization about diachronic shifts in language except to observe that successive structures seem to move from less to more probable states, rectifying existing dissymmetries while planting the seeds for new imbalances. Yet in the area of esthetics, sign systems seem to thrive on competition between artists who vie with each other in the production of internal mechanisms of destruction, i.e., 'new' styles and mannerisms.

Similarly, chess players move into occupied squares by capturing opposing pieces, gradually sharpening or focusing the complexity of the board. In a not unsimilar sense, one could describe sacred ritual as the control of psychic and physical oppositions by consciously acting out their dynamics. On the other hand, cultures that fall into *historical* gamesmanship, gradually lose all sense of the sacred mysteries in their substitution of esthetic and practical considerations. Art thus becomes a series of game strategies played against time. For the artist, "winning" constitutes one of a number of allowable moves for a given time slot. Fully realizing this situation, Marcel Duchamp, calling himself "a child of nickel and platinum," removed himself from an almost atrophied artistic situation, intent on devoting himself to the role of a super catalyst, a dead metal excellent for precipitating chemical reactions which could otherwise only take place with great effort. This begins to explain the artist's little known chess treatise of 1932, *l'Opposition et les Cases Conjuguées sont Reconciliées.*[3] The theory put forth by Duchamp and his co-author Vitally Hal-

1. Photo of Duchamp Playing Chess. From *Marcel Duchamp* by Robert Lebel © Trianon Press.

berstadt involves a rather obscure situation in end-game strategy where 'heterodox opposition,' a term coined by the authors, takes priority over 'orthodox opposition.' But at no time during Duchamp's career was it explained why two chess masters should produce a sizeable and elaborate book on a situation which virtually never arises in tournament chess. Yet if Duchamp's Ready-Mades define many of the closing moves for the game of art, then it is quite probable that his chess book is a continuation of the same theory.

Various occult aspects of the history of chess point to such a conclusion. Duchamp's end-game involves only the Kings and a few Pawns on each side. In hermetic terms the Kings signify the element Water while the Pawns serve as the element Earth. Brought together these elements represent the limits of exhaustion in the alchemical and cabalistic tradition. Crucial stages of Duchamp's and Halberstadt's theory involve specific geometric areas on the board divided by a 'hinge' or 'hinges.' This geometry of the hinge strongly reflects some of the gnostic and cabalistic diagrams representing the *Vesica Piscis* or Fish's Bladder. The *Vesica* is a composite diagram revealing the stabilizing power of the Center, that is, knowledge of where balance lies in linking spirit and matter. It is somewhat revealing that in closing their book the authors observe that:

> The opposition (orthodox or heterodox) is based on the constant relation of the 2 squares occupied by the K's, and its general formula can be applied indifferently to all the squares of a portion of the chess board.
>
> It is a *cipher* by means of which we establish, a priori, the equilibrium between the K's. . . .
>
> It is also important to add that, with the opposition (orthodox or heterodox) or by the occupation of sister squares, no more than a draw can be obtained.
>
> For in order to win, manoeuvers of breach of opposition must be used. It is difficult to make generalization about such manoeuvers as they enter the realm of *tactical* utilization of an advantage and vary with each position.[1]

Again we meet the term *indifference* as when Duchamp writes of "indifferently" applying the rules of opposition to all feasible squares on the board. Perhaps what he is saying is that at a certain point in history the allotted moves open to artists are strictly controlled by mathematical rules, passion and artistic volition no longer being very important. In preparing for this "crash-splash" as Duchamp terms it in his *Green Box* notes, the artist becomes a kind of animated cartoonist devising a film strip for certain cinematic permutations.[5]

The class of art works just prior to the "crash-splash" would appear to depend upon the strict use of axes of symmetry. One can easily recognize such a dependency in much of the Color-Field painting and Minimal or Object Art of the 1960s. Painters such as Barnett Newman, Gene Davis, and later Kenneth Noland are prime examples of artists who managed to break out of the formalist format of lines and masses irregularly balanced on a two-dimensional picture plane. Such proportion depends upon some degree of asymmetry in both dimensions. What most typifies Color-Field painting is its unidirectional composition. Paintings by Newman and Davis usually depend upon a single horizontal axis of symmetry, while Noland's striped canvases of the late-1960s depend upon a vertical axis of symmetry, the left side mirroring the right. Besides axial or mirror symmetry it seems evident that works in this particular group may be expanded to include examples of rotational and translational symmetry. Frank Stella's shaped pinstriped canvases and his later Protractor Series exemplify both. The uses of symmetry in this context would seem to depend upon a kind of progression of possibilities. In his *Green Box* notes Duchamp alludes to this as "This symmetrical fashioning of the *situation distributed* on each side of the vertical axis. . . ." He continues to describe the generation of such axes until:

> —As there is gradually less differentiation
> from axis to axis, i.e. as all the
> axes gradually disappear
> in a fading verticality the front and the back,
> the reverse and the obverse acquire a
> circular significance: the right and
> the left which are the 4 arms of the front and
> back. melt. *along the verticals.*[6]

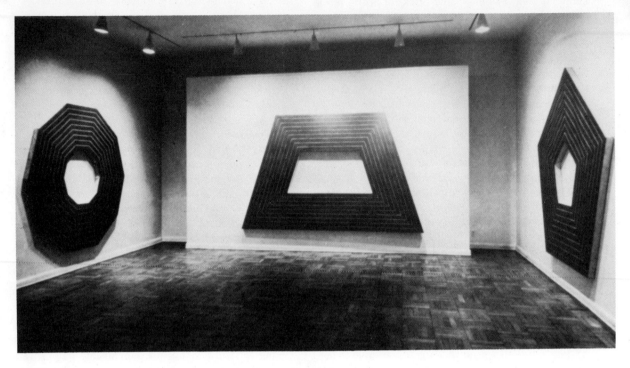

2. Frank Stella, January–February 1964 exhibition at Leo Castelli Gallery.

Duchamp is describing a situation where a lingering vertical axis gradually contracts to a single point, allowing for the "circular significance" or rotational symmetry. Semiotically, these vague descriptions represent a sequence of mathematical operations towards the "crash-splash" — about which more will be explained later. In passing it should be mentioned that both Noland's and Stella's new painting avoids this semiotic abyss by moving back to historically earlier formats.[7]

The particular structures engendered by nonobjective painting and sculpture are concerned with Gestalt complexity and its reductive capacity through the neutralization of oppositions. Like language and sentence structure, representational art is doubly articulated. It contains the equivalent of a grammar and a phonology. But the loss of the first articulation leaves only the second or phonological level. So the Gestalts of nonobjective art most closely parallel the concept of the 'distinctive feature' found on the paradigmatic plane of linguistic analysis. The loss of all such oppositions is anticipated in the hermetic tradition followed by Duchamp with the use of a double semiotic structure, a device that pairs Gestalt unity with materiality or phenomenological unity. The conflict between picture plane and depth of canvas stretcher in Stella's shaped paintings is just such an ambiguity.

Dealing with the properties of materials, this second type of structure can best be expressed with the aid of a simple Venn-diagram. Here the rectangular boundary represents the 'universe of discourse' or the limits of any art work. The inter-

locking circles within the rectangle represent the members of a set. The set is created when attributes are shared by at least two members. These are shown by the overlapping areas of two or more circles or members of the set. Such set relations are usually *simply connected* at this level, meaning that they merely have a middle member sharing the same or different attributes with at least two other members. Logic demands that a set must have at least three members. Avant-garde art reaches the stage of what might be called "critical mass" when it has exhausted all forms of Gestalt opposition. At this point the semiotic shifts to the use of *two sets*. Duchamp refers to this as "AFTER THE 3 CRASHES = SPLASH".[8] In essence this means that three semiotic structures have been progressively eroded, and that the fourth and last remains.

Perhaps Duchamp's most interesting Semi-Ready-Made is one which anticipates the demise of Color-Field painting, *Fresh Widow* of 1920. This is a miniature French window painted light green, corresponding to its new arrival at the alchemical element *Earth* and typified by the use of two sets. *Fresh Widow* is a very dense pun which announces the death of the last 'male' semiotic device, namely the Gestalts that balance composition in nonobjective painting. But because this Semi-Ready-Made is symmetrical and contains a set of eight panels, its superficial appearance is that of a painting just on the brink of the "crash-splash." As in

the title, the ambiguity exists in a conceptual conflict between two and three-dimensional cues, or the tension between illusion (a picture plane *to be seen through*) and physical evidence of the object.

On a more subtle level this concerns a conflict between the Hebrew letters *Heh* and *Daleth*. *Heh* is male and is represented by a window or "wind-door," an opening to see through, to provide visual access so as to allow control of activities outside the viewer's immediate domain, that is, through the mind. *Heh* alludes to the constant conflict between conceptual imagery and concrete physical experience. *Daleth* is signified by a door, or any womb-like aperture through which one passes from one state to another. So here the conflict resides between illusionary conceptual creation (male) and rock-bottom organic creation (female). In any case *Fresh Widow* depends upon two sets of relationships. The first is the series of eight window panes. The second is a set based upon three members: a) the anticipated ability to see *into* a totally darkened room, b) the square wooden structure of the window pane, and c) the realization that the panes are indeed covered with black leather, opaque animal skin. So in both fact and allusion *Fresh Widow* is a false window which must be opened physically to become a door which heretofore has shut out organic existence.

Quite possibly no one took Ad Reinhardt very seriously when he wrote about his 'black' paintings, "I'm just making the last paintings which anyone can make." But given Reinhardt's many years of research into a variety of religious philosophies, it seems more and more likely as one reads his later essays that he had come upon many of the same truths which had earlier motivated Marcel Duchamp. If the major goal of any adept is to center his being through the absence of oppositions experienced by the average person, then Reinhardt's description of his final canvases very nearly approaches that ideal:

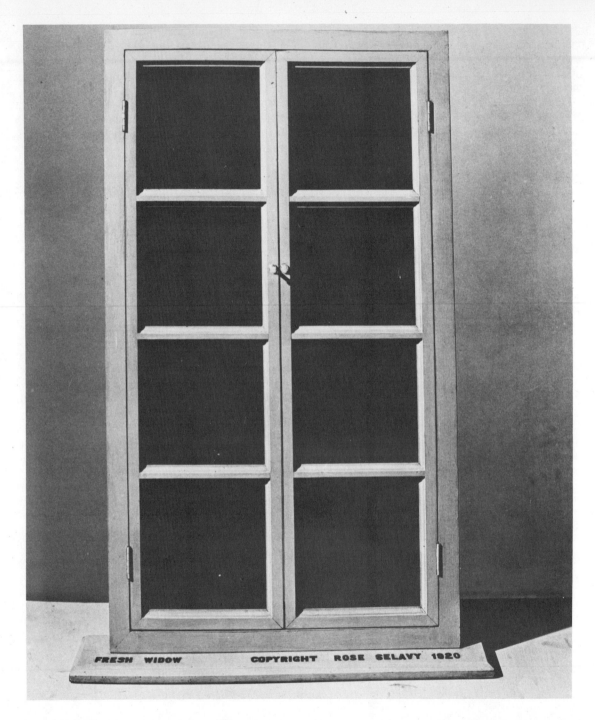

3. Marcel Duchamp, *Fresh Widow*, 1920. Collection, The Museum of Modern Art: Katherine S. Dreier Bequest.

A square (neutral, shapeless) canvas, 5 feet wide, 5 feet high, as high as a man, as wide as a man's outstretched arms (not large, not small, sizeless), trisected (no composition), one horizontal form negating one vertical form (formless, no top, no bottom, directionless), three (more or less) dark (lightless) non-contrasting (colorless) colors, brushwork brushed out to remove brushwork, a mat, flat freehand surface . . . which does not reflect its surroundings — a pure, abstract, non-objective, timeless, spaceless, changeless, relationless, disinterested painting — an object that is self-conscious (no unconsciousness) ideal, transcendent, aware of nothing but Art (no anti-art) . . .[9]

Reinhardt's near-black cruciform paintings are both axially and rotationally symmetrical, but tend to fade out into an anonymous picture plane, as Duchamp describes in his note.[10] However Reinhardt's 'black' paintings are just on this side of the "crash-splash" since their ambiguity involves an almost undiscernable cruciform of primary color squares in opposition to the physical support itself. The square panes of *Fresh Widow* number eight — the number of summation and death; Reinhardt uses the cross, symbol of immortality in physicality, and its squares number nine, the cipher representing penetration and higher knowledge. Another reason for Reinhardt's use of this particular motif can be found in the Waite Tarot Deck, the twentieth Major Arcana, "Judgement," whose letter is *Shin*. "Judgement" marks the physical end of the "Great Work." Death and rebirth fuse into a single idiom, and passivity takes its place alongside aggression. As with the near-black paintings, a banner held by the Angel Gabriel measures five-by-five units and its cross occupies nine units. The square is the geometric shape of complete materialization, while black signifies the final cabalistic Earth and the last means of neutralizing oppositions. So in a sense that only another hermetic philosopher would understand, Reinhardt created the last possible paintings — before the "crash-splash."

With typical irreverence Duchamp anticipates the "crash-splash" through works such as his Ready-Made urinal entitled *Fountain*. Anecdotes about the urinal are common knowledge; what is less understood are the cabalistic references surrounding *Fountain*. The work includes one axis of bilateral symmetry and a set of relationships: a) the normal upright position of the urinal as a plumbing fixture, b) Duchamp's physical displacement of the urinal, and c) the urinal's new horizontal position as a 'work of art.' So in effect, *Fountain* anticipates the final "splash." Here Duchamp compresses the necessary information into several interlocking puns. The bold signature on the fixture, "R. Mutt" is simply a homonym for the German word, *armut*, meaning poverty.

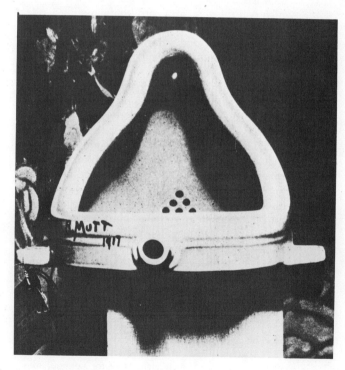

4. Marcel Duchamp, *Fountain*, 1917.

In cabalistic literature the Tree of Knowledge is occasionally referred to as a "Fountain" whose lower sephiroth serve as catch basins for the cascading waters. However if the Tree is conceived anthropomorphically as the body of Universal Man, the "Ancient of Days," then each work issues from the archetypal body as bodily waste, hence Duchamp's small semiotic equation of 1914:

$$\frac{arrhe}{art} = \frac{merdre}{merde} \quad \text{[11]} \qquad (or: \frac{Signifier}{Signified})$$

The relation of art to the anal stage of infant development remains a Freudian truism. But Duchamp encompasses the idea of the inauthenticity of art and bodily wastes to an important Old Testament allusion: not only does the letter *Shin* which controls the Tarot card "Judgement" signify sharpness and acidity, it also spells out the Hebrew word for *urine*. Urine represents the waters of the Tree at their most stagnant, parallel perhaps to Duchamp's use of the term *Rrose Sélavy,* suggesting the term *arroser,* meaning a moistener, or in argot, a urinator. This "fountain" produces a kind of smoke, or a mist or cloud, representing degenerate forms void of any degree of spiritual Light. So gradually a kind of anagogic meaning appears. What begins as an alchemical metaphor for illusionary presence, namely Water, becomes with the "crash-splash" literally a kind of liquid excrescence, a sort of residue which falls to the bottom of a receptacle, settling as it does so. Again, both the exoteric meaning of the Hebrew letters and their hermetic powers are fused into the same container. In his *Green Box* notes Duchamp comments on the progress of the "spangles" which

> . . . rise, *into:* a liquid elemental
> scattering, seeking no direction, a *scattered Suspension —*
> snow on their way out at B, Vapor of inertia, but keeping
> its liquid *character* through instinct for cohesion the only
> manifestation of the individuality of the illuminating gas
> in its habitual games with conventional surroundings.
> What a drip! [12]

And finally the "crash-splash" is signified by one of Duchamp's first post-painting works, the *3 Standard Stoppages* of 1913-1914. The French title, *3 Stoppages Etalon* combines the ideas of invisible mending with a given standard for weights and measures — both themes acknowledged by the artist.[13] Here Duchamp alludes to an important cabalistic secret, that is *the mending of the measure of things* once it is irreparably broken within the domain of esthetic sensibility.

Duchamp best describes the *Stoppages* with this note:

> The idea of fabrication:
> If a straight thread, horizontal, of one meter length falls
> one meter in height on a horizontal plane surface while getting
> out of shape willingly (to its pleasure) and presenting a new
> figure (appearance) of the unity of length (slowness).
> Three exemplary results from the conditions almost similar:
> in their consideration each to each are a reconstitution approaching the unity of length.
> The three standard stoppages are a shortened (or diminished)
> meter.[11]

The resulting assemblage consists of three threads, each glued to strips of dark blue canvas and then mounted on a glass panel. Accompanying this are three wooden templates with the curved outlines of the dropped threads. In essence what Duchamp is presenting is an anticipation of the logic format to be used thirty-seven years later by Jackson Pollock in order to create the first informal 'field' or 'drip' paintings — but with one important difference which is concerned with the number 3. In order to make the *Stoppages* function as a work of art Duchamp was aware that his activities must result in two specific sets covering permissible variations.

Here it must be explained that the dynamics of cabalistic movement are represented by a perpetual coming-into-being. Descending spirit is gradually transformed into matter, ascending matter is reconverted into spirit. In its purest physical form

5. Marcel Duchamp, *3 Standard Stoppages*, 1913–14. Collection, The Museum of Modern Art, New York: Katherine S. Dreier Bequest.

spirit is represented by electromagnetic radiation, while gravitation is the most literal stage of the material process. Gravitation and its manifestations signify the initial implosion of pictorial elements into a kind of esthetic solidity, thus visual form left completely to the most omnipresent process in nature. The set generated by Duchamp's thread-dropping activities consists of a) the quasi-random behavior of each meter-long thread, b) the force of gravitation exerted on each thread, and c) the flat, horizontal position of each dark blue area of canvas situated on the floor. These ritualized circumstances contain essentially the same parameters used by Jackson Pollock for his best known "Action" paintings.

Duchamp referred to this work and others like it as "canned chance." The notion of what is "canned" lies behind the principle of Duchamp's second set for the piece. We are given one note suggesting what this might be.

The game of barrel is a very beautiful "sculpture" of cleverness (skill). It is necessary to record (photographically)
3 successive performances and not to prefer "all the pieces in
the frog" to "all the pieces outside" nor especially to a good
average.[15]

One must understand that in this instance all manual skill in making art has been reduced to the simple expedient of tossing small objects into a container, though in such a way that all the objects neither land *in* the container nor *outside* it, but *both* inside and outside. The principle cited in this case refers to one of the pivotal ideas of Pythagorean mathematics. Learned members of the Pythagorean school conceived of the universe as a limitless space called the *apeiron*. The *apeiron* is defined by fire atoms or *perainon* ("something that limits"). Consequently the inner *apeiron-filling* is theoretically separated from the external *apeiron-surrounding* by the infinitely narrow border of the *perainon*.[16] In a field of natural, quasi-random movements and forms a defined or conceived space is made possible by some delimiting operation so that the viewer is both aware of the inner field and the field as it hypothetically extends beyond the boundary of the picture plane. Thus it appears that Duchamp's "canned chance" is the delimiting step needed to make any infinitely extended, random plane or space conceptually possible. Much of the emotional and kinesthetic mystique behind "Action Painting" becomes understandable once it is realized that such work depends upon no conscious formal device. The fact that Pollock worked on huge, unprimed, unstretched canvases seemed idiosyncratic at the time, but it is evident now that the act of dancing-spilling-dripping on a canvas which had to be cut down as a kind of *post-facto* consideration was an altogether necessary sequence. We can begin to understand the motivation (and criticism) that led to the cutting of Morris Louis's unstretched canvases *after* the artist's death. It really didn't matter where the canvases were cut as long as they were divided through the stained areas — but that remains a point of irony which only someone like Duchamp would enjoy.

The set used to make "art" involving drip or staining technique consists of a) the area of the inside canvas, b) the cut separating the used from the discarded canvas, and c) the unused painted canvas. In deliberate contrast, Duchamp structured his *3 Standard Stoppages* so that the three threads were *not* cut when the dark blue canvas underneath was divided into rectangular sections and mounted on the three glass panels. Since the meter-long threads were contained within the boundaries of each panel, Duchamp was compelled to make *three* panels in order to construct a second set.

APEIRON-FILLING PERAINON

APEIRON-SURROUNDING

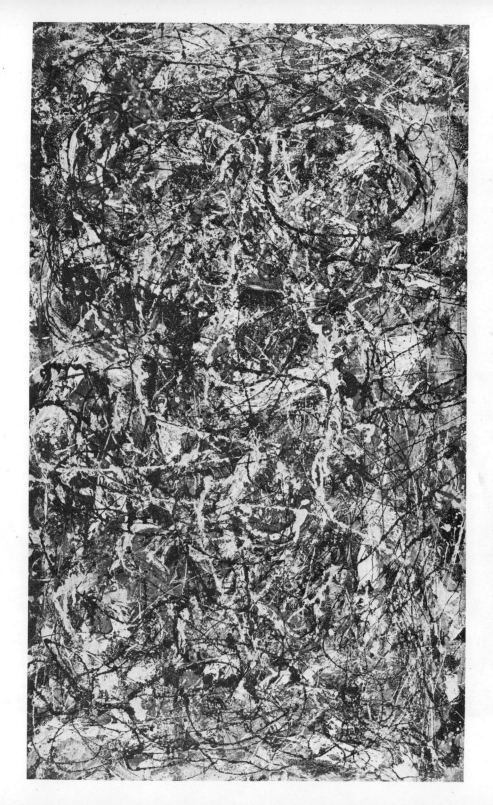

6. Jackson Pollock, *Full Fathom Five*, 1947, 50⅞" x 30⅛", oil on canvas with nails, tacks, buttons, keys, coins, cigarettes, matches, etc. Collection, The Museum of Modern Art, New York: Gift of Peggy Guggenheim.

7. Richard Serra, *Casting*, 1969, lead. Courtesy Leo Castelli Gallery.

8. Robert Morris, *Untitled*, 1968, 30' x 30', thread, mirrors, asphalt, lead, aluminum, felt, copper, steel. Courtesy Leo Castelli Gallery.

There are several possible variations on this second set. Most of these have been developed in the "Anti-form" or "Process Art" of the past five years. For instance, Richard Serra's *Casting* of 1969 is semi-sculptural in the Pollock tradition. Instead of liquid paint, Serra poured molten lead in a line along the corner of a wall. Once the lead hardened and cooled, Serra pulled the castings away one by one. The result is a set through duplication similar to Duchamp's *3 Standard Stoppages*.

Robert Morris's *Untitled* of 1968 at the uptown Castelli Gallery consisted of a room filled ankle-deep with industrial felt and thread waste, asphalt, aluminum, brass, zinc, copper, and steel. Again, the materials themselves were not important except for their 'natural' state but their distribution according to the laws of gravity was critical. Morris provided a second set within his environment by positioning a number of mirrors on the floor. As a result, a viewer unconsciously constructed the set: a) all materials on the floor, b) the mirrors themselves, and c) the images of the materials in the mirrors.

Situated in history, Duchamp's "crash-splash" came nearly twenty-five years before the exhaustion of the semiotic began to make itself felt in avant-garde circles. But in historical sequence the "splash" acts as a kind of starting gate or signal, allowing the formulation of many kinds of visual art free from the concerns of traditional modernism — not the least being the tendency of art to explore the roots of its own structure.

1. See p. 46 of my book, *The Structure of Art*, New York: George Braziller, 1971.
2. See "Duchamp's Bride Stripped Bare."
3. Duchamp, Marcel and Halberstadt, V., *Opposition et Cases Conjuguees sont Reconciliees*, Brussels: L'Echiquier/Edmond Lancel, 1932 (St.-Germain-en-Laye: Gaston Legrain). This 112 page paperback was printed trilingually in French, German, and English. The cover for *Opposition and Sister Squares Reconciled* was designed by Duchamp according to a rather curious procedure. The letters for the title consist of a photograph of the stenciled image using the sun's rays as a light source. A negative of this "uncontrolled deformation" by the sun was used, suggesting that just as uncontrolled gravity is the most powerful force affecting the last significant moves in art, uncontrolled radiation, its polar opposite, can become the means by which we understand the entire process.
4. Duchamp and Halberstadt, *op. cit.*, p. 112.
5. Duchamp, Marcel, *Notes and Projects for The Large Glass* (selected, ordered, and introduced by Arturo Schwarz) New York: Harry N. Abrams Inc., 1969. There are several instances in the notes where Duchamp uses the term "crash-splash" or variations of it, notably with note 112. In the original Duchamp employs the phrase "fracas-éclaboussure," which has the added implication of being splashed with some undesirable substance, that is, to get all the blame for an act that is not one's fault — as is certainly the case with the artist connected to the "crash-splash."
6. Duchamp, *op. cit.*, note 34, p. 74.
7. Stella's exhibition last season reveals a tendency to 'compose' with unambiguous three-dimensional elements; Noland's recent paintings are a hybrid of stain painting and Neoplasticism.
8. Duchamp, *op. cit.*, note 115, p. 170.
9. Rosenstein, Harris, "Black Pastures" in *Art News*, vol. 65, no. 7, Nov. 1966, p. 72.
10. Duchamp, *op. cit.*, p. 74.
11. Duchamp, Marcel, *Marchand du sel*, (Michel Sanouillet ed.) Paris: Le Terrain Vague, 1958, p. 33.
12. Duchamp, *Notes and Projects for the Large Glass*, note 101, p. 156.
13. On page 444 of Arturo Schwarz's volume *The Complete Works of Marcel Duchamp*, Duchamp explains to Schwarz that he decided upon the word "Stoppages" after seeing the sign over a shop for invisible mending. According to Duchamp at a seminar at Yale University in 1961, the "standard stoppages" were the result of an idea provoked by the official measure under glass of the French kilogram and meter in a government building in Paris.
14. Duchamp, *Notes and Projects for the Large Glass*, note 96, p. 150 (not the editor's translation).
15. Duchamp, *Marchand du sel*, p. 32 (translated from the French).
16. Cleve, Felix M., *The Giants of Pre-Sophistic Greek Philosophy*, The Hague: Maetinus Nijhoff, 1965, vol. 2, pp. 461-463.

THE ARTIST AS SHAMAN

In the postscript to his controversial book of the 1950s, *Art in Crisis*, Hans Sedlmayr suggests a remedy to the problems of artistic fragmentation; it reads in part:

> The whole diagnosis of our time can, indeed, only yield results if it is used to refer back to ourselves, so that we may see what manner of men we are — and become different from these. . . .
>
> We must not fail in our trust that the individual by healing himself will contribute to the healing of the whole; for there is such a thing as solidarity in suffering. Moreover, the diseased condition of the whole had its starting-point in the rotting away of individual cells. It will only be overcome by men who have within themselves mastered this radical disturbance, and have thus renewed themselves.[1]

Contemporary art has finally arrived at the critical stage of its crisis, one inducing the dissolution of the component structure of art until it no longer exists in any functional capacity.[2] Such a stage began after the *formal* disintegration of the art object had occurred. Furthermore the *material* disintegration of the art object (Gilliam, Ryman, Saret, and Morris for example) is pretty well conceded, while the *conceptual* unraveling of the work of art (Kosuth, Bochner, Soundheim, and others) is under way. This leaves a significant component of the art equation mainly unexplored. At this most crucial and sensitive point the artist focuses upon the primal aspects of his own creative motivations. In our times, art begins with the psychological make-up of certain individuals who to some degree usually suffer from psychoneurosis. While modern society contains more than its share of neurotic individuals, only a few produce art sufficiently unique to gain wide attention. Nevertheless, one would think it relatively easy to find a good working definition for the artistic temperament in psychoanalytic literature. The opposite is the case; in general this literature tends to deal merely with formal descriptions and medical case histories, since very little is understood about art itself. At one time psychoanalytic circles debated whether art expressed neurosis in sublimated form or was the catharsis of neurosis, that is, the means of working out neurotic syndromes. But as art therapy became an increasingly useful tool, the tendency was to dissociate neurosis from art-making and to see the latter as a manifestation of "healthiness."

However, the question remains: are the neurotic tendencies designed into certain works of art unique, or do they exist as paradigmatic symbols of the entire society? Possibly this is a question relative to the degree of social cohesion found at any given point in a culture's life-span. The more closely knit and integrated a group is in terms of its religious and socio-economic agreements, the less opportunity personal neurosis has to function as part of an archetypal model. On the other hand, as mythic structures deteriorate, the archetypes vanish and it is the "trials" and psychodramas of the individual that provide us with our sense of direction. Since all historic art-making is the sum-total of the individual's emotional potential, it is likely that art in its last stages constitutes a structural reversion to the infantile stages of human development.[3] At this level art deals with those "nuclear" relationships established by a child in its first months of life. In such instances, the artist foregoes the more socially accepted forms of sublimation — such as the art object and public attention — and focuses increasingly upon his own body and the residue of responses existing between himself and his blood-relations. The Freudian anthropologist Géza Róheim has characterized this process as "genitofugal libido," where primary urges and libidinal forces are redirected from the object into the body (of the artist).[4] Dur-

ing this period the person who has sublimated "his sense of loss" through objects still has lingering desires to retain these objects (art or whatever form they may take). But he also feels a sense of positive being flowing back into his body, a new found ability to reach others emotionally and sensuously.

Throughout history fairly constant pressure has been applied to the artist, restricting his output to some set of "higher" (read "socially useful") truths. In this respect the nineteenth century concept of "art for art's sake" is relatively unique, since even at the beginning of the present century it was mainly considered irresponsible and frivolous. So one can begin to understand why there is so much disdain directed towards those contemporary artists who are not primarily concerned with object-making. Yet it is precisely those artists involved in the most naked projections of their personalities who will contribute the most to society's comprehension of its self. In this respect Dennis Oppenheim has arrived at a thoroughly original approach to the problem of presenting these psychic dimensions.

Since 1967 the bulk of Oppenheim's art has depended upon a fairly explicit set of conceptual techniques: sensory substitution, translocation (the relocation of events and spaces), and transmogrification (the shifting of shapes into different forms). Oppenheim's early ecological projects dealt with work tasks and alterations made upon the environment. In his documentations the artist removed himself from the final physical evidence. But by 1970 Oppenheim increasingly projected his bodily activities into the documentation. Some of these works deal with feats of strength and endurance, others with self-inflicted wounds and the recording of fear-inducing situations. Interestingly, Oppenheim finds no significance in the masochistic aspects of these acts, but he does place some value on their longevity as signs or permanent aspects of his personal history. This abreactive recapturing of past events is one of the most important aspects of psychotherapy.

In a number of ways, the methods of Oppenheim's art draws nearer to the traditional techniques used by the shaman in so-called primitive societies. Because of his unique ability to bring about social harmony and heal the sick, the shaman is regarded within his group as an extremely powerful, if not magical, person. But he comes by these powers only after long periods of psychological sickness followed by stages of self-induced cure. The process of becoming a shaman is a treacherous one. In some respects the shaman's ordeal runs parallel to the religious-mystical experience of undergoing a psychic "death" and "rebirth." There are often references to the fact that the shaman began as a man with certain severe disabilities. The process of compensating for physical deformities or mental instabilities is natural enough, but there is often a compulsiveness and intense obsessiveness about the shaman's pre-initiation activities that borders on the demonic. He is driven by "spirits" that carry him deeper and deeper towards the origins of his sickness. Often the shaman has no wish to take on such a calling, but he has no choice.

> Translating this into modern terms intelligible to us, a psychosis that is emerging for some reason or other is so strong that the only way out open to the individual attacked by it is to escape from it into shamanistic activity, that is to say essentially by means of artistic productivity, dancing, singing, etc.[5]

It would be a mistake to imply that Oppenheim has consciously pushed his work in any specific direction over the past five years, or that he is deliberately involved with shamanistic technique. The most revealing of Oppenheim's pieces centers around his recent show at the downtown Sonnabend Gallery (January 6-20). There is a curious autobiographical linkage between these environmental works, but Oppenheim senses this only partially, in fragments.

Polarities (1971-72) is the key to this group. With the death of his father in November of 1971, the artist felt an immediate need to deal with its personal consequences. He searched his father's writing desk, going through dozens of drawings and written papers until he found one that seemed to be his last sketch. Oppenheim felt that it was "important that this was the last movement of his hand across the page." This near-diamond shape

appears to be a singular marking. The artist then came across a drawing by his daughter, suggestively anthropomorphic, which was one of her first efforts. Oppenheim enlarged the two drawings several hundred times, plotting the results with red magnesium flares in a field in Bridgehampton, New York. These were ignited as Oppenheim flew overhead in a small plane, photographing the effects in semi-darkness. Relationships between these acts provide a generation bridge and a set of sexual poles for the artist's own identity. (In a related work, Oppenheim calls the video-taped transfer drawings with his son and daughter ". . . a method for entering the past; consequently it is a process of graphic duplication where he simulates the reflexes of his son and in so doing returns to age eight or nine.) That the artist should fly over the illuminated enlargements of his father's and daughter's drawings is in itself typically shamanistic. For the shaman magnifies every human gesture until it assumes archetypal or collective importance. In such instances the shaman may dream of flying while penetrating the psychic depths below.

A neurosis isolates the personality from most social and sensual contexts; sublimations gradually untie this need for protection and restriction. At an early stage the artist is a detached "manipulator" of materials at a distance. This happens with Oppenheim's decomposition pieces, as, for instance, the ladders in which all materials have been reduced to grains the size of sawdust and stratified in transparent cones. Gradually the artist's sublimations assume a more personal and intimate form; his interests extend from inert materials to the most essential human relationships. But why has this happened only recently; why is art only now moving in this direction? In retrospect, it appears that the restrictions of the art context never allowed for it. Surely Van Gogh and Soutine derived pleasure and temporary stability from the act of producing paintings, but the crucial catharsis of making art through acting out memories and key relationships was not possible at that time in history. This is no longer the case; gradually the artist is being released from a fixation with object-substitutes.

In my talks with Oppenheim it became obvious that there was for him considerable uneasiness in discussing some works. While these perhaps were made in the form of public confessions, there were details still too painful to reflect upon. For instance, a piece dealing with the removal of hubcaps is obsessively repetitious. The gallery floor is strewn with automobile hub-caps while a set of hands on a T.V. monitor repeatedly removes a hub-cap with a tire iron. The click-click of the tool against the tire rim is an absurd mechanical counterpart to the prolonged chanting accompanying the investiture of a shaman. Such chants are never discursive; they appeal neither to the mind nor the emotions, but draw the participant inward toward his own natural powers, the source of strength and vitality.

One space contains a double loop of tracks and two model railroad engines in constant motion. A red spotlight is focused on one of the four crossings. The running of the engines is accompanied by a sound tape of the artist chanting over and over certain temporal specifications — 11:22, 11:22, 11:22, 11:22, 11:22 . . . 1988, 1988, 1988, 1988 . . . 10th, 10th, 10th, 10th, 10th . . . June, June, June, June, June. . . . Oppenheim has described his reasons for making *Predictions* (see installation photograph).

The artist's interests in traffic flow and statistical patterns for railroad accidents are a rationalization of prediction technique. But Oppenheim "concentrates" (the shaman's trance) upon the real railroad crossing, thus establishing a predictive model based upon his own intuitions.

Adrenochrome, dealing with a fragment of Oppenheim's medical history, uses three components: one gram of *adrenochrome* (oxidized) set on the apex of a pyramid base, a color slide projection of an adrenochrome crystal magnified 500 times, and a tape-recording of a letter from Oppenheim's doctor regarding his patient's past mental condition and his medication needs. Oppenheim provides us with the origins and effects of this chemical (see installation photograph).

So in effect, Oppenheim has formalized (rendered into "geometry") the chemical origins of his earlier mental collapse. He has chosen a partic-

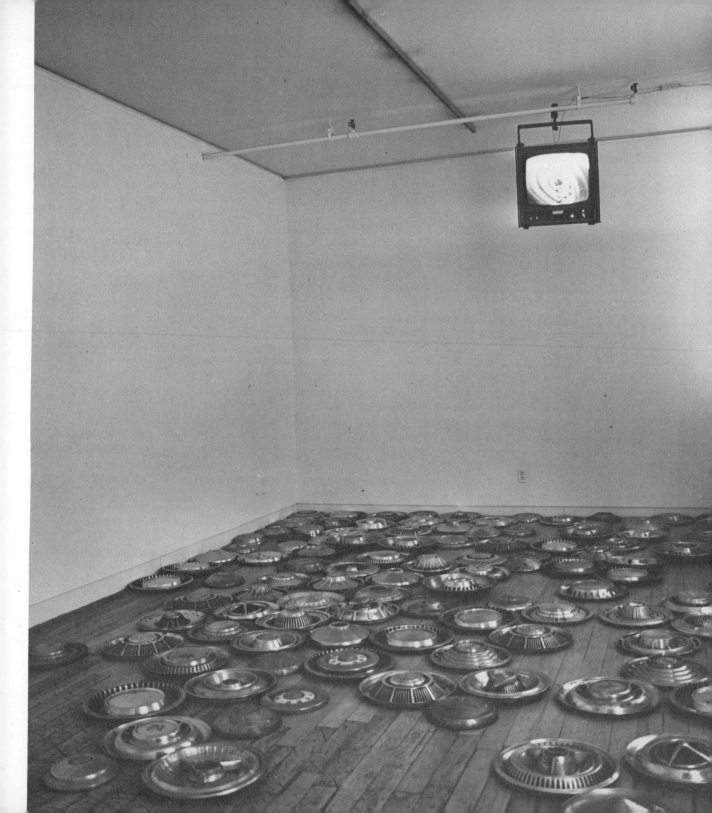

ularly elegant example of the crystal and regards its red image as a kind of painting or sculpture. In a sense he has reified what previously represented a purely emotional experience. Using Claude Lévi-Strauss's description of the "bricoleur," Oppenheim "does not confine himself to accomplishment and execution: he 'speaks' not only *with* things, as we have already seen, but also through the medium of things — giving an account of his personality and life by the choices he makes between the limited possibilities." [6] We ordinarily speak of "internalizing" experiences, but Oppenheim seems to derive a particular abreactive satisfaction by "externalizing" what has been manufactured in his own body. (His 1970-71 *Gingerbread Man* piece testifies to that.) Even adrenochrome's chemical instability and the difficulties of isolating it are seen by the artist as consistent features. And yet Oppenheim claims he has made no deliberate attempt to sever or isolate the elements of his past medical history; the work, and his attitudes towards the work, remain, he feels, quite formal and aloof. In April of 1972 Oppenheim made *2000' Shadow Projection/Carbon Arc Search Light/Trumpet* at Batavia, New York in memory of his father. In a sense that is difficult to define, this remains one of the most powerful and mystical works produced by the artist. Standing directly in the center of a beam of brilliant light, Oppenheim's body splits the beam in two. He blows single, sustained notes on a trumpet for the duration of a breath. These occur at intervals of about twenty to twenty-five sec-

onds each. In a metaphorical sense these trumpet sounds resemble the ritual bringing forth of the *pneuma*, the spirit or "breath of life." In Hebrew the name-word "*Aleph-He-Yod-Te*" is not uttered but is breathed, and represents the cycle from spirituality to materiality and back again. Thus the sound of the trumpet fills the space created by the darkening shadow of Oppenheim's body: "As I blow into the horn away from the light, the sensation of being *in two places at once* begins to take hold." As a result, the two "images" that Oppenheim has created are both negative; one cannot be seen and must be repeated, and the other remains the *absence* of light. Quite literally there is a biblical consistency here that transcends the artist's concern with his own bodily juxtapositions.

Possibly we are just beginning to understand Marcel Duchamp's multiple pun which, twice distilled, reads "*éros c'est la vie.*" *Eros*, of course, is never satisfied, but during the later phases of cultural decline it become insatiable. In art the worship of objects assumes all the appearances of a religious cult. And yet with the acquisition of more and more prized objects, more and more "knowledge," society increasingly removes itself from the "good object" — in the words of Géza Róheim, "nothing satisfies like the original nipple." So it is left to the most original artists of our times, an artist like Dennis Oppenheim, to shamanize us into realizing our true condition. Thus, only by artistic means can the originally-sick man, the shaman, mutilate his body, chant prayers in

1. Dennis Oppenheim, *Violations, December* 1971–1972. Installation view at Sonnabend Gallery, 420 West Broadway. Courtesy Sonnebend Gallery, New York.
Dennis Oppenheim: "The hub-cap piece related quite simply to a manual act of removing an object, or a reductive sculptural process. The material (hub-caps) was lifted on the West Coast and shipped here."

the fields, invert the evils of his tribe, and in do-
ing so draw people away from substitute objects
and back toward the ancient memories of life and
productivity.

1. Hans Sedlmayr, *Art in Crisis: The Lost Center* (translated from
 the German by Brian Battershaw) Chicago: Henry Regnery
 Co., 1958, p. 254.
2. Jack Burnham, "Objects and Ritual" in *Arts Magazine*, De-
 cember-January, 1973, pp. 28-32. The interpretation of a
 part-by-part decomposition of the social fabric is brought out
 in alchemical texts and the anagogic readings of many of the
 world's greatest sacred writings.
3. Burnham, op. cit., pp. 30-31.
4. Géza Róheim, *The Origin and Function of Culture* (1943)
 Doubleday & Co., Inc., Garden City, N.Y.: 1971, p. 97.
5. Andreas Lommel, *Shamanism: The Beginnings, of Art* (trans-
 lated from the German by Michael Bullock) McGraw-Hill Book
 Co., New York, Toronto: 1967, p. 9.
6. Claude Lévi-Strauss, *The Savage Mind* (translated from the
 French by George Weidenfield and Nocolson Ltd.) (1962) The
 University of Chicago Press, Chicago: 1967, p. 84.

2. Dennis Oppenheim, *Adrenochrome*, 1970–1973. Installation
view at Sonnabend Gallery, 420 West Broadway. Courtesy
Sonnabend Gallery, New York.
Components include: 1. 1 gram of Adrenochrome (oxidized),
2. Slide projection of Adrenochrome crystal at 500 x,
3. Tape loop of a medical letter regarding Dennis Oppen-
heim written by James G. Harrison, M.D., in 1963.

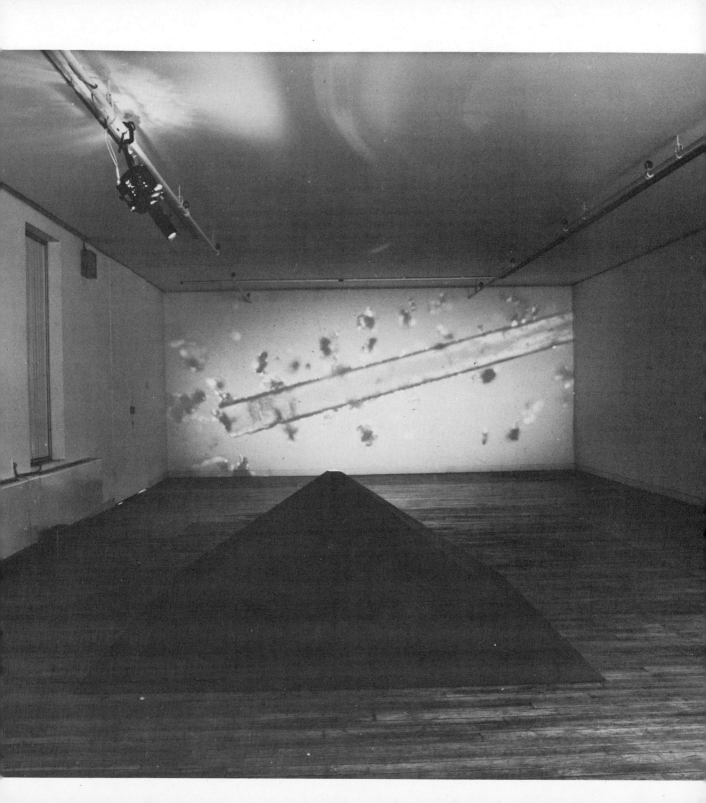

OBJECTS AND RITUAL:
Towards a Working Ontology of Art

In filling a pipe, all space (represented by the offerings to the powers of the six directions) and all things (represented by the grains of tobacco) are contracted within a single point (the bowl or heart of the pipe), so that the pipe contains, or really is, the universe. But since the pipe is the universe, it is also man, and the one who fills a pipe should identify himself with it, thus not only establishing the center of the universe, but also his own center; he so 'expands' that the six directions of space are actually brought within himself. It is by this 'expansion' that a man ceases to be a part, a fragment, and becomes whole or holy; he shatters the illusion of separateness.

From The Sacred Pipe: *Black Elk's Account of the Seven Rites of the Oglala Sioux*

That language universals exist has again become a respectable claim among some linguists. Given the deep structural similarities within the semantic, syntactical, and phoentic frameworks of the studied languages of the world, there is reason to believe that the needed mechanisms of speech are alike for the entire human species. If we want to believe that a child's linguistic system is the result of his comparative intellectual superiority to animals, then how is it that a child obtains a working command of the basic speech patterns by the age of five or six — while the same information remains a mystery to linguists? Or why do both bright and dull children attain a similar degree of speech competence by the age

of five? While language learning depends upon conversational environment, the child does not 'learn' speech in the same way he or she learns the multiplication tables. More than likely, ambient speech heard by the child 'triggers' linguistic patterns ready to be put into use.[1]

To date, most of the work in universals consists of taxonomies of parallel rules, restrictions, and priorities drawn up by linguists studying a fair number of dissimilar languages. In no way do these descriptive lists (semanticity, displacement, openness, tradition, discreteness, reflexiveness, etc.) constitute a coherent, mathematical theory of language's structural features. They represent, instead, patterns of containment, the approximate boundaries defining language usage. Since universals are the creation of linguists, it is not surprising that linguists should regard them as a special province. One of the great linguists of this century, Roman Jakobson has recently written, "In relation to language other (semiotic) systems are concomitant or derivative. Language is the principle means of information communication."[2] Given the confused state of semiotic and ethnological studies in myth and other social systems, this is not surprising to hear. In part due to the presumed rigor of structuralism, and, even more, transformationalism, theoreticians such as Noam Chomsky have tended to separate "natural language" from "arbitrary symbolic systems."[3] Chomsky implies that language is somehow logically encapsulated into a syntactical algebra, while religion, art, dancing, tool-making, architecture, and music are too haphazardly organized to be analyzed by the same methods. There is, of course, the possibility that the pattern of universals may not conform to any mathematical model so far expected of them.

As a prolegomenon to a fuller study, I want to suggest some features for a general theory of universals. Deductions made by linguists for the existence of universals imply an enormous range of functional needs and classifications. At present it is nearly impossible to read much coherence into such a variety of demands. We tend to look at human speech as a disembodied property of man fit for a language laboratory. I suspect that

speech is only part of a constellation of sign-making activities — all interlocked in terms of man's total potential behavior patterns, and that this is finite ontologically. Applying the principle of Ockham's Razor to human communication, what is the nature of social sign systems, and how do they change psychically? Reasonably enough, we regard art, architecture, tool-making, and the crafts as the bulwark of civilization. Because of their material-inanimate nature, such forms endure after men die and are passed from generation to generation. And it is here, I suspect, that we may detect one of the oldest and most chronic illusions of mankind.

Given the already celebrated economy of the human brain, it is likely that all universals are neurally generated from the same very small set of rules. This generator has immense combinatorial capacity. It functions hierarchically so that the same universal would provide both the theme for a Greek Tragedy (or a school of theater) on one level and shape the semantic content of a morpheme on another. Due to their mathematical consistency universals operate as a series of 'bound forms,' that is they are dependent in context upon other specific juxtaposed universals. While they are linked in terms of their semiotic significance, the most significant property of universals lies in a certain degree of hierarchical 'nesting.' Hence it is feasible for universals operating at higher levels of behavior patterning to provide a variety of optional choices for universals put to use at a lower level, and exponentially the number of possibilities would increase with each subsequent level — thus accounting for the fact that the themes of our art and theater change only slightly while the modalities for expressing each theme are immense.

The modern scientist who first suggested that the themes of art, theater, and dreams are embedded in universals (or archetypes) was a psychiatrist, Carl Jung. In an essay written in the early 1950's, "Synchronicity: An Acausal *Connecting* Principle," Jung drew a parallel between the modern imprecisions of physics (i.e., the "Uncertainty Principle') and the ancient need for man to find surety in a world where causality does not always function.[4] The conclusion to Jung's essay can be found in a *quaternio* diagram in part suggested by the physicist Wolfgang Pauli.[5]

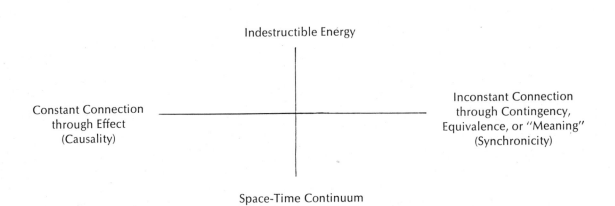

Indestructible Energy

Constant Connection
through Effect
(Causality)

Inconstant Connection
through Contingency,
Equivalence, or "Meaning"
(Synchronicity)

Space-Time Continuum

We live in a space-time world which seems to expend and transmit energy according to perceivable patterns, and yet we are also bound to an anti-entropic principle, the source of organic growth pulsation. This constant coming-into-being has no definable origin or meaning; it in fact appears to be "meaning" itself. The principle of causality expands itself in human consciousness in terms of the temporal formula of cause and effect, while the second principle simply "is." It annuls time as we know it, and juxtaposes certain psychic content with appropriate physical processes. Jung hypothesizes that the human mind is in constant battle to equilibrate the forces of *Causality* and *Synchronicity*. Diverging somewhat from Lévi-Strauss's theory, I have earlier suggested in *The Structure of Art* that the balance between the diachronic and the synchronic is the key to all conceptions of art.[6] In terms of universals, or what Jung refers to as archetypes, I will explain why.

Universals account for the formation of three basic types of human communication: speech, gesture, and iconicity. All forms of human facturing are surrogates for these fundamental means of communication. This fact and Jung's diagram are crucial to the idea of religious paradox. The primary symbols of many organized religions constitute a formal or geometric basis for the system of universals controlling human thought. Symbols are containers of the various levels of knowledge. They represent metaphysical insight into the organizing principle of life itself. At their most condensed, and when logically understood for what they are, symbols possess enormous power as sources of psychic energy. They recapitulate the ontology of natural growth, and more specifically, the evolution of the human race and the intellectual and emotional development of every child. In effect the code of human universals resides in two contrasting forms: the first is in each human brain, the second is in all artifacts comprising the man-made world. In terms of practical function and iconicity, every manufactured object and spatial enclosure represents a deducible imprint of specific universals. Consequently this code is carried from generation to generation by two separate means: *organically* through the brain of every living individual, and *inorganically* through the trans-lingual relationships embodied in every artifact, writing, or spatial arrangement. This invites a great paradox. All profound art and writing lies in conflict between *being* as the essence of spiritual revelation and the illusional permanence of the written word, the icon, or the sacred space.

We necessarily use the entire code of universals in everyday speech, but few minds become insightful enough to consciously understand the code or to use it deliberately. During the early part of the present century, classicists and ethnologists such as James Frazer, Jane Harrison, Francis Cornford, and more recently Lord Raglan and Stanley Hyman, proposed a "ritual theory" of myth. It was their conclusion, in Jane Harrison's words, that "The primary meaning of myth in religion is just the same as in early literature; it is the spoken correlative of the active rite, the thing done . . ."[7] Hence if there is an ontology to human communication, it begins with prescriptions for the conduct of life through living itself as a source of imitation. It could be surmised that the earliest ritual was in no way a repetition of forms such as we know it, but instead a heightened sensitivity to the natural cycles of daily and yearly existence. Originally rituals were not repeated simply because of their efficacy: more likely the functions of organic existence (farming, marriage, chilldbirth, husbandry, wine-making, etc.) were repeated in form because of their *natural universality and synchronicity*. All "magic" exists in the periodic phenomena of life appearing. "Doing" which culminates in technical or pragmatic results is the causal antithesis of ritual, and hence the beginning of "technology" as we know it.

Life lived according to innate patterns and time cycles of nature must have had a double significance for early man. Not only was he able to sustain himself magically, instead of pragmatically, but the living out of such patterns produced their own forms of mental 'resonance' and therefore intrinsic pleasure. The reason for this is very important. *Time cycles directing natural events are proportionally equivalent to the structure of the universals controlling language and other semiotic systems.* Certainly this is a point of extreme signif-

1. Bruce Gunderson and Bob Clark in *Sut-Rut-Ma*, a ritual presented at the School of the Chicago Art Institute, December 1971. The setting was constructed over a period of four months. *Sut-Rut-Ma* was accepted as a thesis project for a master's degree in sculpture.

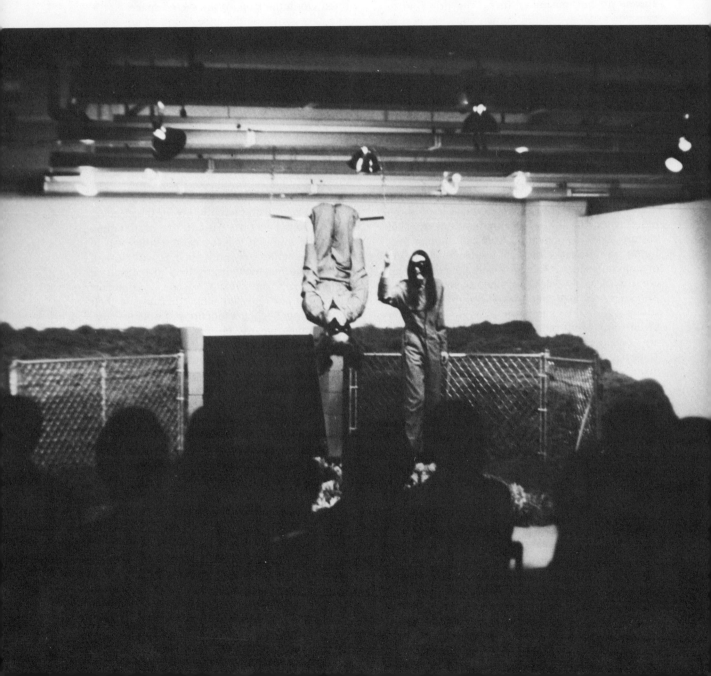

icance which remains unproved, yet for the sake of argument let us assume its possibility.

We can begin to see, as Jane Harrison has pointed out in her books on early Greece, that formalized ritual and theater were two steps by the citizens of Athens leading away from the authenticity of lived ritual down to human, animal, and vegetable growth. In time ritual sustains itself through the use of icons and liturgical artifacts. At a later stage these degenerate into works of "art." Just as we lose the art of living through formalized ritual, we began — many thousands of years ago — to transfer our hopes of maintaining the code of universals to inanimate objects: scrolls, books, paintings, sculpture, and architecture. By living from generation to generation through the medium of objects around us we create a series of surrogate styles and eisptemological worlds, but even more important, we induce the permutative reduction of the universals themselves. Gradually the code is separated into little increments by our arts of historical progressivism. While the code is used daily in everyone's mental operations, we unknowingly dissect it historically into thousands of pieces for spiritual insight, entertainment, and scientific advancement. In the human war between causality and synchronicity, causality slowly wins in the shape of culture and its inorganic handmaiden. Certain classes of objects become enormously valuable without us really knowing why; on the other hand, the word "ritual" becomes almost synonymous with boredom, tiring repetition, outdatedness and meaninglessness. And the inversion is complete.

Yet it must be remembered that all art forms serve a crucial function during their historical evolution. The urge to preserve and classify is considerable; objectively speaking, the curatorial role is almost as obsessive as creativity itself. Still compulsive historicity plays a valuable function; it sustains a completed model of language universals in time. These represent the *alpha* and *omega*, the beginning and the end. Yet one of nature's ironies is that the end of the code is very much like the beginning. As the code destroys itself systematically, it destroys those aspects of itself which are inorganic. The code eventually denies its temporal-linear format and wants to be simply "lived."

In 1967 an often quoted article by Michael Fried, "Art and Objecthood," was published. The essence of Fried's polemic against the then prevailing anti-formalist esthetics lay in two assertions: *1) The success, even the survival, of the arts has come increasingly to depend on their ability to defeat theater. 2) Art degenerates as it approaches the conditon of theater.*[8] In some quarters it is considered that Fried made the last intelligent statement defending formalist sensibilities, given that what has been under the most direct attack for the past ten years is the physical support structure itself: the two-dimensional plane in painting and the three-dimensional device in sculpture. As painting and sculpture have relinquished some, if not most of their energy to Environments, Body Art, Real-Time Systems, Conceptual Art, and that all-embracing caption, "Personal Mythologies," academia has slipped into a kind of unexamined self-serving homage to the past, virtually unable to cope with these contemporary usurpers of the Fine Arts tradition. Fried in his articles talks of the grace of an eternal "now" pervading works of "quality." And in closing Fried pleads that "faced with the need to defeat theater, it is above all the condition of painting and sculpture — the condition, that is, of existing in, indeed of secreting or constituting, a continuous and perpetual *present* — that the other contemporary modernist arts, most notably poetry and music, aspire."[9]

Actually Fried's "continuous and perpetual *present*" is an historical counterpart to the synchronic world of ritual for archaic man. Fried is bound to lose this battle because his schema depends upon a small fragment of man's complete set of universal processes, since only "lived" primordial myth can preserve true history, the history of the total human condition. In the words of Mircea Eliade:

... for modern nonreligious man he accepts no model for humanity outside the human conditions as shown by various historical cultures. Man makes himself, and he only makes himself completely in

proportion as he desacralizes himself and the world. He will become himself only when he is totally demysticised.[10]

Each generation produces its own version of the Universal Man. The businessman is an example of Eliade's modern archetype, profane man oblivious to the mysteries, a master of the art of the artificial, of that which is contrived because of modern conditions. Primal myth or ritual, on the other hand, is always "a recital of creation, it tells how something was accomplished, began to be." Mythic or artistic creation is a direct adjunct to birth and growth. Primitive man collaborates in the creation of his cosmos, but "For modern man the Universe does not properly constitute a cosmos — a living articulate unity; it is simply a sum of material reserves and physical energies of the planet. . . ."[11] Many sophisticated people regard the possibility of man's early unity as a faddish, utopian myth in itself, the dream of those unable to face up to the rigors of contemporary civilization. But "practicality" in many instances is no more than a conscious annihilation of the alternatives to a rationalized world, so that ". . . what men do on their own initiative, what they do without mythical model, belongs to the sphere of the profane; hence it is vain and illusionary activity, and, in the last analysis, unreal."[12]

The erosion in the plastic arts towards theater was in progress early in the beginning of this century, though never so evident as when critics began to describe in detail the activities of Pollock and de Kooning in front of or over a canvas. For a century the artist has chosen to be not only his best subject matter, but in many cases his only legitimate subject. Looking back at the enormous, chaotic energy of the Happenings and Fluxus in Europe, one can even now begin to draw a chronological trajectory focusing on the rudiments of ritual consciousness. The works of Al Hanson, George Brecht, Jackson Mac Low, Jim Dine, Claes Oldenburg, and Dick Higgins were pieces of theater-life set to a backdrop of late 1950's Abstract Expressionism, a sublime messy confusion pervaded with occasional moments of truth. John Cage and Allen Kaprow managed to erect definable styles through their own didactic methodologies, and at the time the Judson Theater served as the church of the New York Gallery system. Yet like the art of the late 1950's and 1960's, artists' performances had two underlying functions: to juxtapose the improbable and to subtract. Perhaps this can be summed up by a description of the activities of Tadeusz Kantor, the Polish dramatist and leader of the avant-garde theater in Eastern Europe for the past 15 years.

Kantor also mentions a number of features characterizing this process: loosening links of the content, creating a sphere of free happening, juggling with chance, bits and pieces, ridiculously unimportant things, anything at all, nullity: indifference to the importance of events and emotions, *annulment* chilling the temperature, ungluing any form of organization, throwing a spanner in the works; elimination by noise, platitudes, dullness, terror, incoherent acting, "anyhow" acting, "stealthily" acting, non-acting. At the same time Kantor emphasizes that "the reduction to zero in living practice means negation and nullity — in art it may give quite the opposite results."[13]

Plainly this is not ritual in the primordial sense that Eliade describes, but an acted out continuation of what has happened to painting and sculpture. As contemporary ritual activity arises, it does so first by the simple observation of rhythms and

2. *Gilbert & George as Singing Sculptures in "Underneath the Arches . . .",* 1970. Courtesy Sonnabend Gallery, New York.
The artists affirm the origins of art in ritual by creating an art context which succeeds by denying art's most essential features, silence and immobility. Just as the "Singing Sculptures" represent inorganic, metallic forms, their elaborate praise of artistic convention defines a set of worn-out attitudes. In contrast, as Gilbert & George are living beings, their praise of art's vitality and truthfulness is completely consistent with art's origins.

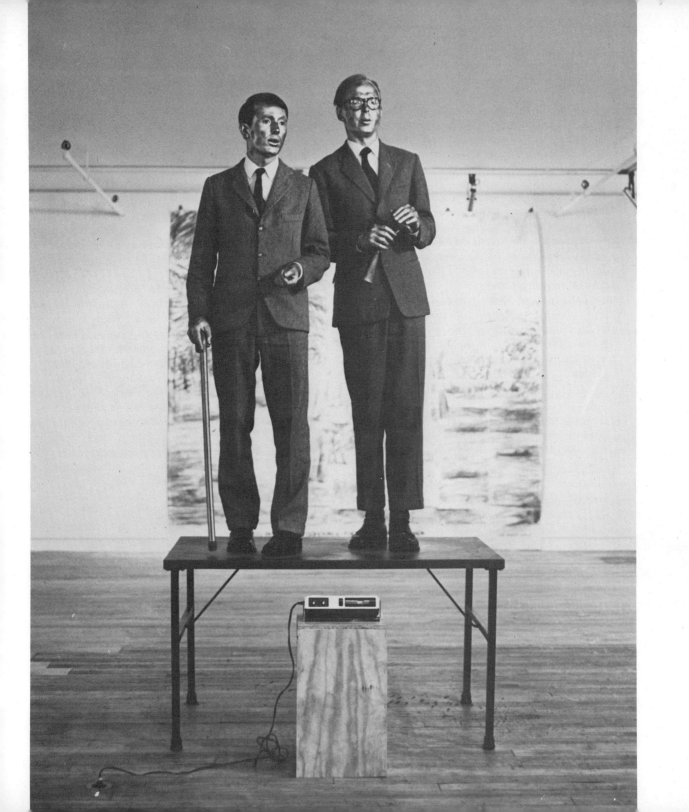

polarities that continue to control the world in spite of our will to mastery. But only gradually does ritual assume its ancient form of the "Mysteries," a word once synonymous with craft and drama. Only by reliving the Mysteries periodically can man save himself from history and refind psychic unity. That all art is esentially therapeutic, a leading toward *wholeness*, has been lost in the drive towards fragmentation in modernism; thus in Norman O. Brown's words, "The true sacrifice is total, a making holy of the whole; the false sacrifices a part. . . ." [14] The earliest *dromenon* or "rites done" of pre-Classical Attica lasted just so long as people were free of doubts concerning the psychical importance of their performance. Gradually the dance ring became a stage and activity polarized between those directly acting and spectator participation. The separation between conscious involved existence and its detached perception is a prerequisite for both art and science as we know them. The truth of this can be sensed in a recent discussion of body works by the artist Terry Fox:

> I didn't take the audience into account at all. I was really into a ritual which defined the boundaries of my piece. I never thought about how my work is being received. It's not so much a dismissal as part of the structure of my work. [15]

Among people adhering to sacred ways, a unity of purpose exists between the planting of a seed in the fields, the act of copulation, a human breath cycle, a marriage well conceived and performed, and the utterance of any sentence. From this we can begin to understand the value of words for tradition-oriented cultures. Each of these acts is paradigmatically organic and thus facilitates the joining of opposites so that a new form is consummated. In terms of Eastern thought, Ernest Fenollosa observed that as natural phenomena, sentences reflect a "transference of power" through the temporal order. All such processes, according to the orientalist, redistribute force. [16]

agent → act (copula) → object

In the largest sense the theistic concept was recognition of a perfect continuity existing between nature and culture. Culture fulfills and *is* nature. Human greed or laziness could provoke Yahwah or Zeus through the power of encompassing symbols to sever the abundances of nature. So the Hebrews, as with many other ancient peoples, possessed a law which analyzes the structure of verbal thought, human biological acts, and social semiotic systems as a necessary continuum of events. Such an all-embracing "Law" specifies that man is an element of nature and that he may only live by duplicating the laws of nature *as they are*, not according to interpretation.

As I have mentioned earlier, the structure of the universals controlling thought processes are organized ontologically. Their order precisely recapitulates human learning processes as they are sequentially related through the nervous system. Various forms of post-painting and post-sculpture now being practiced by artists relate to the earliest stages of infant development. Here, first attempts at interpersonal relationships, measuring of spaces, exploring the body, making discrete and random piles of objects, and other pre-verbal activities mirror the artist's striving to reach the seat of the unconscious itself. Just as alchemists understood the return of chaos (mental oblivion) as an essential part of the Great Work, the role of the shaman in ritual activity was to neutralize and realign the individual ego, replacing it in part with a balanced and complete superego. In a parallel fashion, we are witnessing the destruction of signature art as artistic behavior becomes increasingly archetypal and ontological. The stages of tribal initiation once condensed the entire span of art history into the set of universals, namely through the stages of psychic and social growth of the individual. Such "rites of passage" or in mythical metaphor, the "Hero's Adventure," form an inversion of the chronological progressions of cultural history. Yet within primitive societies every young man or woman has the option of becoming a "hero" by successfully meeting tribal initiation. In modern society heroes are rare individuals who have successfully achieved artistic or mythic recognition. Still their initiation, because it is his-

3. Graham Metson (Western Tantric), *Rebirth*, Colorado, 1969.

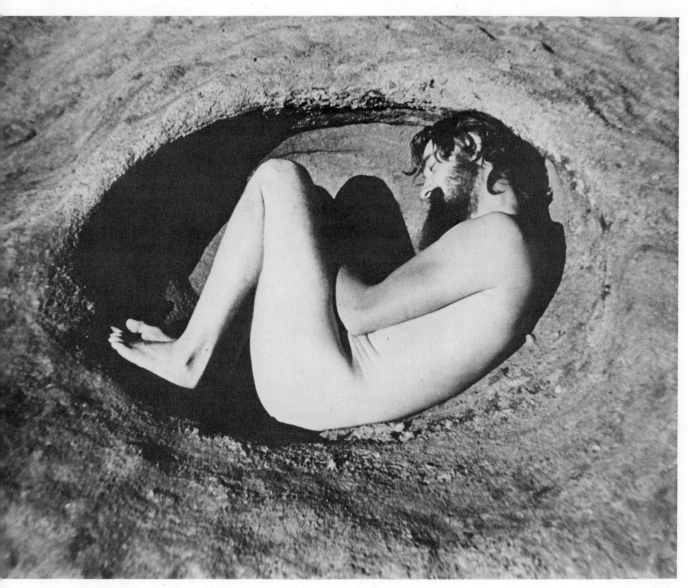

torically bound to a failing culture, is fragmentary and often tragic. All art in history is a series of models of the human experience, and being models, they are imperfect — except in summation. The dichotomy between ritual and game as social structures has been brilliantly analyzed by Lévi-Strauss. He reflects that games function disjunctively. They establish differences between individual players or teams by creating winners and losers; thus men are made separate according to their competitive skills. Rituals, on the other hand, conjoin people. Groups or individuals previously separated are unified through the rhythms of collective activity. Games begin symmetrically but generate asymmetry between teams; inversely, ritual produces symmetry or group unification out of psychological disparity. Observing similar patterns in art, the ritual functions of art-usage are strongest during the beginning of any particular art cycle, while the competitive aspects of artist rivalry dominate the final stages.

In societies organized ritualistically, such as the tribes of the American Indian, all objects are in effect art objects. Due to their integral relation to the organic activities of man, sacred societies view the unnecessary proliferation of artifacts, utensils, and goods as a form of blasphemy, provoking a loss of meaning. Tools and household articles are in effect liturgical implements, frequently serving as sources of metaphors for tribal tales. Iconic and ceremonial artifacts embody the natural cycles of change and growth. They approximate our works of art with one important difference. Unlike objects in a museum they possess no significance as interdependent entities of an historical code: they comprise a unity out of time. If the knowledge invested in sacred symbology is understood and therefore lived, the symbolizing object achieves a purely organic consistency. Its physical substance is completely secondary to its genetic encoding. Since the essence of the universal code is cyclical and nonlinear, the sacred artifact (or work of art) becomes an expendable container for the transmission of "lived" truths.

1. Langacker, Ronald W., *Language and Its Structure: Some Fundamental Linguistic Concepts*, New York/Chicago/San Francisco/Atlanta: Harcourt, Brace & World, Inc., 1967, pp. 235-246. The issue of language "universals" remains central to a satisfactory approach to cognitive anthropology or a cognitive theory of art. What has been done to date in structuralist studies is simply a drawing up of taxonomies of various types of text and subjecting the resulting categories to indiscriminate low-level logical relationships. Twenty years ago "universals" were an unfashionable if not dead issue among the major schools of language theory, though various individuals differed. In 1963 the M.I.T. Press printed a collection of papers entitled *Universals of Language* (edited by Joseph H. Greenberg) resulting from a conference held in 1961. Since then the debate about "universals" has sharpened: if nothing else, many naive heuristics have been discarded. A more recent volume, *Universals In Linguistic Theory* (edited by Emmon Bach and Robert T. Harms) New York, London: Holt, Rinehart and Winston, Inc. was published in 1968. Possibly the most fruitful approaches to this problem are the various psycho-linguistic theories on the development of animal communication and children's speech. These have resulted in some rudimentary theories of language genesis. Much of the discussion on "universals" ends by being confronted with the *Sapir-Whorf Hypothesis*, namely the notion that every language and every culture contains its own particular metaphysics, or means of evaluating the phenomena of the world, which is directly reflected in its language organization. Given that enormous structural differences arise in terms of tenses, case structure, meanings, and word order, then it would seem that "universals" could only exist as a very deep and abstract cognitive structure, perhaps as a many-leveled branching system utilizing the major areas of mathematical logic. Provided this is true, a complete semiotic theory of art, architecture, or music would have to remain essentially a theory of the same code of universals colored by geographical and physiological constraints.
2. From a preliminary version of a paper to be given by William P. McLean at the symposium on "Pragmatic Aspects of Plastic and Graphic Modalities of Semioses: Multiple System Processes of Communication Viewed in Context" at the meeting of the A.A.A.S. in Washington, December 27, 1972, p. 3.
3. McLean, *op. cit.*, p. 7.
4. Jung, C. G. and Pauli, W., *The Interpretation of Nature and Psyche*, (translated from the German by R. F. S. Hull) New York: Pantheon Books, Inc., 1952, pp. 1-146.
5. Jung and Pauli, *op. cit.*, p. 137.
6. Burnham, Jack, *The Structure of Art*, New York: George Braziller, Inc., 1971.
7. Fortenrose, Joseph, *The Ritual Theory of Myth*, Berkeley/Los Angeles/London: University of California Press, 1971, p. 26.
8. Fried, Michael, "Art and Objecthood" in *Artforum*, Summer, 1967, p. 21.
9. Fried, *op. cit.*, p. 22.
10. Eliad, Mircea, *Cosmos and History: The Math of the Eternal Return* (1949) (translated from the French by Willard R. Trask) New York: Harper & Row, 1959, p. 202.
11. Eliade, *op. cit.*, p. 98.
12. Eliade, *op. cit.*, p. 96.
13. Borowski, Wieslaw, "The Theatre of Tadeusz Kantor 'Cricot-2' " (from a program from the *Edinburgh Festival 1972*) (translated from the Polish by Marcin J. Dabrowski).
14. Brown, Norman O., *Love's Body* (1966) New York: Vintage Books, 1968, p. 174.
15. Sharp, Willoughby, 'A Discussion with Acconci, Fox, and Oppenheim" in *Avalanche*, Winter, 1971, p. 99.
16. Benthall, Jonathan, "Language, Ecology and Art: New Structures for Education" in *The Structuralist*, No. 19, 1970, p. 50.

4. Peter Hutchinson, *Foraging:* Being an Account of a Hike Through the Snowmass Wilderness as a Work of Art, July 1971. Courtesy Peter Hutchinson.
Until this work the artist had been an "ecological" artist; here Hutchinson has transcended the "framed" art work and has decided to simply take a two-week walk through the Colorado Mountains, living off the land as much as possible. One night's meal is spread out on a tree stump: wild greens, mushrooms, almonds, chopped carrots, white-flowered shepherd's purse, and light blue violets.

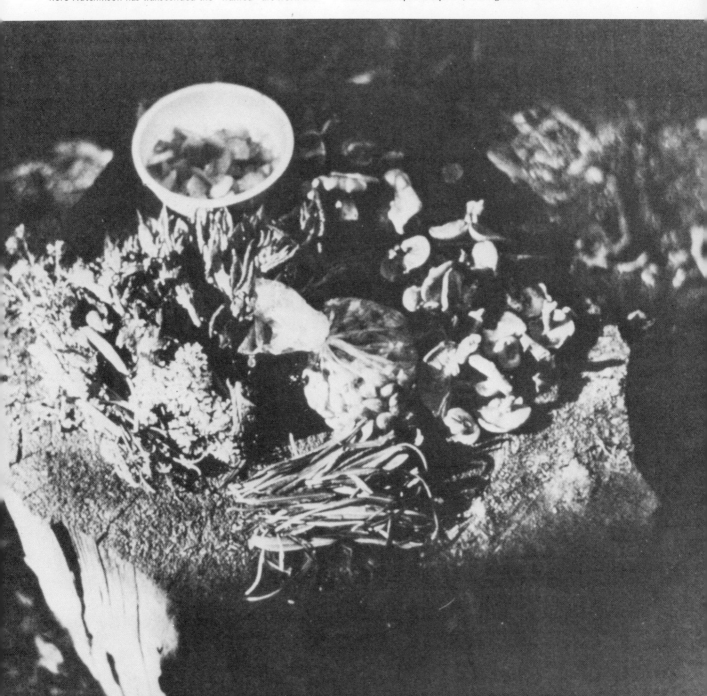

CONTEMPORARY RITUAL:

A Search for Meaning in Post-Historical Terms

In treating his patient the shaman also offers his audience a performance. What is this performance? Risking a rash generalization on the basis of a few observations, we shall say that it always involves the shaman's enactment of the "call," or the initial crisis which brought him the revelation of his condition. But we must not be deceived by the word performance. The shaman does not limit himself to reproducing or miming certain events. He actually relives them in all their vividness, originality, and violence.

Claude Lévi-Strauss in
Structural Anthropology [1]

Certain forms of documentary art (especially those recorded from the body or various personal acts) seem to repel most critics and historians, and much talk abounds about art being at its nadir. Though upon deep examination, one senses that this stage of art represents a tearing away of the final set of veils between the underlying psychology of art and the repressed fears of the artist's most critical audience. Never before have the plastic arts attempted to produce quite the same abreactive or purging effect. In this respect some recent personal art approaches the archetypal quality of true ritual.

At our point in time, at least, ritual and art appear to have little to do with one another. Involvement with the plastic arts seems somehow more appropriate, more civilized. Yet the same equilibrium sought in ritual — through control of analogies and oppositions — is also essential to art. In ritual the raw materials are human beings, and the 'truths' sought for are *relived* by the participants, not sublimated through objects. In describing the Hayoka ceremony of the Sioux — a ritual revealing certain distasteful truths — Black Elk explains the use of foolish tricks to balance the solemnity of the message: "One Side and I were fellow clowns. We had our bodies painted red all over and streaked with black lightning. The right sides of our heads were shaved, and the hair on the left was left hanging long. This looked very funny, but it had meaning. . . ." [2] At the time of the ceremony, nearly one hundred years ago, these Sioux medicine men were aware that their culture and its mythic foundations were rapidly crumbling — a condition not unlike our own. It is ironic that today some artists, descendents perhaps of the white settlers of Sioux lands, are attempting to relearn the principles of ritual practice. We sense this in some avant-garde art such as that organized by Darryl Sapien and Michael Hinton a little over a year ago at the San Francisco Art Institute.

The artists were given a room 20-feet by 30-feet, and divided it into a symmetrical space. One 20-foot wall was painted blue, the opposing wall orange. These colors were balanced in value and intensity. At the center of the room the artists placed a tidy 10-foot diameter circle of steer manure. Hanging above they suspended a 10-foot diameter mylar-covered, reflecting disc. The artists included two high-intensity tungsten spotlights, necessary for filming. On the floor, near the center of each wall, lay four props: one black blindfold, one jar of vaseline, one tray of paint (orange and blue at their respective walls), and a 20-foot length of rope bolted to each wall.

Sapien and Hinton proceeded to enter the room, nude except for dyed skull caps. One man was painted orange, the other blue. Each stood against his wall staring at his opponent. After three minutes the Blue Man began by crossing the room. With a piece of chalk he outlined the Orange Man on the orange wall. Blue Man returned to his wall to await Orange Man who repeated the outlining process using orange chalk. Orange Man returned to his wall. Next, the celebrants covered the lower half of their bodies with

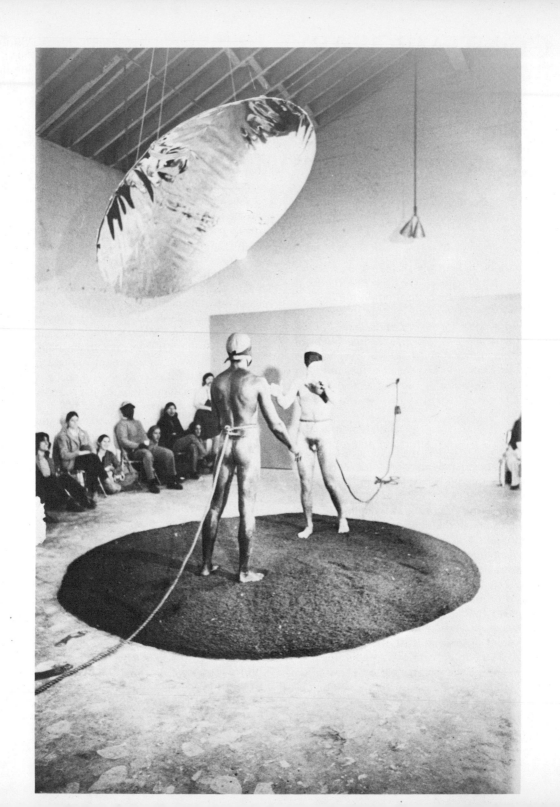

the stick jelly and tied the free end of the ropes around their waists. The ropes almost gave them the freedom of the room. But so long as they remained attached to their rope, they remained extensions of the wall.

Sapien and Hinton then simultaneously fixed the black blindfolds over their eyes, tying them securely. They placed each foot into their respective trays of paint and then walked straight ahead into the circle of steer manure. Magically, footprints in orange and blue lead out of the chalk outlines. With arms outstretched in simulated blindness the two men touched for the first time, instigating a passive, tactile dialogue which lasted about four or five minutes. The two then removed the blindfolds from each other. The dialogue gained in intensity as the two moved from a blind sense of each other's presence into an active contest. They began to wrestle with all their strength, each trying to throw the other to the ground. The violence of the struggle reached a peak after about seven minutes and then began to subside. Both celebrants were soon exhausted.

Through the course of this aggressive dialogue, paint and steer manure intermixed on their bodies. Gradually the two human forms accomplished a certain homogenization. Through the catalyst of wrestling, they reached a level of relative unity. The result was satiation and monochromaticity. When both parties became too exhausted to continue, they untied themselves and left the room.

The residue of the contest remained: chalk outlines on the walls, footprints, tangled ropes, manure strewn throughout the room, and the lingering energy of the combat. All of these aspects remained as a kind of residual mythology. The artist's intent was to leave the room intact for as long as possible. Due to complaints about the odor, the residue of the ritual combat was cleaned up after two days. Ideally, people walking through the room would be allowed to reassemble the sequence of activities. Sapien feels that these ritual by-products are symbolically important.

This reveals an important difference in attitude from those in more traditional cultures. While the contemporary artist is still historically attuned — either via the media, storing his paintings, or simply preserving film and tape records of his events — the essence of ritual lies in its freshness and emotional intensity, virtues which demand live recreation. The truth of this only came to me a few years ago when a novelist, eighty years old at the time, told me this story: Her mother grew up as a member of an Indian tribe in Southern California. The novelist spent much of her life in China, writemotional intensity, virtues which demand lice recing about its people. In later years she was made an honorary member of her mother's tribe — possessing some Indian blood herself. She was thus given the privilege of partaking in the tribe's ritual life. Customarily, some tribes open certain lesser sacred festivals to the public. This novelist brought her tape-recorder to a closed ceremony. An elder of the tribe came over and told her that she could not use it. She replied that it was a shame since none of the younger people of the tribe were learning the songs, and in a few years the songs would be extinct, with no trace of them. The tribal elder replied that that was not a bad thing — since the meaning of the sacred songs depends upon the desire to sing them; after being sung they disappear into the air — until someone wishes to sing them again.

We tend to think of serious ritual as being terribly primitive and embarrassingly sensual. Quite possibly it is, at least in its purer forms. On its most integral level ritual is the interface between Nature and Culture. To pursue this comparison further, one could say that if ecology is the syntax of Nature, then ritual is its daily, procedural counterpart in Culture. While ecology is simply the way of Nature, ritual has to be learned and adhered to. Given the nonconnectedness of the institutions of Western Culture, and with anti-ritual as a way of life, it is probably difficult to envision any fundamental connection between ritual and Nature. In ways rarely understood by social scientists "magical" and organic are synonymous.[3] Yet as we withdraw from the acausal essence of the organic, we

progressively diminish the syntax of living interaction and replace it with property and abstract values. In the anthropologist Mary Douglas's words this constitutes "a denunciation not only of irrelevant rituals, but of ritualism as such; exaltation of the inner experience and denigration of its standardized expressions; preference for intuitive and instant forms of knowledge; rejection of mediating institutions, rejection of any tendency to allow habit to provide the basis for a new symbolic system. In its extreme forms anti-ritualism is an attempt to abolish communication by means of complex symbolic systems." [4] One of the truisms of ecology is that *the only test of Nature is the ability to remain.* Two hundred years of technological domination has given us an illusionary sense of our own permanence. One of the basic principles of Nature is concerned with asymmetries that develop between bordering ecological subsystems. Given two bordering subsystems (either natural or cultural or a mixture of both), the less-organized subsystem releases energy to the more-organized, and in the process the less-organized subsystem loses information while the more-organized gains some. [5] Over a period of time this produces imbalances between neighboring ecosystems precipitating crises within the more-organized system. As a culture builds up its urban areas, mechanizes and simplifies its food chains, cuts down its diversity of relations with Nature, it assumes the form of a more-organized ecosystem drawing on the surpluses of energy from the simpler ecosystems around it.

Considering the atrophied and unpopular condition of the avant-garde today, it is difficult in some respects to connect it with fundamental ecological needs. Still there is evidence that this may be the case in some vestigial form. One of the most remarkable anthropological theories to appear in some years is found in Roy A. Rappaport's book *Pigs for the Ancestors,* a study of ritual in the ecology of a tribe of New Guinea mountain farmers. [6] The Tsembaga Maring are a tribe of several hundred situated in the Central Highlands of New Guinea. Rappaport's fieldwork among the Tsembaga group convinced him that the traditional rationalizations concerning the purposes of

ritual, i.e., rituals suppress fear, reduce anxiety, and provide a sense of security, were at best only secondary motivations. The author regards ritual as the set of regulating mechanisms controlling relationships between the Tsembaga and important components within their environment. According to Rappaport:

> It will be argued . . . that Tsembaga ritual, particularly in the context of a ritual cycle, operates as a regulating mechanism in a system, or set of interlocking systems, in which such variables as the area of available land, necessary lengths of fallow periods, size and composition of both human and pig populations, trophic requirements of pigs and people, energy expended on various activities, and the frequencies of misfortunes are included. [7]

One of the more interesting problems discussed by Rappaport deals with differences between climax and cultivated ecological communities. Climax communities are natural ecological areas which have achieved their greatest possible complexity and orderliness. This is defined by maximum biomass production, long and sophisticated food-chains, and inhabitance by stable hierarchies of organisms. Many wilderness areas may or may not be climax ecologies, but in contrast humanly inhabited areas are generally cultivated communities — simply because there is some external regulation of animal and vegetable life. Cultivated communities protect favored species and tend to deplete those less useful. Consequently they are ecologically less sophisticated than the climax communities they replace. The stability of cultivated communities depends upon maintenance by the dominant species, and it is usually a people's lack of concern with long-term environmental depletion which transforms a fertile area into one of lower production. "Anthropocentric degradation" is evident in most areas of the populated world since at least the period of Neolithic Man. A prime example is the loss of forests and farming land throughout the Mediterranean area since the Second Millennium B.C. It is significant that, in Rappaport's words,

> The question of whether or not degradation, absolute or anthropocentric, is widespread over Tsembaga territory was touched upon earlier in the

discussion of the adequacy of fallow periods. Evidence indicated that except in highly localized areas there is no degradation of either sort.[8]

Relationships between ritual and regulation of crops, lands, and tribal activities are not precisely understood by the author. However, it is clear that rituals are initiated according to statistically average periods of repetition so that "the ritual cycle may be regarded as a mechanism that, by responding to changes in the relationships between variables in a system, returns these variables to former and more viable levels."[9] Rappaport's model is basically that of a heating thermostat. He sees rituals as a kind of binary regulating device where signals are either go ahead or stop. Decisions to institute certain rituals are the result of tribal discussion and consensus. Given any input of complex quantitative information (e.g., concerning going to war, slaughtering pigs, or opening fields to planting, etc.), ritual for the Tsembaga represents a qualitative simplification of a given situation. In other words, the initiation of a ritual is *reaffirmation* of an archetypal plan; the occurrence of ritual *provides information* as to the feasibility of the next ritual stage. In the absence of any theory that might correlate the syntax of ecological balance with the syntactical nature of ritual, the author simply assumes that the absence of strong secular authority and the power of the sacred to the unsophisticated Tsembaga are enough to insure the observance of ritual.

> Binary mechanisms thus make suitable regulators and transducers. But why is it that such mechanisms should be embedded in religious practice? In other words, what advantage does sanctity confer upon transducers and homeostats? . . . Any form of communication that employs symbols can accommodate lies. But a ritual is not only an act of communication; it is also a sacred performance. Although sanctity inheres ultimately in conceptions that are not only assumed by the faithful to be true but whose truth is placed beyond question or criticism, objects and activities associated with these conceptions partake of their sanctity. Since that which is sacred is taken by the faithful to be unquestionably true, sanctified messages are more likely than unsanctified messages to be accepted as true.[10]

Summarizing from Rappaport's theory of ritual among the Tsembaga, it appears likely that in its most essential form ritual parallels and coordinates all the aspects of organic existence including conception, birth, growth, regulation, and death. Consequently the art of historical cultures approximates these cultures's metaphysical life-and-death cycle *in historical time,* while the art of ahistorical cultures tends to reinforce the metabolic routines of day-to-day living. Art-consciousness grows proportionally as a culture becomes aware of its own past; art-consciousness dies as this same culture recognizes the non-unique quality of its past, that is, its inevitable cyclic periodicity.

It is not surprising that a very few artists are beginning to become involved with growth and harvest cycles of nature. Newton Harrison is one of the most intuitive and perceptive artists to move beyond the concerns of recent Ecological Art. His career in this respect is revealing. In the 1950's Harrison began as a sculptor, turned to painting in the 1960's, and by the late sixties moved into Technological Art with a series of glow discharge tubes. These provoked several proposals directed towards creating atmospheric effects at high altitudes. Two years ago Harrison produced a compost-earth pasture for the Boston Museum's "Elements of Art" exhibition and a *Brine Shrimp Farm* for the Los Angeles County Museum's "Art and Technology" project.

The notion of Ecological Art was well established before these projects. What distinguishes Harrison's attempts is a desire to question and record his own interactions and to construct systems involving complex hierarchies of organisms. While Harrison, acting out of the long tradition of gallery art, has made strenuous efforts to place his "Survival Ecosystems" in gallery and museum contexts, he has been forced to rethink the direction and meaning of such large-scale programs. It seems clear that the relationship between a painter or sculptor and his work is fundamentally different from that of an artist making sophisticated ecosystems. The psychological growth of a studio artist rarely depends upon the success or failure of his art. Though according to Harrison, one cannot work successfully with natural systems

without undergoing fundamental personality changes — as slow as these may be. The more a synthesized ecological system depends upon the interaction of its human provider, the more that person must attune himself to its rhythms. Being drawn into an integral, on-going, natural system gradually alters the artist's attitude towards self and the world.

In the fall of 1971, Harrison set up a fish-farm at an American exhibition under the sponsorship of the British Arts Council in London. Fish were grown in tanks for several weeks in preparation for a series of ritual meals. The fish were harvested and prepared for frying and stews. The fact that this was done at a public opening of an art exhibition caused enormous controversy. Harrison was attacked as a publicity-seeking sadist and the Arts Council was accused of wasting public funds. Though obviously, as a few critics insisted, not only does the killing of animal life go on as a daily aspect of modern survival, but Harrison took pains to kill his fish as humanely as possible. The real focus should have been on the fact that humans feeding on lesser-developed life forms remains a fundamental aspect of ritual art. Rather than suppressing the fact in the unconscious mind — as modern mechanized existence allows us to do — the artist wanted to reveal the most critical aspects of the life-chain.

Harrison believes that effective ritual stems from homage to our life-support systems, which in turn give sustenance and coherence to each social group that participates. Ritual behavior attaches itself to specific and visible outputs of the system. This homage becomes ritual as people involve themselves with compulsive regularity, and their behavior assumes the complementary qualities of a natural event. In the artist's eyes, it is this movement towards ornamentation and formalization that makes the whole activity creative and lends the group a sense of oneness, identifying it with a unity greater than itself.

This is true of the simplest task. For instance, there is an enormous difference between "making earth" and simply composting manure to enrich the soil. Harrison associates all of his mixing with an earlier — yet still important — mixing of paint, clay, and plaster, which he now sees as a surrogate for mixing earth and water. Harrison goes on to state that,

> Our most important pre-ritual activities so far are making earth and water, where, in an alchemical fashion we mix sterile and separately hostile elements, where the mixture combines with time and our touch, becoming literally a living element, a medium for growth. Some of this is private and does not bear publicity as yet. For instance, every morning I turn earth for one-half hour. I spend ten minutes of my time with a shovel, ten with a hoe, ten with my hands — and one minute with a hose. Two weeks ago this mixture smelled vile since 30% of it was sewage waste. This morning it smelled neutral — by next week it will smell fresh and go into one of the indoor pastures and I will start the process over again. In the abstract I understand that I make the condition for life and that my activity is homage to that life and feeds back into my body both the food that will come from it and the physical strength that comes from slow rhythmic work. I notice that I breathe in when I pick up a shovel full of earth and breathe out when emptying it. I notice that I make three hoe strokes on inward breathing and three strokes on outward breathing. In the beginning when the mixture smells vile I take very deep breaths, drawing in air slowly, but letting it out quickly. At that point my behaviour is almost gluttonous. I become very possessive, running my hands through the earth to break up small lumps. This behavior seems compulsive to me. Yet it is very necessary that I touch the soil all over, as a form of ornamentation.[11]

Harrison's wife Helen has been an instrumental force in many of these projects. She takes over the planting and nurturing of the pastures. Harrison speaks of watching her wash and inspect every leaf of some plants attacked by cabbage worms. The female-male division of tasks between Helen and Newton seems to be a natural detail of their work together. Each has his strengths. Helen comments, "I talk to plants, tell them what I expect of them and what I will give them — warmth, attention, food, water and companionship. They respond well. It's not that I'm urging or pushing, it's that this behavior is in some deep sense right and usually works. I treat the flowers and plants

2. Newton Harrison, *Lagoon—Simulating Monsoon*, January 1973,
La Jolla, California. Photo Philip Steinmetz.

as I would animals or children, the words are there but often the relationship occurs without them."[12]

Lagoon is one of Harrison's more recent projects. This is an indoor micro-system, a tank 8-feet by 10-feet by 3-feet deep containing 1,500 gallons of water. *Lagoon* is a body of water organized to simulate an estuarial pool on or near the equator. High-intensity lamps run in 12-hour cycles like the sun. The entire bottom forms a gravel filter, and the water temperature varies three degrees day and night. While Pacific Ocean water is used, weekly evaporation and the necessary addition of fresh water sets up a condition in part similar to rain, in part like estuarial flow. Within the animal hierarchy, crabs are the end product of this lagoon. Harrison concedes that if he were creating *Lagoon* in the Southern California desert, as he eventually hopes to do, he would introduce a natural food-chain to support the crabs. Thus organic life could and would take care of itself. As it is, human energy and processed food complete the ecosystem. Harrison and his wife feed the crabs because their natural foods are not available. Thus the human transaction substitutes and becomes a metaphor for nature.

The feeding procedures simulate conditions, in part, both like estuarial and tidal input. As the crabs are introduced to the tank, their feces activate the bottom filter. They kill, attack, and eat each other until the population is reduced to a reasonable number for the space — about 8-square-feet per crab; in such a way territories are established for each animal. After territories are recognized, cannibalism ceases, pecking orders are arranged, and mating and molting proceed. Harrison and his wife have been particularly successful in getting their crabs to mate and produce larvae. Crabs almost never produce offspring under artificial conditions.

Part of Harrison's time is spent in minutely observing the crabs and mimicking their behavior. This may not be proper zoological procedure, but this little piece of ritual is one of the best ways to learn the crab's habits. At times crabs swim over one another with no signal of recognition, sometimes they approach each other with claws outstretched and open, circling like wary boxers waiting for an opening. Harrison feels that when he is taking care of the crabs on their terms, he is substituting for nature. Eventually Harrison and his wife want to reintroduce the utilitarian into art at an extremely refined level. And in the process they hope to provide an antidote for the prevailing cynicism of the Art World by making art the non-verbal teaching system it once was.

As social life functions are quantified and mechanized, art is progressively trivialized into the shape of consumer goods. Tentative as it is, Harrison's art poses a most complex but fundamental question: namely, can we really sever ourselves from our food and material resources so that there is no longer a magical interface (ritual-art) between the two? In Harrison's mind, such institutions as the supermarket represent mass cultural defocusing mechanisms, the means of disintegrating the bonds between natural micro-systems and human micro-systems (read home or family unit). And in closing Harrison writes, "It is not the supermarket as a center of trade, which is its legitimate cultural function, that disrupts man's intuitive contact with his biological sources, but the supermarket as a utopian simplifier and developer of artificial needs that eventually erodes our inner sense of discrimination and our ability to relate magically to the environment."[13] During the later phases of historical art, the role of the artist, historian, and critic was to indoctrinate the public into the esthetic mystique, thus facilitating "art appreciation." Presently, in this post-historical period, we can begin by rediscovering art's quintessential roots. By understanding our lives we can begin to restore art to its rightful function.

1. Lévi-Strauss, Claude, *Structural Anthropology*, (translated from the French by Claire Jacobson and Brooke Grundfest Schoepf) New York, London: Basic Books, 1963, pp. 180-181.
2. Neihardt, John G., *Black Elk Speaks*, Lincoln: University of Nebraska Press, 1961, p. 195.
3. See "Objects and Ritual."
4. Douglas, Mary, *Natural Symbols*, New York: Pantheon Books, 1970, p. 19.
5. Margalef, Ramon, *Perspective in Ecological Theory*, Chicago and London: University of Chicago Press, 1968, p. 16.

6. Rappaport, Roy A., *Pigs for the Ancestors*, New Haven and London: Yale University Press, 1968.
7. Rappaport, *op. cit.*, p. 4.
8. Rappaport, *op. cit.*, p. 90.
9. Rappaport, *op. cit.*, p. 164.
10. Rappaport, *op. cit.*, p. 236.
11. From a letter by the artist dated October 10, 1972.
12. *Ibid.*
13. From a letter by the artist dated November 28, 1972.